VICTORIAN
Traveller's Guide TO
NORWICH

C. B. HAWKINS

AMBERLEY

Front cover image courtesy of the Library of Congress.

First published in 1910
This edition published 2014

Amberley Publishing
The Hill, Stroud
Gloucestershire, GL5 4EP

www.amberley-books.com

British Library Cataloguing in Publication Data.
A catalogue record for this book is available from the British Library.

ISBN 978 1 4456 4357 1 (print)
ISBN 978 1 4456 4329 2 (ebook)

Typesetting and Origination by Amberley Publishing.
Printed in the UK.

Contents

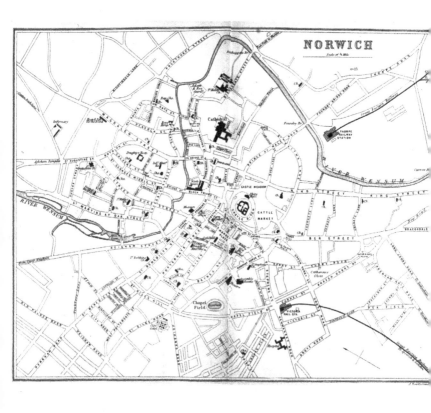

Introduction

There is great value to the citizen of any important town in having some book which gives him a complete and impartial account of the various activities of which his particular city is the centre. It is not merely the interest of being able to take a general view, but one can form true judgments and express reasoned criticism.

Norwich is a place with a very full life, and having great individuality. It possesses the strength and weakness of its isolated position. It is strong because it can make efforts of its own, without regard to the attitude of competing neighbours. It is weak because it may grow indifferent through the lack of wholesome competition, and because it may also become self-satisfied through being self-centred. It is well that we in Norwich should know ourselves. I believe that in the pages of this book, to which my few words form a preface, there will be found matter of a very helpful character for forming a sound judgment as to our city.

We have much to be proud of, much to remind us of our responsibilities. Antiquity inspires us, and, happily, we are not left without opportunity for putting into present action the feelings aroused in us by the proofs of the past earnestness which we see around us. There is a large population needing good present-day workers. There is a great local patriotism, but it needs to be rightly directed. I cannot help feeling that we are not very successful in bringing Norwich under the notice of the country generally. I have

met many people who thought of our great town as being of the same size and character as some of the small cathedral cities. We are a little inclined to isolate ourselves, mentally as well as geographically. I trust this book may help us to delight in social service to Norwich, and thereby to bring us into closer touch with the country generally. We are blessed with fine institutions, glorious buildings, considerable industries. We live in the midst of a great agricultural district; we have a past remarkable for the number of great men who, in various fields of labour, have lived and worked in our city. Let us make the most of our opportunities, getting rid of those things which are obstacles to our true progress, and using to the full the advantages which we have received, and of which, the better we realize them, we shall make the fuller use.

H. Russell Wakefield
Dean of Norwich

Introductory

Geographical situation has counted for much in the history and prosperity of Norwich. The city stands in the middle of a wide agricultural area, famous in mediaeval times for the production of wool, with the fine, long staple required for worsted manufacture. Its situation at the navigable head of the Wensum provided cheap and easy communication with the sea; and, by a network of inland waters, with all the low-lying country to the south and east. At the same time a road at least as old as the Roman occupation brought London within reach. These facilities gave Norwich military as well as commercial importance, and made it from the first a centre of ecclesiastical activity. A market for wool, the protection of a castle, and the business which gathered round a bishop and a great monastic house inevitably brought population to the city. It was thus natural that Norwich with raw material and labour ready to hand should have turned to manufacture at a very early date. For more than six hundred years the looms have never been idle in the city. Few towns have such a record of continuous industrial activity. Whether, as history has it, it was the prescience of Edward III which first brought the artisans of Bruges and Ghent to settle in the city, or, as is more probable, the simple pressure of economic advantages, there is no dispute that at the end of the fourteenth century there was a large Flemish immigration. Towards the close of the sixteenth century there was a second Flemish settlement,

due to religious troubles in the Low Countries. At this time great improvements took place in the technique of the trade, especially in dyeing, and the weaving of mixed silk and woollen fabrics was introduced. A century later the existence of an important weaving industry in the city was the occasion of another foreign settlement. Just as in the sixteenth century the Flemish weavers had come to find refuge from religious persecution, as well as a new outlet for their labour, so in 1688 the French Protestants came to escape the religious fervour of Madame de Maintenon. They also were weavers, but they brought with them a new industry. From this time onwards silk entered more largely into the products of the Norwich looms. In 1771, when Arthur Young visited the city, it was noted for the manufacture of crapes and 'camlets', mixed fabrics of silk and worsted. He estimated the annual value of the trade at just under a million and a half.

These facts may appear somewhat remote from the purpose of this essay, which is a social analysis of Norwich in the twentieth century, but they are really essential to a proper statement of the problem. Its long, industrial history and its successive waves of foreign immigration still exert an enormous influence on the life and character of Norwich. To a stranger indeed, coming to it for the first time, it is still in many ways a foreign city. The Norwich housewives, for instance, like their French and Flemish cousins, still retain the habit of buying provisions in an open market. In the morning one may see the milk being carried round by women in vessels similar in size and shape to those which may be seen any morning carried in the same way through the streets of Bruges. Even in architecture Flemish step gables are still to be seen here and there in the old parts of the city. In another sphere the sturdy nonconformity of Norwich, which has its parallel in a strong evangelical movement in the Established Church, doubtless owes much to the Protestant heretics who came here for conscience sake.

That these things survive is partly due to the comparative isolation of the city. If you take the map, Norwich lies clearly far away from the main stream of traffic up and down the country. It is more than eighty miles from Peterborough, the nearest point of intersection for a main line to the north. It is 114 miles from London, through

which any traveller to whom time is important must go to reach the south or west. It is 123 miles and over four hours in the train from Northampton, and still further from Leicester. Ipswich, the nearest great town, except Yarmouth, is scarcely more than half the size, and is almost as isolated. This simple geographical fact, as will appear in the sequel, underlies nearly all the difficulties of Norwich.

At the outset it raises this important question: How has it come about that Norwich has survived at all as an industrial centre? An important agricultural market it must always be; and this in itself, it must be remembered, will account for a very large part of the miscellaneous services by which Norwich lives. The cattle market – almost the largest in the kingdom – with its subsidiary industries alone creates quite a considerable demand for labour. Moreover, Norwich is the commercial centre of the most important wheat-growing district in the three kingdoms. Although this city now ranks after London as a market for English wheat, there has been a steady increase in the volume of oats and barley. Altogether, in 1908, over 500,000 quarters of English grain passed through the Norwich Corn Exchange. It is sold by sample and very little actually passes through the city. Unlike the cattle market, the corn exchange employs no labour, and it has not had therefore the same direct influence on the social character of Norwich. Nevertheless it brings an enormous amount of business, and it is one of the fundamental facts underlying the metropolitan position of the city in East Anglia.

At the time when Arthur Young was writing, the population of the city was 36,000, and it was the third greatest town in the kingdom. In 1851, though its dignity was dwarfed by the more rapid growth of other cities, Norwich was still a great city, and its population had reached the respectable figure of 68,713. But between these dates the introduction of steam power and the factory system had revolutionised the whole structure of industry. Despite this, Norwich had not only not fallen behind but had doubled her population. What factor had enabled her to survive the competition of cheap steam power in the Yorkshire clothing towns?

The answer has been partly given in the statement that Norwich possesses the most important markets for corn and cattle in England. It is consequently a place where there will be

much buying and selling of many kinds of goods and therefore a place where some goods are likely to be made. Besides, it is just as hard to arrest the economic activity of a city as to call it into being. When a certain point of development has been reached, almost anything is more likely to happen than progressive decline over a long period. The mere concentration of population on a small area in itself creates employment.

These economic tendencies are well illustrated by the economic history of Norwich during the last century. By 1807 less than forty years from the date of Arthur Young's description, the production of woollen and mixed fabrics had fallen to an annual value of £800,000 – a fall of more than one-third. This decline was partly due to the changes of fashion and to war having closed continental markets to Norwich manufacturers. But another change began to be noticed soon afterwards which looked ominous for the future of the town. In 1812 yarns spun by power began to be brought from Yorkshire, as they were cheaper than the home-spun yarns of Norfolk and Lincolnshire. Handicapped by dearer raw material, Norwich was unable to compete in the manufacture of heavy worsted fabrics with the Yorkshire towns. No attempt seems to have been made to make this sort of weaving a factory industry. Factories came later, and were always confined to the lighter fabrics.

The ancient trade in baize and serge quietly disappeared. But in any case, this was no longer the staple manufacture of the city. In the eighteenth century the lighter and relatively more costly mixed fabrics of silk and wool had been largely produced. Here the inherited skill of the Norwich weaver and the comparatively high value and light bulk of his product helped him in competition against superior organisation and machinery. The Norwich specialities, bombazine, camlet – and crepe, which began to be worn about the beginning of the century – fairly held their own for the first quarter of the nineteenth century. A serious blow was struck about 1830 when the East India Company ceased to export Norwich camlets to the East. More and more the Norwich manufacturers had to depend for their market on the production of novelties. The amount of business, if precarious, must have been fairly large, because in 1836 the Albion Mills were built

for the spinning of yarn to supply the weavers. Power mills in St James and St Augustine's were also built about this time, in which weaving was done as well as spinning.

In 1839 the textile industry of Norwich was the subject of a special report to the Royal Commission on the hand-loom weavers. It presents the picture of a considerable though decaying trade. At that time the total number of looms in the city was 5,075, of which 1,021 were unemployed. Of this number 3,398 were in the houses of weavers, and only 656 in workshops and factories. The hand-looms employed nearly 4,000 hands, about half of whom were women. On power-looms rather over a thousand hands were occupied, two-thirds of whom were engaged in weaving silk. The latter numbered 730. Curiously enough the census of 1901 gives almost the same number as being engaged in silk-weaving processes. The staple trade of Norwich at that time lay still in the production of mixed fabrics. The manufacture of bombazines employed 1,200 hands, and about the same number were occupied in weaving challis. Some of these also wove 'Yorkshire stuffs' which no doubt represent a survival of the old worsted fabrics. The trade had been subject to violent fluctuations. Strikes and riots had been frequent, and in their efforts to retain a market against desperate odds employers had cut wages, so that the average weekly earnings of weavers did not amount to more than eight shillings a week. The whole report paints a condition of demoralisation and misery which is absolutely appalling.

During the decade 1840–1850 matters began to adjust themselves. New industries came in to absorb the surplus labour, and the old industries were reorganised on a new and healthier basis. Population, which had been almost stationary in the intercensal period 1831–1841, increased in the next ten years from 62,000 to nearly 69,000. About 1840 the manufacture of ready-made boots began to grow into a great industry, favoured by a good supply of leather from the tanneries of the city and other places in the neighbourhood. The trade, indeed, was not a new one in Norwich. The idea of stocking boots in sizes had occurred to a certain John Smith who kept a shop in the marketplace forty years before, and one of the leading factories in this trade today is lineally descended from the business which he founded. Then the

manufacture of fillover shawls, with borders of richly figured silk, produced on Jacquard looms which had been first introduced in 1833, set a fashion which reached its height in the year of the great exhibition of 1851. There are two small workshops in the city where examples of these looms can still be seen, though a few dozen Paisley mufflers is all that remains of what was once an important trade. Another industry in which weavers found employment was the manufacture of wire netting – a clear case of unoccupied labour attracting new enterprise, and to this was added hammered iron and general engineering. In 1856 Jeremiah Colman, rather than renew a lease, moved from Stoke to Carrow, and thus secured the labour and transport facilities needed by an expanding business. At this time, too, fashion decreed that ladies should wear crinolines, and the haircloth which was used for them became and remained an important industry in Norwich. When it was no longer in demand for crinolines it was extensively used by tailors and dressmakers as 'stiffening'.

When the trade of Norwich was described by Baynes, a local journalist, in 1868, the industrial future of the city was assured. At that time all the trades on which Norwich now depends were represented, with the exception of chocolate and electrical engineering. There has been expansion in some directions and contraction in others, notably in weaving, but the main lines of activity are still clearly visible as they were laid down in the early decades of the second half of the nineteenth century. Though this is clear now, it was not clear to contemporary observers. They could still think of Norwich as being mainly a textile town, and as such it was visibly decaying. The looms which had numbered over 5,000 in 1840, numbered just a thousand in 1868. Half of them even at that date were hand-looms, and the number employed had shrunk to about three thousand.

It is easy to see how the character of the new trades was determined by the previous industrial history, and the geographical situation of the city. Faraway from coal and iron, Norwich could not hope to share in the new industry of which these things are the very life breath. Cut off by obstinate distance from the great main lines of communication, she could

not even shake off the burden of her surplus population, and this burden was enormously increased by the mere fact of her isolation. The one great city of East Anglia, Norwich inevitably attracts the unemployed labour of all the eastern counties. In one decade, for instance, between 1811 and 1821, when enclosures, power-spinning and improvements in cultivation led to a great displacement of rural population, the population of the city leapt up from thirty-seven to over fifty thousand. This influx must have enormously increased the privations due to a shrinking and irregular demand for labour. For two and perhaps three decades half of the population of Norwich must have been in a chronic state of semi-starvation. The low wages, the low standard of comfort, and perhaps some darker things which characterise Norwich, may be in some degree the outcome of this long struggle. Thirty years of suffering must have profoundly modified the morale and even the physique of Norwich working men.

The most important economic feature of the city for the last hundred years has thus been a ready supply of cheap and abundant labour. It was this which brought the great packing manufacturers. Norwich enjoys no special advantages in the actual processesof manufacturing blue and starch and mustard and chocolate. The important factor is the cost of labour for packing the finished article ready for consumption. It is here that her advantage really lies, and it is good and cheap labour whichen ables Norwich to command a world market for these commodities. The gradual decline of the textile trade again, set free a supply of labour which, in virtue of skill transmitted by many generations of weavers, was endowed with just the lightness and dexterity of hand required for manufacturing the finer kinds of boots. In turn-shoe work especially, a process in which light shoes are made wrong side out and then turned, workmanship of a subtle and instinctive kind has given Norwich a competitive advantage over other places.

These considerations, brief and inadequate as they are, help to explain how it is that Norwich has survived the loss of her pre-eminence in worsted. From the busy activities of the past, a new commerce has grown up on an infinitely larger scale than anything which has preceded it.

What Norwich Lives By

In the last chapter some attempt was made, by an examination of historical and geographical data, to analyse the causes which underly industrial life in Norwich. It is now proposed to review in greater detail the occupations and earnings of the principal wage-earning groups in the modern city. In this way it is hoped to gain some idea of the extent and social character of the population. Subsequent chapters will deal with housing, public health, the standard of life, and with the methods which Norwich adopts to protect and educate childhood, to cherish old age, to relieve unemployment and distress, and to enrich the lives of its citizens with organised recreation and the resources of art and knowledge.

At the date of the last census in 1901 the population of Norwich amounted to 111,753. There were 51,065 males and 60,688 females, women outnumbering males by no fewer than 9,623. The preponderance of women is a common feature everywhere. In the whole county of Norfolk, for instance, for every 1,000 men there were 1,086 women. But in Norwich the proportion of women is even higher. For every 1,000 males there are 1,188 females. As there are considerably more male than female births – in 1908 there were, for instance, 48 more boys than girls born in Norwich – this discrepancy perhaps calls for explanation. Women, it has to be remembered, are longer lived

than men, so that in a normal population they are always in excess of males. Taking England and Wales, there were in 1901, 107 females to 100 males. In Norwich, to every 100 males there were 119 females, a figure which must obviously be accounted for by some factor specially operative in the city. Everything suggests that this is to be found in a general tendency for the supply of male labour to exceed the demand for it. The economic history of the place for the last hundred years in itself points to this. Industry, as we have seen, has been brought into the city by the attraction of cheap unemployed labour, instead of the reverse process of population having been brought in by the attraction of high wages due to expanding industry and a keen demand for labour. It may be objected that wages in Norwich are, as a matter of fact, rather higher than they are in the country; but it is only a nominal difference. The influx from the country is due to other and partly social causes – to the attraction of town life and to a diminishing demand for labour in agriculture.

But if further evidence is needed to illustrate the relative over-supply of male labour, it is not far to seek.

In the first place, Norwich is notoriously a good recruiting centre, and this must take a good many young men from the city. Against this has to be reckoned the fact that it is a garrison town, but on the census night only 617 males were enumerated in barracks, and this is probably an insufficient number to counterbalance the loss of recruits who have been sent to other stations. In the second place, during the last intercensal period the city lost by migration upwards of 2,000 people, and when migration takes place the men go rather than the women. This is all the more likely to be so in Norwich as there are exceptional opportunities for the employment of women. Out of every 1,000 women aged fifteen and upwards, 432 are engaged in occupations, and one out of every four of these is either married or a widow. Altogether, 18 per cent of the 24,912 married or widowed women in the city are called upon to perform the double duties of motherhood and industry. The corresponding figure for Ipswich is 13-2, and for the whole country, taking urban districts only, 14 per cent.

Where the percentage of married women employed in industry is high, there is always likely to be too little employment for men. Married women are supplementary wage-earners, and if they go to work, it is because they have to eke out the insufficient earnings of their husbands. If as a result industry comes to be dependent on women's labour, the underemployment of men is inevitably aggravated; their wages fall and their numbers increase, because women are attracted to the city and bring their men folk with them.

During the last half century population has increased steadily though not rapidly. Between 1891 and 1901 the rate of increase for the decade was 10.7 percent. Assuming that this rate has been maintained the population is now 123,956, or adding the population of the area which has recently been brought within the city boundary, a little under 125,000. It is probable, however, that this rate of increase has not been maintained, and in that case the number is put too high.

The males over ten years in 1901 numbered 38,940, of whom 3,771 were retired or unoccupied, whilst 32,054 were engaged in occupations. The proportion returned as unoccupied is rather higher than it otherwise would be owing to the fact that Norwich men come of a long lived race. For every 1,000 persons living in Norwich there are 86 aged 60 years and upwards, and for the United Kingdom the corresponding figure is 70.

The professional classes, including teachers, who were nearly half, numbered 388, or 21 out of every 1,000. Businessmen or clerks accounted for 2,243 of the enumerated population of 1901, or 20 per 1,000. If we add to these the 3,520 persons who were enumerated as having retired from business or as living on their own means, many of whom would be pensioners, and the 3,939 dealers, shopkeepers, and publicans, we have a group of rather more than 12,000, consisting mainly of heads of families who were not engaged in manual labour. In this group come no doubt those rich enough to employ domestic servants, who numbered 3659, or 32 per 1,000 of the population.

In York, where Mr Rowntree puts the servant-keeping class at 28.8 per cent of the whole population, female domestic

servants numbered 40 per 1,000. The proportion of this class in Norwich is therefore considerably less. Assuming that each family in this class keep on an average two servants each, they did not amount to quite 2,000. Families, however, whose service is done by charwomen living out would to some extent fall within this category. There were 686 women on the census night who described themselves as charwomen, and this is certainly an understatement of the total number. Many women so occupied would be returned by their husbands as 'married' simply. Bearing this in mind, the servant-keeping families might reasonably be placed as high as 2,500. If each household on an average contain five individuals, excluding servants, the total number of persons falling within this class would be 12,500, or slightly over 11 per cent of the population. Another way of making the same estimate is to take the proportion per cent of domestic servants to the total number of separate occupiers or families. In Norwich this is 14.3 per cent, and making an allowance for families who keep more than one servant – which would of course diminish the total of the servant-keeping class – we reach approximately the same result.

Passing on to the principal wage-earning groups, boot manufacture easily comes first with a total of 4,931 men and boys, and 2,539 women and girls, of whom were married. Altogether this trade occupied 7,470 individuals in 1901.

The next largest group is that connected with the manufacture of food and drink. The census tables unfortunately do not give much guidance here. Carrow works alone employ over 2,600 hands, though the Registrar-General only gives 280 males and 218 females as engaged in making mustard, vinegar, spice, and pickle. As part of this group would also come most of the 296 males and 351 females described in the census as manufacturing chemists, and the 300 brewers and distillers. But the actual making of mustard, blue, starch, chocolate, vinegar, beer, and patent wine comprises only a small proportion of the labour employed in factories producing these commodities. Very many of those employed appear in the census tables under

other categories of skilled and unskilled labour. Altogether there must be nearly 5,000 people occupied in this group.

The next group in point of size are the workers connected with dress other than boots and shoes. Excluding dealers, these totalled 4,549. Tailors numbered 645, tailoresses 1,635, and milliners and dressmakers 1,827. Altogether the clothing trades in Norwich employ over 12,000 people.

Building accounted for 3569 individuals, of whom carpenters and joiners numbered over 1000, and bricklayers and bricklayers' labourers a little more. Of masons and masons' labourers there were only 130, illustrating the very restricted use of stone in Norwich building. Painters numbered 597 and plumbers 191.

In the conveyance of men and goods by road, rail, or river, and in storage and porterage, 3,503 individuals were employed, of whom 900 were on railways. The other principal sub-divisions under this group were coachmen (not domestic), horsekeepers, and cabmen 363, carters 853, and 817 porters and messengers.

Engineering and machine making occupied 1,082 men at the time of the census. There were also 155 wire-weavers and 240 tin-plate workers.

Printing and lithography is an important trade in Norwich, and employed 684 men and 167 women, and there were 174 bookbinders, of whom 108 were women. In paper-box and bag making – a considerable industry – 374 women were engaged as against 40 men. The whole number of individuals connected with printing and paper trades amounted to little under 1,700.

The textile group is comparatively small. In silk-weaving only 643 women and girls were occupied and 60 men, and in hair-weaving and brush making 319 men and 431 women.

Cabinet makers, French polishers, and upholsterers numbered 5530. Finally there were 574 gardeners and 1,300 general labourers.

More than half of the 50,000 citizens who were earning a livelihood were engaged in workshops and factories. In 1908 workshops numbered 618 and factories 332.

These facts are summarised for convenience of reference in the table over the page.

Necessary and valuable as they are, these cold statistics only become vital and significant when brought into relation with other facts about life and work in Norwich. Information concerning earnings, housing, health, and social opportunities, must all come under review before their full meaning can be grasped. The best way perhaps in which to begin an analysis of occupations from the standpoint of social economics is to arrange them according to continuity or discontinuity of employment. Broadly speaking, occupations may be grouped according as they afford continuous, discontinuous, or casual employment. Accordingly we now pass on to classify the wage-earners of Norwich by the character of their work, and the continuous occupations come first in virtue of their social and numerical importance.

NORWICH

Occupied population aged 10 years and upwards. Total occupied 50,555. Males 32,054, Females 18,511.

PRINCIPAL OCCUPATIONS.

MALES 10 YEARS AND UPWARDS	
Non-Manual Workers	9,000
Boot and Shoe Makers	4,931
Mustard, Starch, Blue, Chocolate, Win-carnis, Beer	3,000
Tailors	645
Building	3,569
Conveyance	3,503
Engineering	1,082
Wire-Weaving	155
Tin-Plate Workers	240
Printing and Lithography	684
Cabinet Making, etc.	463
Paper-Box, Bag Making, Stationery Manufacture	40
Gardeners	574
General Labourers	1,320
Others	2,848
TOTAL OCCUPIED MALES	**32,054**

FEMALES 10 YEARS AND UPWARDS	
Non-Manual Workers	3,000
Boot and Shoe Makers	2,539
Mustard, Starch, Blue, Chocolate, Win-carnis, Beer	2,000
Tailoresses	1,635
Milliners and Dressmakers	1,827
Domestic Service	3,659
Charwomen	686
Laundry and Washing	828
Printing and Lithography	17
Cabinet Making	88
Paper-Box, Bag Making, Stationery Manufacture	374
Others	2,858
TOTAL OCCUPIED FEMALES	**18,511**

The Boot Trade

In Norwich, as indeed everywhere else, industries which give regular employment are by far the largest class. The majority of workers, even in such highly seasonable occupations as the manufacture of boots and clothing, are quite regularly employed. As there is an impression that this cannot be claimed for the boot trade, it may be worth while to appeal to the evidence of statistics. The Board of Trade have for some time been collecting material for a census of wages, the second instalment of which has just been published. This contains a return of members employed and wages paid for the last pay week in each month of the year 1906. From Norwich returns were obtained relating to some 2,400 employees whose average weekly earnings amounted to £1,880. The regularity of employment is indicated by the slight variation in the amount of wages paid above or below the average. The worst month of the year was January, when the total wages bill was 6 per cent below the average, and the best months were May and July, when the total was 5 per cent above the average. Or, taking the numbers employed, for every hundred persons at work in May there were 97 at work in February and 103 in October. This is only a variation of six points in the total number employed, or of eleven points in the weekly wages bill.

Bootmaking must therefore be classified as one of the occupations in which employment is on the whole continuous.

This statement, it is true, has to be largely qualified, and the subject is one which cannot be disposed of at this stage. At the outset it has to be observed that the returns just quoted relate only to factory workers, and there are still over a thousand out-workers in the trade. Amongst these employment is much less certain, and they have, even in busy seasons, a great deal of broken time. This is largely due to the fact that boot manufacture is still in a transition stage in Norwich. Up till about twelve years ago it was largely, though by no means entirely, in the hands of small employers, popularly known as garret masters. Clicking and pressing – the process of cutting out the uppers and the soles – were done on the premises, and the materials were then given out to different sets of workers to be manufactured. First the uppers were taken out by women to be 'closed' or machined together. They were then brought back to the employer, who matched them with the proper size and quality of bottom stuff. The next stage was 'lasting', which was done by men who also worked at home.

When lasted the boots came back again to the employer, who either sewed them by machinery on his own premises or sent them out to a man who made a business of sewing for the trade. They were then returned once more to the makers to have the heels put on, and the groove or 'channel' which had been made round the edge of the sole to receive the stitches, hammered down. The boot then passed once again through the employers' premises into the hands of yet another set of workers to be finished.

Such a system inevitably wasted a great deal of time in carrying work backwards and forwards. Besides, employers had not the same inducement to make efforts to secure a reasonable regularity of work as in the highly organised modern factory with its expensive plant. They had practically no expenses beyond a moderate outlay in rent for clicking and store rooms, and their loss in slack periods from standing charges was relatively low. As a consequence the trade was much more seasonal, and even now regularity of employment seems to vary inversely with the size and equipment of the factories.

Social workers in Norwich, comparing the conditions of the present day with those of twenty years ago, are unanimous that

there has been a great improvement in the conduct and sobriety of boot operatives. When the work was mainly done at home it was a common practice to keep Monday as a holiday and to put in very long hours on other days. This was not altogether the men's fault. The smaller masters, hampered by insufficient capital, could only put new work in hand week by week, as the output of the week before was sent into the large factors, who paid ready money for it. This enforced idleness, however, encouraged drinking and bad habits amongst the weaker sort of men, and the highly seasonal character of the trade must have intensified these tendencies. It is a general opinion that factories with their more constant work and enforced discipline have reacted favourably on the social habits of work people.

In spite of the economic and social disadvantages of this system it has died hard in Norwich. Both masters and men, shut out as they are from contact with the outer world, have been slow to see the advantages of higher organisation. Home work in the boot trade, it must be remembered, had been taken over from the weaving industry, which it to a large extent replaced, and it was therefore a custom of very ancient standing. Low wages and low expenses, moreover, made competition against more efficiently organised production less unequal than might be supposed. Sooner or later, however, a change was bound to come, and a strike, which took place in 1897, was followed by the introduction of new methods and new machinery. There had always been some large firms in the city – perhaps not more than half a dozen – who combined the business of middlemen and manufacturers. These firms had always done more work inside than was the case with the smaller masters. They gave out most of the machining and finishing, it is true, but lasting as well as clicking was done inside. These were naturally the first to put in the machinery which had come to England from America, and to adopt what is known as the Team system. It was not merely that they were in a better position to command the necessary capital, but the change involved was in their case rather less revolutionary than with the smaller masters. This reorganisation was immensely facilitated by the use of electric

power. Electricity, at a penny a unit – the price in Norwich – can be economically used for driving light machinery, where the cost of raising steam would be almost prohibitive in relation to the amount of power required. Cheap electricity indeed, for light as well as power, has perhaps done more to develop and preserve the trade in Norwich than any other factor. Of the progress there can happily be no doubt at all. The output has increased enormously in quantity and improved in quality. In light shoes and in women's and in children's boots – men's are scarcely made at all – Norwich can now compete on equal terms with any other centre. The best ladies' evening shoes, which were till recently made in Paris and Vienna, are now, for example, being made in Norwich. The numbers employed have also increased, in spite, or rather because of the new machinery. One good authority put the increase at at least a third on the number employed in 1901, which would bring the total up to over 10,000.

The changes which have been brought about during the last decade have made the process of manufacturing boots so intricate that no layman can hope to describe it. Yet some description is inevitable if any real attempt is to be made to understand the lives of the largest industrial group in Norwich. There are six distinct stages and more than a hundred operations in making every pair of boots which passes through a modern factory. The following very able summary of the most important processes is borrowed from a report issued by the Board of Trade:

The manufacture of boots and shoes in factories in the earlier days of the industry was generally divided into four sections, viz. clicking, rough stuff cutting, closing, and making; each one was a distinct operation with little division of labour. At the present date the work in these four sections has been subdivided into more than a hundred different processes. A brief description of some of the more important processes is given in the following paragraphs:

(1) Clicking. This means the cutting of the uppers, an operation which, until comparatively recent times, was performed throughout by one person. Gradually, however, the work

has been subdivided, and every year machines are being introduced to perform separate operations such as driving, punching, scalloping, blocking, marking, etc. Although clicking is largely done by hand, the introduction of cutting presses has displaced hand clickers to some extent.

(2) Rough stuff cutting. Under this term is included the cutting of all material used in the battening of boots or shoes. It is fifty years or more since hand labour began to be superseded by machines in this department. Machines are now used to cut soles, lifts, and other parts. Sole moulding, heel building, and compressing, shank making, puff cutting, and skiving, leather rolling, sole and insole rounding are all accomplished by mechanical means, and everything required for the bottom of the boot or shoe is made ready in this department for the use of the lasters in the lasting room.

(3) Machining and upper closing, that is – stitching all the pieces together which go to make the top or uppers of the boot or shoe. Prior to 1860, when the introduction of the sewing machine began to displace hand labour, this work was commonly done by men and women at their own homes; hand work, however, has vanished, as the improved sewing machines now in use can give more uniformity of stitch and greater regularity of tension than can as a rule be obtained by hand workers. Machines have been produced to meet every want, and are so arranged in the workrooms that the work can be passed from one machine to another with a minimum of delay. At one time a large staff of fitters, either men or women – the latter predominating – were employed to paste the various parts of the upper together before they were handed over to the machinist for stitching. The process is now fast disappearing, as the accurate designing and cutting of the upper in the clicking room make it easy for the sewing machine operator to hold the parts together whilst they are being machined.

(4) Lasting. In this department the machined upper and the bottom stuff that is the insoles, outsoles, and stiffeners, are brought together. Twenty years ago the work of lasting was

done entirely by hand, whereas machinery for the purpose is now fairly general. The upper is stretched over the last by the pulling-over machine, and is then passed to the lasting machine on which the upper is drawn down into position and automatically tacked to the insole. The shoe is then passed to the operator of the knocking up machine, which levels all ridges produced when lasting, and makes the work fit to receive the outsole which has been moulded to fit the exact conformation of the bottom of the last; the sole is then temporarily secured by the aid of a tacking machine. The last is drawn out and the shoe is passed to the loose nailer, or to the sole sewing machine, as the case may be, for the sole to be permanently secured to the upper; either operation only takes a few seconds. The next operation is to level the bottom of the sole, a machine of considerable power taking the place of the shoemaker's hammer. The heel is then fixed by machinery. The welted shoe is made on the same principle as the old hand sewn article, only all the stitching is done by machine, the other processes being subdivided and performed by special machines and appliances invented for the purpose. On this work a greater proportion of highly skilled labour is needed than on the previously described classes of goods. In factories where dress shoes are made the process of attaching the upper to the sole is called 'making' instead of 'lasting', and the sewing is either done by hand or machine; the terms 'sew-rounds' or 'turnshoes' being used to distinguish the respective methods of sewing, but both implying that the upper and sole are attached 'inside' out, and the 'turning' takes place immediately afterwards. An increasing quantity of 'turnshoes' is now being made for ladies outdoor shoes, lightness and flexibility forming their chief characteristics.

(5) Finishing. From the lasting room the work is then passed to the finishing department, where almost every process is performed by the aid of machinery. Thus the heel and the edges are trimmed, and some other processes performed before the shoe reaches the finisher proper, by whom

the edge and heel are first inked and then burnished on a rotary machine. The edge of the sole is then set by fast running reciprocating irons made to fit the substance of the sole required, and so on from one process to another until completed. Twenty years ago practically all the finishing was done by the workman in his own home, where he usually employed a number of boys and youths to assist him. In some centres of the industry the system of home work finishing has been, or is now being, abolished, more especially in districts where the most modern factories have been built and the newest machinery has been installed.

(6) Treeing, Cleaning, and Boxing. From the finisher the work goes to this section, where women and girls are mostly engaged for the work that is to be performed. Machines have been introduced even to meet the demand of this department, such as rotary brushes of various kinds, electric ironers, treeing machines, appliances for labelling and numbering the cartons, all of which economise time and perform work more efficiently.

There are a dozen firms in Norwich who have factories to which the description would apply in its entirety. Work in these is, generally speaking, carried on under good conditions. The buildings are spacious, and ample provision is made for decent sanitation, light, and ventilation, and for protection against fire and dangerous machinery. It is impossible to exaggerate the influence which such things have on the health and efficiency of workpeople. It is the very lowest price at which good work and good citizenship is to be obtained. There are in addition perhaps twenty other firms who have more or less complete sets of machinery, and are able to work a team. A team, it should be explained, consists of the men who operate the machines employed in one stage of manufacture, and who have necessarily to feed one another. In a lasting team, for instance, there are five men and two boys, and they have to keep pace with the man who operates the mechanical laster. The mere statement of fact hardly conveys an idea of the strain imposed by this inexorable

necessity of speed. Besides these modern factories at least forty of the old garret masters still survive. Amongst the latter is to be found every possible variety of organisation. Some of them finish by machinery – finishing done by home workers indeed is comparatively rare – and give out the rest. A few adhere to the old process of giving out every process except clicking. In some instances the business is on so small a scale as to resemble in many ways the old system of domestic manufacture. The master, usually a clicker, makes a sample, secures an order for a few dozen, buys the material, cuts and presses himself in a tiny workshop, and employs half a dozen home workers to do the machining, lasting-, and finishing. Except the press for stamping out soles and heel leather, and the machines for sewing, no machinery is used at all, and the master himself usually owns the presses. Only common work is usually made in this way, especially the cheapest sort of strap shoe for children.

This section of the trade is characterised by very low wages and great uncertainty of employment. It is only by cutting rates, and by taking work from the large factories at busy times, when orders have to be completed under pressure, that they manage to survive at all. The latter, as we have seen, belong in a number of cases to firms who were originally in business as middlemen, and it still pays them to carry on this trade to a limited extent. An expensive plant can only be profitable when it is kept running up to its full capacity. When this limit has been reached, a manufacturer must either refuse to accept additional orders or supply goods from outside his factory; the only alternative is to sink capital in new machinery, and it would not pay to do this merely to make a few thousand pairs of boots in the busy season. It is more economical to rely on the garret master, and in order to ensure that his services should be there when wanted, it is policy to keep him alive by small orders judiciously distributed through the year. This of course applies particularly to the low grade goods which do not admit of a margin being taken against idle machinery. Another plan common to all firms, but especially characteristic of those employing modern methods on a small scale, is to meet a rush of orders by giving

work out at home. A good many women who machine uppers are kept precariously occupied in this way.

Enough has been said to bring out the fact that garret masters and outworkers constitute a reserve on which the large manufacturers can fall back when pressed to complete orders. Being a reserve, they are only casually employed, profits are low, and earnings are low, and both masters and men are beneath the average in efficiency. The men are largely those who were too old or too incapable to adapt themselves to the new methods and higher speed of factory work. They are moreover competing for a diminishing quantity of work. As the scale of factory production extends, it will become less and less necessary to buy work in. If factories are large enough and there are enough of them their resources become sufficiently elastic to meet any normal fluctuations. Nor can this be regretted, though the process of extinction is a painful one. It is perhaps the gravest problem which Norwich has to face. A relatively inefficient class dragging out life on insufficient earnings must always be a source of weakness in all kinds of ways. It makes life possible at an undesirably low level of efficiency and income, and is a constant menace to the whole standard of life in the industry. The earnings are certainly miserably low. Women are said on reliable authority not to earn more than 3s a week on an average through the year, though when busy they earn from 9s to 10s a week, and in exceptional cases as much as 15s. Men taking the year through cannot average more than 12s weekly.

The small masters, on the other hand, who have factories equipped with modern machinery, seem confident that they will hold their own. They use electric power, and it costs them little, if anything, more in proportion than it costs the largest manufacturer. Satisfactory as this may be in some ways, it has its disadvantages. It is very noticeable that these small factories are generally in buildings which have been adapted for the purpose. They are old and crowded, and the arrangements for heating and ventilation are said to be bad. This may help to account for the comparatively high incidence of tubercular disease in Norwich, and for the fact that the rate of mortality in this disease has scarcely fallen for ten

years. The increase in machine finishing, which is a rather dusty process, may also have had a tendency in the same direction.

This sketch of the staple trade of Norwich would be incomplete without some further reference to what earnest social workers in Norwich probably consider its leading feature. The present writer, in the course of his enquiry, was told over and over again that constant employment for men hardly existed in Norwich, and the casual nature of a bootmaker's work was nearly always given in illustration. It is clear from what has been said above that this could only be accurately applied to the comparatively small part of the trade which is in the hands of garret masters. This does not amount to more than an eighth of the total output. The older and less competent workmen, and the home-workers, are naturally those with whom district visitors and others come most in contact, and this has led to a distorted and exaggerated view. The chronically under-employed bootmaker to be found in the courts and yards of an old city parish is by no means representative of the average factory operative who lives in Catton or in the working-class streets off the Dereham, Magdalen, and Earlham Roads. It is, however, undeniable that this industry is still to some extent seasonal, though much less so than formerly. One large employer, for instance, said that the demand for women's and children's boots kept him fairly busy throughout the year. Then it fortunately happens that Norwich manufactures two distinct kinds of footwear which each have a different season. 'Turn-shoes' – mainly shoes for evening wear – are busy from July to December, and the season for double soled qualities runs from February to July, though there are a few busy weeks in October. The two seasons, therefore, dovetail into one another, and clickers, machinists, and finishers are pretty constantly employed, as their work is required as much for one kind as for the other. The only distinction is between 'makers' who last and 'turn' pumps and light walking shoes, and the 'lasters' proper who make boots and shoes of the normal kind. There is now a tendency to make these processes interchangeable. The lasters, especially, often take to turn-shoe work. The change demands a good deal of readiness and adaptability. As one of them pointed out, the operation of turning

a shoe which has been made and sewn inside out exercises a set of muscles which they have never developed. Another difficulty is the fact that turn-shoe makers are accustomed to work at a higher speed and to earn rather better money, and men who are strange to the work are apt to become disheartened when on pay day they find themselves far behind their fellows at the bench. These men can now improve themselves by attending classes for turn-shoe makers at the Technical Institute. This, it may be remarked in passing, is a good example of what technical education can and ought to do to make labour better able to respond to the varying demands of industry.

Where it is not possible for lasters and makers to interchange, it is more usual to work short time than to discharge the hands for whom there is no work. A different method practised by one of the large firms which specialise in turn-shoes is to let men stand down in batches. Either way, of course, considerably diminishes the average weekly income throughout the year.

If the worst comes to the worst, a decent operative can always fall back on the unemployed pay of his trade union. The National Society of Boot and Shoe Operatives gives an out-of-work benefit of 10s a week for ten weeks. This benefit cannot be drawn twice in any period of twelve months. The contribution is 8d a week, but this entitles a member to sick pay and strike pay in addition, together with a funeral benefit for himself and his wife.

Recently, this Society has made a very great increase in its membership – a sure sign that the boot industry is flourishing in Norwich. At the end of 1906 the two branches of the Union had a total membership of just over 800. In August 1909, it was just under 2,000. A few of these are women. The difference is accounted for by a large number of new members having come in at the time of an agitation for a rise in wages about two years ago. The agitation was successful, and ended in the Masters Federation agreeing to a minimum wage for time workers and a revision of the piecework statement. A minimum of 26s per week, it was agreed, should be paid to clickers, lasters, finishers, sole cutters, and sorters and fitters up, who do sorting as well. For rough stuff cutters and fitters up the minimum was fixed at 24s. In the case of

men earning less than 23s there was to be an immediate advance of 2s per week, with a further advance of 1s one year after March 9th, 1908, the date of the agreement, with a further increase every six months until the minima were reached. Working hours were not to amount to more than fifty-four per week. We give this agreement in some detail as a good example of collective bargaining. Both masters and men say that the agreement on the whole has worked well, and the advances arranged for have taken place without undue friction. Under the agreement there is to be a general increase of 1s a week in January, 1910, and a similar increase in 1911, when the minimum will stand at 28s. This agreement does not affect women or the old-fashioned type of small master. Both are beyond the pale of collective bargaining.

In the following table, which is taken from the Board of Trade Report on earnings in the clothing trades, information as to earnings of operatives in Norwich boot factories is given in detail. It does not refer to out-workers, to whose average earnings some reference has been already made. The earnings of men must be modified to allow for the substantial increase which has taken place since September 1906, when the material was obtained. The table refers to 3,381 workpeople, of whom 1,756 were men, or 52 per cent; 462 boys under twenty, or 14 per cent; 850 women, or 25 per cent; 313 girls under eighteen, or 9 per cent. These percentages may be taken as representing the proportion of each age and sex employed in Norwich boot factories. Put in another way, they mean that for every 100 men employed there are 27 boys – which is well under the proportion of 1 boy to 3 men allowed by the Trade Union – 48 women and 11 girls. The difference between the average earnings of those employed on full time and the average earnings of those employed less or more than full time would in September – a relatively slack time – be mainly accounted for by the amount of short time worked. The small difference involved does not suggest that this was very prevalent. The only other point to which attention need be drawn is the low average level of earnings as compared with the average for the United Kingdom. This is specially marked in the case of women and girls.

NET EARNINGS OF WORKPEOPLE EMPLOYED ON EMPLOYERS' PREMISES IN THE LAST PAY-WEEK OF SEPTEMBER, 1906.

NORWICH.

Occupation.		Workpeople who worked Full Time.				All Workpeople (including those who worked less or more than Full Time).	
		Average Earnings for Full Time.	Lower Quartile.	Median.	Upper Quartile.	Number.	Average Earnings of all Workpeople.
		s. d.	s. d.	s. d.	s. d.		s. d.
Men (of and above 20 years of age).							
Foremen	Time...	39 7	32 0	35 0	45 0	85	39 7
Clickers	Time...	25 1	23 0	25 0	26 0	254	24 0
Pressmen or Rough stuff Cutters	Time...	22 11	21 0	23 0	24 0	95	20 9
Lasters or Rivetters {	Time...	26 2	23 0	26 0	29 0	125	22 4
{	Piece ..	25 8	22 0	26 0	30 0	203	20 2
Sole and Welt Sewers	Time...	31 10	30 0	30 0	34 0	42	29 9
Finishers {	Time...	24 8	23 0	25 0	26 0	261	21 7
{	Piece ..	27 11	24 0	27 0	30 0	66	25 0
Other Men {	Time...	22 0	18 0	21 0	25 0	351	22 8
{	Piece ..	27 1	23 6	26 6	30 0	274	24 5
ALL MEN		25 11	—	—	—	1,756	23 8
Average United Kingdom		28 8					

	s. d.	s. d.	s. d.	s. d.		s. d.
Apprentices (all ages) and Lads and Boys (under 20 years of age).						
Full Timers:—						
Apprentices . . Time...	7 4	5 6	6 6	10 0	115	7 4
Other Lads and Boys . {Time...	9 6	6 0	9 0	12 0	325	9 2
Other Lads and Boys . {Piece..	16 9	14 6	18 0	20 6	22	16 9
ALL LADS AND BOYS	9 4				462	9 0
Average United Kingdom	10 6					
Women (of and above 18 years of age).						
Fitters . Time...	10 3	9 0	10 0	11 0	318	10 1
Machinists or Closers . Time...	10 10	10 0	11 0	12 6	381	10 7
Other Women . {Time...	10 0	8 0	9 0	10 6	76	9 7
Other Women . {Piece..	10 9	9 0	10 6	12 0	75	10 3
ALL WOMEN	10 6				850	10 3
Average United Kingdom	13 1					
Girls (under 18 years of age).						
Full Timers:—						
Fitters . Time...	4 4	3 0	4 0	5 0	151	4 2
Machinists or Closers . Time...	3 11	3 0	3 6	5 0	97	3 10
Other Girls . {Time...	5 1	3 6	5 0	6 0	47	5 3
Other Girls . {Piece..	8 10				18	7 9
ALL GIRLS	4 6				—	4 5
Average United Kingdom	6 10					

Other Industries in Norwich

TRADES CONNECTED WITH FOOD AND DRINK

The group of industries next in importance to boot manufacture, amongst those which provide regular employment, are the trades connected with food and drink. Some reference has been made to these in the first chapter. They are typical of large cities, where population is for some reason comparatively immobile, and skilled industries few relatively to population, the proportion of casual labour high, and the supply of women's and children's labour at low rates consequently good. In all these respects Norwich is not unlike York, Bristol, the East End of London, and even Birmingham, where the staple hardware manufacture employs an astonishingly high percentage of low skilled labour. On the other hand, there is perhaps a danger that this comparison may be pushed too far. It may be that this description could be applied more accurately to the Norwich of forty years ago than it could to-day. There is now a tendency for skilled labour to grow in Norwich. This could not have been said in the sixties and seventies, when the making of mustard and starch, blue and chocolate, was growing up into the vast business it has since become. An industry once established is likely to remain,

not merely because the cost of removal is inevitably high, but also for the reason that a large business exerts immense social influence by its demand for a particular kind of labour. In this way it is likely to perpetuate and develop the conditions which are favourable to itself. This is well illustrated in the case of the great factories in Norwich which produce washing requisites, mustard, vinegar, confectionery, and a widely advertised patent wine. These are all things which have to be packed in small quantities. Some of this is done by machinery, but most of the millions of tins, boxes, and packets, crates and bottles, which carry the trade-marks of Norwich firms all over the world, are still laboriously filled and wrapped by hand. The great bulk of this work is done by women, girls, and boys, who make boxes, fill boxes, and wrap boxes from one year's end to another. To these simple operatives the principle of subdivision is applied with scientific thoroughness, so that the task performed by individual workers becomes a purely mechanical movement of a single set of muscles. They are literally the living parts of a machine as finely and delicately adjusted as the mechanism of a watch. And it is a machine which works at appalling speed. Other machinery wears out and has to be replaced, but not this. It is always kept in good repair. Every day and every month some of the 21,000 boys and girls whom Norwich educates, inspects, and disciplines, at a cost of £80,000 a year, leave their classrooms to replace minute parts of this monster engine which helps to feed and clothe us. It is scarcely wonderful that such a thing should influence profoundly for good and ill the whole fabric of social and civic life.

To this aspect of industry in Norwich further reference must be made at a later stage. Here it is only necessary to mention the enormous demand which is created by it for the labour of women and young people. Excluding breweries, who employ about seven hundred people, it may be estimated that over 65 per cent of the labour required by food and drink factories is supplied by women and girls and boys. The social importance of such a fact can hardly be exaggerated. Where there is good employment for wives and sons and daughters families will come into a town and

stay in a town, however little work there may be for adult males. The family as a whole can be certain of a regular though possibly insufficient income, even if the proper breadwinner is dependent on casual work. This will make the chance of a casual job even more attractive than it otherwise would be. There are many men in Norwich who would not be content to stay for five or six days' work a month, who do, in fact, stay now because they can add to their own highly speculative earnings the more regular wage of their wives and children. The great packing industries in Norwich do in this way profoundly influence the social character of the city. They certainly account for some part at least of the overwhelmingly large supply of casual unskilled labour which all observers agree underlies so much that is unsatisfactory in Norwich. This is not to say, of course, that if there were no packing of mustard and chocolate there would be no problem of casual employment in the city. There are many other influences all tending in the same direction. They help to explain the supply of this particular kind of labour, but not the demand for it. With one notable exception, indeed, these industries do not themselves employ casual hands to any noticeable extent. At the famous Carrow works, for instance, of Messrs. J. J. Colman, the largest factory in Norwich, which employ over 2,600 hands, there is no casual work at all. Even in chocolate making, where hot weather is liable to interfere with the process of manufacture, seasonal variations in the amount of labour employed is said not to be large and to be diminishing. The same firm which makes chocolate also manufactures a very large number of paper crackers, and here again employment is stated to be fairly regular. It is only in mineral water manufacture – a fairly large industry in Norwich connected mainly with breweries – that there is really marked fluctuation of employment. This, of course, is busy in summer and very slack in winter. Indeed, it was to meet this difficulty that the manufacture of chocolate and cocoa was introduced by the largest firm of mineral water manufacturers many years ago. The expectation that cocoa would be busiest in winter, and would therefore provide employment for the mineral water hands in their slack season was not, however, realised. There is also one

firm in the city which employs a small amount of seasonal labour in jam boiling. With these exceptions – they would not amount to 5 per cent of the total numbers employed in the food and drink group – this very important industry provides surprisingly regular work.

Wages, on the other hand, are decidedly lower than in the boot trade. The labour is not of a highly skilled character, though more so than is perhaps commonly supposed, and there is keen competition for it. The best wages are earned at Carrow, where the minimum for labourers is 21s a week. On the mustard and starch floors the earnings are rather higher, and not less than 22s 6d a week. There is only one other employer in Norwich whose labourers are paid as much, namely, the city itself. Street sweepers and other unskilled workmen are paid the minimum of one guinea a week. Other firms manufacturing food and drink average 18s a week for an ordinary labourer, but there are men who earn considerably less. Many brewers' labourers, for example, earn as little as 16s a week, and a few earn no more than 12s. These rates of course correspond to those earned by other unskilled weekly labourers in the city. It will be convenient to summarise here such information as need be given as to the earnings of this class generally. Wages of labourers in sawmills and woodyards, and in ironworks, warehouses, and miscellaneous occupations, all approximate to about the same average wage of 18s. A carter earns 18s a week, but the drivers of tradesmen's carts, it is said, earn rather less. For these men 16s a week would be an average wage. Strikers in engineering shops earn a standing wage of 18s, as also do porters on railways, but gangmen earn no more than 16s. Hours, like wages, vary considerably, from fifty-four per week in the best factories, to over sixty. Carters especially work very long hours. Railway carters, for instance, work from 6.30 a.m. to 7 p.m., whilst men delivering beer or mineral waters are often not home till ten or eleven at night. The van boys who go with them have perforce to work the same hours.

Women in food and drink factories earn on an average from 9s to 10s weekly; girls under eighteen from 3s 6d to 8s. A rough

class of girl employed in covering chocolates appears to be paid at a slightly lower rate, and this would apply also to mineral waters. Girls and women in this trade earn as little as 6s for a full week. A few women and girls doing rather better work earn a little more, but do not exceed 14s a week. Speaking generally, women employed in these factories belong to the middle class amongst working people in Norwich, socially inferior to machinists in boot factories, but decidedly above the worst-paid workers in laundries and the very low-class women who do rag-sorting or fur-pulling. The aristocrats in the group are those who make fancy boxes and crackers. These are clean and rather artistic processes, and attract a superior class of workpeople. The managing director of one important firm said that in his experience the character of the material had a marked influence on the appearance and behaviour of the girls in his employ. Girls engaged in monotonous and dirty processes always seemed to give more trouble than those in other departments where good taste and delicate handling are required. Working hours in these factories begin earlier and finish earlier than in the boot trade. Boxmakers other than those employed in these factories arc mainly engaged in making boxes for boot manufacturers. There are three or four small firms who do this work. Cutters (men) earn up to 24s a week. The women and girls, who do the bulk of the work, are pieceworkers, and their earnings are irregular. On the whole, they belong to the rougher class amongst factory workers, and may be compared with the women engaged in laundries.

CLOTHING TRADES OTHER THAN BOOT MANUFACTURE

In a systematic examination of industries in Norwich, tailoring and dressmaking must rank amongst continuous occupations. At the outset a distinction must be drawn between bespoke work and wholesale factory work. Both kinds are well represented in Norwich, but on the whole, bespoke tailoring and dressmaking is more seasonal and less regular than the ready made factory work. Dressmaking again shows greater season al fluctuation than bespoke tailoring. A man will sometimes buy a new coat when he wants it, a woman will always have her new dresses at

such seasons as fashion has decreed. In both kinds of bespoke work the seasons are the same; March, April, May, and June are the busiest months. Work falls off rapidly in July, is very slack in August, and begins to revive in September. October is a very busy month, though not so busy as spring or early summer. Work then falls off and revives again just before Christmas. The slackest months of the year are January and February. In ready-made clothing seasonal fluctuations are slightly less violent and run a rather different course. The busiest month is December, whilst January is the slackest. A curve drawn to illustrate the variations in the numbers employed from month to month rises almost continuously from the beginning of the year to the end. For every 100 workpeople employed in August there are 92 employed in January and 108 in December. Taking the tailoring and dressmaking trade as a whole in Norwich, employment, so far as factories and workshops are concerned, is less constant, and there is more short time work than in the boot factories. If, however, outworkers are taken into consideration, as in fairness perhaps, they should be, tailors in Norwich are probably rather better off than boot workers in respect to the certainty of their work. In workshops working hours do not generally number more than fifty-six per week, and are often less.

Earnings in bespoke tailoring are good. Journeymen tailors earn from 25s to 30s a week, taking the year through, but as they are almost always paid by piecework, and their trade is seasonal, the week's earnings vary from under 15s to over 40s. A good deal, perhaps most of the work, is done in workshops belonging to the retailer, who is often also his own cutter. Different hands are employed to make coats and trousers, whilst vests arc usually made by women, who earn up to as much as £1 a week in the season.

All the retail shops when busy send work out to be made up by a tailor working at home, and there are a few master tailors who do nothing beyond cutting on their own premises. The journeyman tailor, if he works at home, usually employs one or two girls to assist him, whom he pays at the rate of from 11s to 12s a week. In the cheaper class of bespoke work more

girls are employed, and the process becomes very much akin to the manufacture of wholesale readymade clothing. Bespoke suits which cost from 40s to 50s are in fact made up as special orders by the large wholesale firms. One of these does quite a considerable business in this class of work, and employs a staff of travellers to solicit orders on its own account in country districts. Clothes made up in this way do not really compete with the higher grades of bespoke work. They are the mechanical products of a highly subdivided factory process, and possess none of the subtle qualities with which a good tailor who makes a garment throughout endows his handiwork.

The Amalgamated Society of Tailors has a small branch in Norwich with about fifty members. It is not powerful enough to enforce any uniform statement for piecework, which accordingly varies from shop to shop. One firm works to the London Log on the basis of 4½d an hour. The London Log is a statement agreed upon by masters and men of the time which is to be allowed for each operation in making up a garment, so much for sleeves, seams, etc. Whatever time is actually taken the man is paid according to the log at 8d an hour. In Norwich the basis of 4½d an hour is generally adopted, though one firm gives 5d, but in the absence of a uniform log, this has little practical significance. For ordinary lounge coats the rates paid vary according to class of work. For common work the tailor gets from 5s 6d to 6s, for medium 8s 6d to 9s is paid, and for best work 10s 6d to 13s.

Dressmaking and millinery is sharply divided according as the work is done in the showrooms attached to large shops or by private dressmakers in their own homes. Of the latter there are a considerable number in Norwich, as would be expected in a large county town. It is noticeable, too, that feminine Norwich dresses well. It is possibly the fact that a training in one of the large shops is a stepping-stone to success in private business later on, which explains the very low wages paid by them. The average wage earned by dressmakers working for shops in the eastern counties is 10s 9d a week, but a large employer, when questioned on the subject, thought that the average in Norwich was not so high as this. It may not unreasonably be placed at a

little above 9s, less than a woman can earn in unskilled factory work. Better workwomen earn from 12s to 15s. Girls under eighteen, including apprentices and learners who often get no wages at all, earn on an average rather less than 3s a week. Socially they belong to a very superior class, and the conditions of work are rather better than in an ordinary factory. These advantages are no doubt a set-off against the low wages. Private dressmakers are said to do well in Norwich, and the women who work for them earn on an average from 14s to 15s a week, but their hours are probably long. These statements, however, must be taken with some reserve. It is difficult to be accurate in the case of workers so scattered and disorganised.

Conditions in the large factories for ready made clothing can be described with more confidence, and they are, fortunately, the most important branch of the trade in Norwich. Women and girls form by far the largest proportion amongst the hands employed; males of all ages arc less than 20 per cent of the total number. Working hours number fifty-six per week, the working day beginning at 5 a.m. and ending at 7 p.m., an hour being allowed for dinner, while Saturday is a half-holiday. For men, the average wage is 28s 4d, including cutters who go up to as much as 38s a week, while lads and boys earn 8s 7d a week. Women earn on an average 10s 9d a week, though basters earn as little as 8s, and machinists sometimes earn as much as 18s. Girls under eighteen average 5s 6d a week, and never earn more than 9s. These earnings are the lowest in the whole county. The average earnings in the United Kingdom, in this trade, are for men 31s 11d per week, and 9s 9d for boys, and for women and girls 12s 11d and 6s 1d respectively.

In tailoring there are now comparatively few outworkers. The register which is kept by the Medical Officer of Health under the Factory Act of 1901 contains 250 names and addresses. The actual number is probably rather more, as small employers often omit to return the name and address of their outworkers. These figures apply to the whole trade, wholesale and bespoke, and not merely to wholesale factories. Some machining is still done by women at home for the latter, though the practice is dying out. A few shirts are also machined in this way for one important firm.

Experienced social workers say that these women are miserably poor, though it may well be doubted whether their condition is really worse than that of women outworkers in the boot trade. Investigation did, however, reveal remarkable differences in the rates paid to outworkers for the same class of work. One firm, whom we will call 'A', paid 1*s* 6*d* for lining and making a bespoke waistcoat, and for the same work another firm, 'B', paid only 11*d*. Again, for machining cheap ready-made garments 'A' gives 6*d*; 'B', for identically the same quantity and quality of work, 4½*d*; and another firm, 'C', as little as 4¼*d*. Such facts bear eloquent witness to the utter impossibility of isolated and unorganised women workers being able to make or maintain fair terms for themselves. Under the recent Trade Boards Act, which applies to wholesale tailoring, a Trade Board, composed of employers and workpeople, will have power to lay down a minimum rate for each district. Employers need not in the first instance accept this rate, although unless they do so they will not be qualified to tender for any public contract. After the lapse of six months, the Board of Trade will make the minimum legally binding by departmental order. Incomplete as the Act is, it provides a method of public and organised bargaining which will help to prevent glaring inequalities such as those just noticed. Incidentally it will tend to raise the very low rates which are now paid in Norwich. As things stand at present the city has an unpleasant reputation for undercutting.

CONVEYANCE OF MEN AND GOODS

This section is numerically important, though it need only be mentioned here. Railway porters and carmen have already been referred to, and porters and messengers other than those on railways, who numbered nearly a thousand, according to the census tables, must be reserved for treatment with the other classes of casual labourers. We may therefore pass on to

ENGINEERING AND METALS

This is not a large industry in Norwich, the only important engineering shops being those of the Great Eastern Railway

for repairing engines, if we except those belonging to a firm which makes very high-class electric motors. This trade is new to Norwich, and has grown rapidly of recent years. It is said to employ upwards of 600 hands. The presence of such a trade in Norwich at all is rather curious, since all the materials have to be brought from a distance. The explanation which is given is no doubt the true one, that it is easy to get labour of exactly the quality required for this delicate and highly technical work. One would naturally expect to find this in the workmen of a city which has been an industrial centre for so long, and in Norwich good workmen are cheaper than in most places. Semi-skilled workmen, of whom there are a considerable number, are said to earn from 20s to 25s, and skilled men earn, of course, considerably more. The standard rate of engineers is from 32s to 34s, according to the class of work, for a fifty-four hour week. Iron founders and pattern-makers make 28s.

There are several iron foundries in the city, where agricultural implements, iron fencing, galvanised sheet-iron, and wire-netting are produced. The trade is declining, and fewer men are employed than formerly, and especially in wire weaving for export. A good authority thought that in this kind of work there are now less than 450 men employed. One firm employs in addition some hundreds of men in the manufacture of horticultural and temporary buildings. This is mainly semi-skilled labour, and it is not well paid.

Wire-weaving especially has become so precarious that it must be reserved for discussion in the section which deals with casual occupations. There is also a small manufacture of tin-plate goods. The census of 1901 gives 240 men occupied under this heading. It is a slow, steady business in Norwich, practically the whole process being done by hand. Skilled men earn from 30s to 35s weekly. Trade unionism in this section is not strong. Electrical engineers are practically not organised at all. The Amalgamated Society of Engineers musters under 200 members, and the Steam Engine Makers less than 100.

PRINTING AND LITHOGRAPHY

This industry in 1901 employed fewer men than engineering, but it is growing in Norwich, and now possibly employs rather more. Besides a considerable local trade, a good deal of printing is now done for London and elsewhere. One firm prints annually some millions of calendars with coloured illustrations, and another has a large business in theological books and cheap reprints of all kinds. A few girls are employed in bookbinding. The standard rate of wages for compositors and machine-minders is 28s for a week of fifty-two hours. Lithographers earn from 35s to 40s. On newspapers, which require specially skilled men, earnings are considerably higher, and for compositors not less than 35s to 40s weekly. The Typographical Association, the Printers' Trade Union, has a branch in the city with 170 members. It has not yet succeeded in persuading all the masters to pay trade union wages, though the most important do so.

CABINET MAKING

Amongst those trades in Norwich which provide fairly regular employment must be included the cabinet making industry. This is a fairly large trade, and shows signs of becoming larger. The Directory gives the names of thirty-three firms, most of them, no doubt, quite small, but including two at least in a large way of business. Common furniture made by cheap semi-skilled labour is produced, as well as high-class reproductions of old models, which requires workmanship of a better kind, whilst one firm does a large middle class trade for a local market. There is no organisation, and rates are very low, and range from 4½d to 6d an hour. Earnings for a fifty-six hour week vary from £1 to £1 10s, though exceptional men may earn more. Upholsterers (men) earn from 18s to 28s a week, according to season. Some women are employed in this branch of the trade, and earn from 10s to 14s a week. There are also a few girls employed in polishing, though not to the same extent as in London, who are said not to average more than from 6s to 7s weekly. Men in this branch earn from

20s to 26s, but they usually work at home on piecework, so that they are rather a class apart. There are, however, less than fifty French polishers altogether in the city.

SILK WEAVING HAIR WEAVING AND BRUSH MAKING

This group includes all that is left of the old textile industry of Norwich, which, in process of time, is likely to disappear completely. There are still two important silk factories which produce a quantity of crepe, mainly for foreign markets, and a small amount of crepe-de-chine. In 1901, 60 males and 643 women described themselves as silk-weavers. The number occupied now is certainly considerably less. Weavers earn 2¾d an hour, and, in a full week, take as much as 12s; but there is a good deal of short time worked, and the average weekly earnings amount to not more than 10s. In the weaving sheds the number of elderly women is noticeably large. Socially they are hardly equal to the machinists in the better class of boot factories. A rough class of girls and women employed in 'throwing' belong to the same type as those to be found among the lower grades of confectionery workers. Their average wage is not more than 8s weekly. Younger girls find employment in winding and cleaning the thread, and earn from 3s to 6s 6d a week. Many of them ultimately become weavers. Adult winders are paid piecework rates, and their average weekly earnings come out at about 10s.

Hair weaving occupies perhaps 400 people, only a few of whom would be men. The cloth is made on a hand-loom with cotton warp and hair weft, and is largely a home industry. One employer has recently installed a few power-looms. The number of registered outworkers in 1909 was 168. In the older quarters of the city an observer can still hear the peculiar click-clack of the hand looms, and if he happens to be in Calvert Street or Peacock Street, where the houses date back to the eighteenth century, he has a perfect example of what industrial Norwich was 150 years ago. Hair weavers are said to be rather more constantly employed than outworkers, in either boots or tailoring, but there is a slack season in

summer. Socially the outworker may be ranked above the boot machinists who take home work, but below tailoresses doing the better kind of work, and on the whole they belong to a rough class. An exceptionally industrious woman, beginning at six in the morning and working till night, can earn as much as 15s a week, but this must be rare. Other women, in a good week, say that they can only earn 9s. Women with household duties earn of course very much less. Workers in this trade are paid a piece-rate, so much a pound, according to the amount of hair they work up. One employer pays 2s a pound for 18- and 22-inch cloth, and 2s 3d for the 16-inch, as there are more hairs to the pound. For a cheaper quality of cloth, in which vegetable fibre takes the place of hair, 1s 6d a pound is paid. Another employer, however, only pays 1s 3d for this class of work, and a uniform 2s for narrow as well as for wide cloth. The outworker often owns her own loom, and, in that case, she has paid about £3 for it. If it belongs to the employer she has to pay 3d a piece for hire. The looms are set by men, and for this the outworker pays 2s each time.

Brush making, a small trade in Norwich, has become almost entirely a factory industry, registered outworkers numbering only fifteen. For filling and drawing brushes women outworkers receive 6d or 7d a thousand knots, according to quality. In the factory girls earn up to 10s a week, and women up to 12s; men on full time earn 25s a week; paint-brush makers earn considerably more. The work is seasonal and is very busy in spring and autumn, when brushes are in demand for house cleaning.

LAUNDRIES AND CHARWOMEN

Charwomen, who numbered over 600 in 1901, earn 1s 6d a day and food. Charing is a common way of supplementing the insufficient earnings of the male breadwinner, and seldom reaches the dignity of a regular occupation. Office cleaners, who earn from 3s 6d to 5s a week, have the most definite employment in this group. Charing, and in a less degree washing, are essentially married women's work. Of the 800 laundresses, for instance, enumerated in 1901, over 500 were

married. A day's washing or charing – the terms are largely synonymous – is obviously within the compass of many women who could not spare the time for regular factory work.

Even in Norwich, however, laundry work is becoming more and more a definitely organised factory trade, though the work is less specialised and less subdivided than in other centres, and there are a great many small hand laundries. Employers complain that their workpeople are apt to take half-holidays at will, and that on piecework it is difficult to get women to earn more than 10s a week. Once they have earned this they would rather go home. Both these things suggest that the trade has not yet outgrown the traditions of a casual by-industry. For a full week of sixty hours the best hands earn 2s a day or 12s a week, but a rougher class of women earn from 1s 6d to 1s 9d a day, and seldom exceed 10s 6d a week. Girls under eighteen do not average more than 5s 6d a week. It is not uncommon for women to work four or four and a half days a week, when their earnings are correspondingly less. Skilled ironers in power-laundries, however, earn slightly higher wages, and from 13s to 18s a week, but these are exceptional workers.

THE MEN OF DISCONTINUOUS EMPLOYMENT

There remain to be considered two groups of wage-earners who merit special attention because they supply three-fourths of the applicants to the Distress Committee. The Report of this Committee for 1908 – the figures for last year are abnormal and perhaps misleading – reveals the fact that out of 1,800 applicants 425 belonged to the building trades, whilst over 800 were general labourers. 'Builders' labourer and 'general' labourer are to some extent interchangeable terms, but there is a real distinction between the two classes which it is sometimes useful to remember. General labourers are typically the men who live by odd jobs; it is their function to fill up the gaps in an imperfectly organised industrial system. Economically and socially they form a very important class, and require separate treatment. They differ from the builders' labourer, because the work of the latter consists not

so much in doing odd jobs as in a succession of jobs which are perfectly regular whilst they last.

What is said here of the builders' labourer is true also of other classes of employes in the building trade. Carpenters, bricklayers, masons, plumbers, painters, and plasterers are all men whose employment is discontinuous. This circumstance exerts an important influence on the social character of the trade. Wages in the first place are – for Norwich – comparatively high. The standard rate for masons, carpenters, bricklayers, plasterers, and plumbers is 8*d* an hour, or 37*s* 4*d* for a full week of fifty-six hours in summer. Most of the plumbers and more than half of the other classes actually earn this rate. For painters the standard rate is 6½*d* an hour for a fifty-six hour week, but this is for a fully qualified man. Labourers are supposed to earn 3*d* an hour – 23*s* 4*d* a week – but in practice the rate is more often 4½*d* or even less. Even so, it is more than can be earned by unskilled labourers in factories. The difference is, no doubt, accounted for by the fact that employees in this trade have to be compensated for the periods of idleness between jobs. Such considerations seldom count for much with working men, who attach more importance to rates than to total earnings, and the building trades therefore tend to attract surplus labour from other industries and from the country. In addition, the very discontinuity of employment is in itself an attraction. A newcomer can always hope to be taken on when a new job starts. The building trade is in consequence almost everywhere an overcrowded one. But in Norwich there are grounds for supposing that overcrowding is exceptionally serious. It so happened that about 1900 there were large works of construction in the city, making street improvements and putting down the electric tramway, and in the reconstruction of sewers. There is a general concensus of opinion that a great many men came into the town at this time who did not go away when the work was completed. They married and made homes for themselves, and the ties of family life effectively prevented them from going elsewhere to seek employment. This would have mattered less if the building trade as a whole had been prosperous, but the figures suggest that for a whole decade this

industry has been declining in Norwich. In 1898 the number of plans for new buildings or new additions to existing buildings approved by the city engineer was 767. In 1908 the number was only 363, or less than one-half. The history of the trade during the last decade may be read in the diagram below, which is based on the number of new buildings erected annually since 1898.

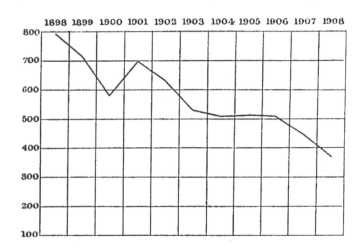

In the light of these facts it is not difficult to understand why the building trades should bulk so largely in Distress Committee Reports, and figures convey no real idea of the enormous social cost of a long period of insufficient work. As a leading foreman put it to the present writer, it has made his fellow workmen 'twenty years older in five years'.

THE MEN OF CASUAL WORK

Finally, we come to the group which is social rather than industrial, because it includes the men of all trades and of none who live by odd jobs. For these men no definite statement is possible as to average earnings or average amount of work. Both are inconceivably little. As one of them put it, the problem of how they live is a book which has yet to be written. Everyone who has come in contact with them knows how impossible it is

to put down on paper the resources of families who fall within this group. Indeed, they do not know themselves. The money is spent as it is earned, a day's work here and a half-a-day there in all sorts of precarious ways. It is important to remember too that the demand for casual labour is not limited to any particular group of industry, though it is more characteristic of some trades than of others. Nor is it limited to the unskilled section of any trade, though it is most common there, since the unskilled man can always be had for the asking. The skilled as well as the relatively unskilled man may find himself amongst those who are only taken on occasionally when trade is brisk. These men constitute in fact the reserve army of industry. Every business, except the largest and the best organised, must have within call some men who can be brought in to meet an exceptional demand. When the pressure is over it is naturally the less efficient man who is selected for dismissal, so that the ranks of casual labour are always recruited from amongst the relatively inefficient. With a fluctuating and generally insufficient income, varied with long periods of worklessness, they tend to become less efficient still, and the vicious circle is thus complete.

The less organised or the more fluctuating a trade is, the greater will be its demand for casual services. We have already met with this phenomenon in considering the organisation of the Norwich boot trade. It is the small masters working for a highly seasonal market who create most of the demand for casual work amongst bootmakers. But this trade is not the only or the principal source of casual work. There is the very fluctuating wire-weaving industry, the cattle market, and the host of employers who from time to time require the temporary services of porters, messengers, gardeners, handymen, labourers, or other kinds of low skilled workmen. A very large percentage of the 800 porters and the 1,300 general labourers, and many of the 700 gardeners enumerated in the census tables must find a living in this way.

Some of the more general causes which help to explain the existence of an exceptionally large amount of this type of labour in Norwich have already been touched upon. As

the metropolis of the eastern counties, and as a centre of employment for women, Norwich is naturally endowed with a ready supply of the lower grades of male labour. Once a man finds himself in Norwich he cannot easily get out of it. He is not wanted in the country, and if he were he would probably find a difficulty in securing house-room for his family, and even a single ticket to any large town will cost him from 8s to 10s. An unemployed workman will not be able to find the money for his own ticket very readily, let alone the cost of transporting his family and household effects, so that he is almost as effectually shut up as if the city were besieged. If his employer dismisses him, he has perforce to stay where he is until his services are wanted, and when they are wanted he is sure to be there. Where these conditions prevail it is fatally easy to carry on business with a casual staff.

Then again, just as London has its docks, Norwich has its cattle-market, and if one industry employs casual labour, other industries are likely to do the same. Saturday after Saturday a varying number of men are required to drive the cattle to the market-place on the hill, tend them whilst there, and drive them away, supposing the purchaser not to have brought his own men with him. The number necessarily varies with the size of the market, being highest just after harvest when the great sales of store cattle take place. On these occasions, when five or six thousand cattle change hands, as many as seven or eight hundred men find work in one way or another, and at least as many more will be there on the chance of getting taken on. A few of these men are agricultural labourers who have come in for the day; others are regular drovers who make a profession of the market and earn a livelihood by it, but the great bulk are ordinary casual labourers for whom bullock-whacking is only one of many odd jobs. The regular drovers include a small number of 'topsters', the leading hands who are responsible to the dealers for handling their cattle. These men may earn as much as £2 a week, and they are regularly employed. A casual man, if he helps to prepare the beasts on Friday at the cattle lairs in Trowse, as well as to look after

them on the Saturday, earns 7s 6d; if he is only taken on for the market he will not get more than 3s or 4s. If he is merely engaged to drive the cattle home, he is paid according to distance. The most reliable of the men are said to be those who work on other days as porters for commercial travellers. It is possible that by this combination a limited number earn a fair weekly income. But the great bulk of those who are attracted by the market have to depend on more precarious ways of livelihood, and this means in practice, that anyone in Norwich who wants to employ casual labour can be certain of finding a supply ready to his hand. An industry can in this way maintain a large reserve of labour at a minimum of cost to the employer, though the cost to the community may be high.

The wire-weaving industry in Norwich may serve to illustrate this point. This trade has of recent years been doing rather badly, and the two wire-weaving firms in the city are only busy for the three autumn months, from October to December. Wire-weaving is a skilled operation, and the weavers earn, when in full work, on piece rates, an average of 30s a week, and in individual cases considerably more. This would be a good wage – for Norwich – if it were not for the fact that the men have to work so much short time, and that for most of them there are many weeks in the year when there is no work at all. One man, for instance, known to the writer, whose wages were assessed under the Compensation Act, found that when his earnings were spread over the year they did not come to more than 14s a week. It would be impossible for the employers to keep sufficient labour available to enable them to fulfil contracts in a reasonable time if it were not that the weavers, in some instances, and certainly many of the labourers who work with them, can always hope to pick up a few shillings now and again in the cattle-market, or by doing some of the multifarious odd jobs which are always to be had in a large agricultural market town.

It might perhaps be argued that this is an advantage, and that the casual labour required by the cattle-market and the county trade serves a useful purpose because it can be fitted

in with other kinds of casual services. But this leaves out of account the fact that the demand for these services is itself irregular. The cattle-market requires more men at one time than at another, and it does not necessarily happen that on those particular Saturdays there are correspondingly more or fewer wire-weavers, or travellers' porters, messengers, or bootmakers required than at ordinary times.

Even if there were, there is no organisation which would automatically transfer the labour required from one form of casual service to another, and failing that there is inevitably a tendency to duplicate labour unnecessarily. The men who look to the market for part of their income cannot keep in touch with more than one or two other sources of employment. Every employer, consciously or more usually unconsciously, is anxious to furnish himself with a reserve of labour sufficient for any crisis which is likely to occur in his business. He therefore likes to know that he has men within call, and to ensure this he often adopts the policy of spreading work. In wire-weaving, for instance, when short time has to be worked, every man who is wanted in busy times is given the opportunity of doing some work. Not unusually the men stand down in batches a week at a time. If he is not there when called upon his claims are apt to be overlooked afterwards, and he has therefore to follow up his work, as he expresses it, even when there is slight chance of his being taken on. This necessity gives a man little opportunity of 'following up' many other employers, and it results in each employer, or small group of employers, having their own reserve of labour. In the wire-weaving industry the policy of each firm having its own reserve has even reached the point of a well understood agreement between the two firms concerned, not to take one another's men, however much they may be pressed.

Another illustration of the way in which a system of casual engagement tends to waste labour may be found in the practice, common to all provincial towns, of employing gardeners by the day. In Norwich such men are given 2s 6d a day, and there is no difficulty in finding men at this price. Really skilled men, however, earn 3s 6d a day.

There must be very few men who are so fortunate as to fill up their whole time with regular engagements, and a large part of it is inevitably spent in the search for work. It must often happen that whilst A is calling on Mr Smith at number one, from whom he now and again gets a day's work, Mr Smith's neighbour is sending out for a man to do up the patch of garden belonging to number two. If, as is probably the case, he is in the habit of employing some other man than A, two men are in fact required to perform services which might easily be done by one of them. Even if A's working for Smith's neighbours involved throwing some other men out of work altogether, it would be a clear gain to society and the employers of casual gardeners.

One man fully employed is worth a good deal more than two or three who are only at work two days out of six, and are not even secure of that. Nothing is so demoralising as the hopeless uncertainty of a casual labourer's life, and if you add to that a chronic condition of semi-starvation, it is unreasonable to expect really efficient work. Yet uncertainty and inefficiency are innate in any unorganised haphazard system of casual engagement. Where there is no method of taking men on, every one has a chance of getting work. If you are unemployed in Norwich, for instance, it is always worthwhile to try your luck of a Saturday on the Hill. And if you try long enough you are just as certain to pick up a few shillings as a gambler is to win on the turn of a card if he has the necessary patience. There is therefore only one limit possible to the number of men who will compete for a given quantity of casual work, the limit which is set by starvation. The work will be divided and subdivided amongst a crowd which is always growing hungrier, until it reaches the point when to take on a new man literally involves starving another out of competition altogether. But this point is not reached until all extraneous sources of income have been exhausted. Every additional bit of casual work which may be had elsewhere, every casual dole, every penny taken from the earnings of wives and children, adds to the number of applicants who clamour for casual work in the cattle market or elsewhere.

For this reason, if for no other, it would be a step in advance if the city were to issue licenses to the drovers. It would set a limit to this harmful competition for demoralising doles of work. And it would be a good thing in other ways. No one who has walked through the cattle market on a busy day can avoid feeling that there is something particularly brutalising about this kind of casual work. The process of sorting out hundreds of stupid and frightened beasts by sheer strength of lungs and arms seems to make a fatal appeal to the baser instincts. And to make matters worse, it is the custom for buyers to tip the drovers whenever a beast changes hands, and the money is invariably spent in beer. Free beer added to all the noise and excitement of a fair is hardly calculated to encourage a desirable type of character, and the drovers have a very unenviable reputation.

Hitherto all attempts to obtain a more disciplined class of man by issuing licenses to ply for employment have broken down largely because it has been felt to be unjust to deprive the unemployed of Norwich of the chance of a job. It is impossible not to sympathise with this feeling, however unreasonable it may be, and equally impossible not to see that casual labour, whether in the market or elsewhere, creates and perpetuates the very distress which it seems to alleviate. In this section it has only been possible to state the problem; how it is being met, and what further steps might be taken, will be the subject of a future chapter on Unemployment and its Remedies.

How Norwich Lives

In this chapter it is proposed to discuss housing, rents, the standard of life, and some aspects of public health in Norwich. The outstanding facts about Norwich are its low wages, low rents, and good housing. These factors, it must be remembered, act and react upon one another; low wages mean cheap building, and cheap building, other things being equal, means low rent. But rent is only one clement, though an important one, in the problem of housing. Sanitation, air, and sunlight are at least equally important. If the first has scarcely as yet reached a satisfactory level, Norwich can at least boast of ample space. The city, with a population of 124,000, has a total area of 7,556 acres. Even for a provincial town this is exceptional. Compared with London it is simply enormous. In the metropolitan borough of Stepney, for instance, 300,000 people are housed on under 2,000 acres, nearly three times the number on less than a third of the space. It is therefore lamentable to find that back-to-back houses arc still to be found in Norwich, though the number is certainly diminishing. The accompanying illustrations show one of those which remain in Coburg Street, where a number of similar houses have recently been demolished. Incidentally this picture gives an example of the difficulties which an old city throws in the way of reformers, as the houses arc built against the city wall.

Housing in Norwich, in fact, tends to be good or bad according to its situation outside or inside the boundaries of the medieval city.

In the courts and yards, which number 749, are to be found housing conditions as bad and insanitary perhaps as those to be found anywhere. A photograph of a typical bad yard is given opposite page 82. In 1898 the Town Council passed a bye-law under the Housing Acts so as to enable them to throw the cost of improvement on the owners, and a special Courts and Yards Committee was appointed to enforce the law. Up to the present time 232 courts and yards have been so dealt with, and the work is being actively pushed on. A few of the worst courts have been closed altogether. Up to the present the total outlay has amounted to £15,700, of which the owners have found nearly £14,000, an achievement which reflects no small credit on the Council and its advisers.

Improvement has mainly taken the form of substituting impermeable paving for the old cobbles, which merely served to collect insanitary deposits, and in replacing bins and privies by a suitable system of water carriage. The yards have also been lighted, though the standard reached at present is not a high one. To a Londoner, accustomed to what Norwich people no doubt refer to as East End slums, it is still something of an adventure to go through the unlighted nooks and corners of Ber Street or Pockthorpe after dark.

Judged by any common standard of comparison, it cannot be said that housing accommodation in the improved yards is really bad, and rents are decidedly low. In many instances, though not invariably, the landlords have recouped themselves for the cost of improvement by adding threepence a week to the rent. For two-roomed tenements in the courts the rents average from 2*s* to 2*s* 6*d* a week; for three-roomed houses the rents are from 2*s* 9*d* to 3*s* 3*d* per week. There are besides a number of single-roomed tenements which command rentals of from 1*s* upwards. They attract an exceedingly undesirable class of tenant, and require careful administrative supervision, especially those which are let furnished. There are happily fewer of these now than formerly.

Except in the smaller courts – unfortunately they are rather numerous – where the houses are apt to be sunless and probably damp, it is noticeable that even in the centre of the city the yards are often built round gardens. Many of these are quite charming

in summer when the flowers are out. Norwich, indeed, is a city of gardens, and gardening, amongst popular recreations, is a formidable rival to professional football. It seems a pity that more is not done to encourage this admirable enthusiasm for flowers amongst the labourers and casual workmen who live in the central area of the city. It is noticeable how many little forecourts and plots of vacant ground in yards and courts have been allowed to fall into neglect. This tendency is said to be increasing as the better paid workmen move out to the suburbs. The Norwich Open Spaces Association, which is doing admirable work in laying out the old churchyards as public gardens, might well add to its activities the encouragement of cottage gardening by offering prizes and facilities for buying seeds and plants. The landlords would probably be very willing to encourage the movement, as it would add sensibly to the amenities of their property, and possibly even make the work of rent collection less arduous than at present. Men who care for their gardens are likely to have 'good principles' about paying rent.

Nothing, however, is likely to hinder the drift of population to the outer residential quarters. The standard of housing, fortunately for everyone except the owners of bad houses, has everywhere risen enormously during the last generation. Children are no longer content with the houses of their fathers, but are willing to pay rather more for a better article. This striking change of demand, common as it is to all classes, accounts in a large measure for the number of empty houses to be found in all great cities. In Norwich, at the present time, the number is estimated to amount to at least 2,000 as against 765 at the date of the last census. Electric trams have counted for something in this change, bringing the suburbs within easier reach. It is necessary to insist on these rather obvious facts, because in political debate this phenomenon has been attributed almost entirely to high rates, although in Norwich, where rates may be assumed to affect all houses equally and not merely those in the centre, they have clearly had no influence in driving people to the suburbs.

Outside the old city boundaries working class houses are mainly of two types, which form an inner and outer zone. In the first or inner zone, the predominant type of house is one containing five

rooms. On the ground floor are a sitting room, kitchen or living room, and scullery, with three bedrooms upstairs, one over each of the main lower rooms, and a smaller one over the scullery. Access to the latter is usually through the middle bedroom. The houses have, as a rule, plain fronts with small forecourts. The front door opens directly into the sitting room. At the back there is almost invariably a patch of garden in which vegetables are grown. Houses of this kind can be had at rentals of from 4s 3d to 4s 9d a week, according to situation. They are occupied mainly by the better class of labourers and by skilled artisans. Better paid workmen live in newer houses with the same general plan, but with large rooms and gardens, for which they pay from 5s to 5s 6d a week. There is also an older type of house, with only four rooms, two below and two above, with a scullery in the back yard, with rentals from 2s 9d to 4s 1d a week.

In the outer or newest zone are to be found six-roomed houses of a superior type, with two sitting rooms, kitchen, scullery and three bedrooms. These houses are adorned with bay windows, and possess a small front garden with a larger garden at the back. They are occupied by foremen, clerks, etc. who pay from 7s 6d to 8s a week for them.

As regards rent and accommodation, working men can be said to be, on the whole, well off in Norwich. In 1908 the Board of Trade issued an elaborate Report into the cost of living of the working classes, in which index numbers have been constructed for all the great towns, showing the relative levels of rent, prices of common necessaries, and wages. An index number, it should be explained, expresses the ratio which different sets of figures bear to some common standard of comparison. If, for instance, the rent of two rooms in London is 6s a week, whilst in the provinces it is 3s 3d, an index number may be constructed by representing London rent as a hundred, and provincial rents as a percentage of this number, or fifty-four. By this method it was ascertained that for similar accommodation a workman in Norwich pays 48 per cent of what he would have to pay in London. On the other hand, of course, his wages are much lower. It was found, for instance, that a skilled workman in the building trade in Norwich would earn

83 per cent of what he would get at his trade in London, whilst a labourer would earn no more than 80 per cent. The corresponding figures in the case of the printing and furnishing trades is 69 per cent. A workingman asking himself whether he would be better off in Norwich or in London would have to balance these facts against one another. He would have to take into consideration the price of fuel and food. The former is rather dear in Norwich, but cheaper than in London, with an index number of 92 as against 100 in the latter. As regards food, groceries are a little cheaper, with an index number of 96; meat, on the other hand, is just a trifle dearer, with an index number of 101. Combining these figures, the general level of prices for necessaries is represented by an index number of 97 as against 100 for London. If rent is included as well, the total cost of living in Norwich is denoted by an index number of 87 as compared with London.

A similar comparison for Ipswich and Leicester gives index numbers of 91 and 84 respectively.

Valuable as they are, these figures provide evidence which it would be dangerous to push too far. They only answer the question as to whether a man is better or worse off in Norwich or in London in regard to certain details of expenditure, and even with this limitation only in so far as it can be assumed that the standard of life in Norwich is comparable with the standard of life in London. No doubt there is a broad similarity between the two, but there are almost certainly important differences, some of which hardly admit of arithmetical measurement.

It is easy, however, to establish one important difference. Class for class, working men of all social grades in Norwich, except the very lowest, require and obtain more house-room, more air, and more sunlight, than their fellows in London. This can be proved by a simple appeal to figures. The number of persons per acre in Norwich as a whole at the date of the last census was only 15.5, in London it was 60.6. Or again, taking the comparison in another way, whilst there were only five parishes in Norwich where the density of population per acre was a hundred or more – St Mary's and St John Timberhill, where it was exactly 100, St Benedict's and St Augustine's, where it was

not more than 110, and St Paul's, the most crowded area, where it was 126; in London there were six whole boroughs where there were more than 150 persons to the acre.

A comparison, based on the number of overcrowded tenements (tenements with more than two persons to a room), shows the same result. At the time of the 1901 census there were 506 tenements in Norwich having more than two persons to a room, with a total population of 3,732 persons, or 3.34 per cent of the whole population. The corresponding figure for London is 16 per cent, and for all urban districts 8.9 per cent. The average number of persons per house in Norwich is 4.5, which must be exceptionally low. These figures, however, convey an impression which is perhaps too favourable to Norwich, because more than half of the overcrowded tenements occur in the three wards of Ber Street, Coslany, and Fye Bridge. In these districts just under 9 per cent of the population live under conditions of overcrowding principally in tenements of two, three, or four rooms. Outside these areas the proportion of tenements with less than five rooms is comparatively low. Taking the whole city, the proportion of tenements with less than five rooms was 23 per cent in 1901, as compared with 29 per cent in the aggregate of urban districts in Norfolk.

In regard to housing, therefore, it is clear that the standard of consumption in Norwich is a high one. Almost every family has a whole house to itself, and block dwellings or houses let in tenements are comparatively few, amongst them being the solitary block built by the Town Council. Unfortunately it was not possible to obtain evidence of so definite a character with regard to other factors of consumption, especially as to food, clothing, and recreation. The only evidence of real value would be a collection of workmen's budgets showing household expenditure in detail. Short of this it is only possible to give, for what it is worth, a general impression mainly based on interviews. In respect to food, Norwich people certainly eat less meat than in most industrial centres, and they prefer the homegrown article to foreign or colonial produce. On the other hand, they consume more vegetables, especially potatoes, and flour in the shape of 'pudding'. In the hands of Norwich housewives, who are strange to the value of peas and lentils as

substitutes for meat, a vegetable diet is not the best imaginable basis for a hard day's work, and employers are probably justified in their contention that the average output per man is less in Norwich than in other towns. The manager of a large silk mill, for instance, who had had experience in both towns, found that at the same piecework rates weavers in Norwich earned less than two-third soft he average earnings in Macclesfield. A low average output is always good a priori evidence of a low standard of diet. Another thing which points in the same direction is the remarkable sobriety of Norwich. In 1908 convictions for drunkenness per thousand of population amounted to only 1.48, against 2 in Ipswich, and nearly 11 amongst the prosperous artisans of Middlesborough. Taken in conjunction with the well-known fact that convictions for drunkenness, taking the whole country, rise and fall with the fluctuations of trade, this evidence is not without significance. On the whole, therefore, we shall probably be safe in concluding that Norwich lives poorly. On the other side, however, has to be placed the fact that most classes of workpeople live near enough to their work to take their meals at home. This is particularly important in the case of women, who are notoriously apt to save unwisely in the matter of food. At Carrow Works, Messrs. Colman provide a dining-room and cheap food for girls who are unable to go home for the midday meal, and this is an example which might be more widely followed, even in Norwich.

With regard to clothing, the evidence is less conclusive, but two facts may be worth recording. In the first place, it is a common complaint in Norwich, both amongst working men and with social workers, that children living at home contribute too small a proportion of their earnings to household expenses. Single men, living with their parents, whatever their earnings, seldom give more than from 8s to 10s a week, and girls customarily give from 4s to 6s, even when their earnings reach 14s or 15s a week. A trade union secretary, with a lifelong experience of Norwich, told the writer that the balance, so far as the girls were concerned, was mainly spent in dress. This is not altogether an evil. Clothes, after all, are an important factor in the general environment which reacts upon character. Class for class, Norwich girls are better

dressed, and in better taste, than similar girls in London. The real evil is that their standard of consumption in other directions is too quickly satisfied. They do not care to earn more than 10s or 12s a week, even when opportunity offers.

Some evidence is also to be found in the Report on the Medical Inspection of School Children. The Inspector writes, 'Whilst the standard of clothing compares favourably with that found in many large centres, there are in the poorer class schools a considerable number of children insufficiently clothed and shod; often the unsuitability of the clothing is evidence of a striking lack of knowledge on the part of parents as to the heat-retaining value of different materials, relatively to their cost.' This passage suggests that amongst children the standard of clothing is at any rate not a high one.

Compared with Ipswich, which is in many respects not unlike Norwich, it is difficult to resist the conclusion that the standard of comfort amongst children is higher in the former place. Out of 2,200 children inspected, the medical officer in Ipswich reports that he only found sixty who were insufficiently clothed, though he qualifies this by the statement that the great majority of children had obviously been specially prepared for inspection.

In other respects, too, the medical officer's report on school children rather goes to strengthen an impression derived from other evidence as to the relatively low standard of living in Norwich. Whilst, for instance, in Norwich 72 per cent of the mothers attended the medical examination of their children, in Ipswich the proportion was 75 per cent. The intimate connection between poverty and the attendance of parents is revealed by the fact that at Quayside – a very poor Norwich school – only 21 per cent of the mothers attended.

Again, taking specific morbid conditions, while 1.5 of Norwich children showed signs of phthisis – essentially a disease of poverty – in Ipswich the percentage drops to 1 per cent. Of all children examined in Norwich, 20.5 showed morbid conditions of the nose and throat, and in Ipswich 20.3. Slight as these differences are, too slight to be in themselves of much importance, taken in conjunction with other things they become at least symptomatic.

The close relation which exists between the physique of children and their general standard of life may be further illustrated by some rather striking figures which appear in the same report of the medical officer. The children were classified according as they came from better class, mixed class, or poorer class elementary schools, in a table giving the average height of children at certain ages in each class. From this it appears that boys aged three years measured 3 ft. 1½ in. in better class schools, as against 3 ft. 1 in. in mixed class, and 2 ft. 11½ in. in poorer class schools, a difference of 2 in. between poor and relatively well-to-do children. At thirteen this difference has fallen to in. in favour of the richer child. The same facts for girls are given in the table below, together with the normal height of children in health at the ages given for the whole country.

<div align="center">NORWICH ELEMENTARY SCHOOLS.</div>

BOYS	Better Class.	Mixed Class.	Poorer Class.	Normal Height [1] for whole country
	Ft. Ins.	Ft. Ins.	Ft. Ins.	Ft. Ins.
3 Years	3 1½	3 1	2 11½	2 11
13 Years	4 9½	4 9½	4 9	4 10⅛
GIRLS				
3 Years	3 1	3 ½	2 11	2 11
13 Years	4 10½	4 10	4 9	4 10$\frac{7}{12}$

From this table it would appear that Norwich children at three years of age are decidedly taller than the normal child, and that this is so even with children of the poorer class. At thirteen, however, children of both sexes and all classes are decidedly below the normal height.

A similar comparison in respect to weight reveals the fact that, if anything, Norwich children are slightly heavier than the normal child at three years of age, but very much lighter at thirteen. This will be clear from the table over the page:

	Norwich.	Normal Standard.
BOYS		
3 years . . .	32 lbs.	31·2 lbs.
13 years . . .	77 lbs.	88·3 lbs.
GIRLS		
3 years . . .	30 lbs.	30 lbs.
13 years . . .	79 lbs.	91·2 lbs.

The exact significance of these figures will only become clear when it is possible to compare them with other towns in East Anglia. Height and weight are factors which are specially liable to be influenced by differences of race. It is particularly unfortunate that comparable figures are not yet obtainable for Ipswich, as they would afford some indication as to how much should be allowed for this factor in Norwich.

It is fairly clear, however, that against the favourable influence of good housing Norwich has to weigh the bad influences of a relatively low standard of living.

The way in which poverty and bad housing combined can affect the statistics of public health is shown to some extent in the differential parish statistics which appear in the very able report of Dr. C. Pattin, the Medical Officer of Health. The gross death-rate for the whole city in 1908 was 14.1 per thousand, but in eight parishes it was considerably higher, and varied from 15 per thousand in St Stephen's to 21 per thousand in the parish of St Martin-at-Palace. It is noticeable that six of these parishes are either within the old city walls or contain a large number of houses which are old and small.

It is rather surprising to find, on the other hand, that this list does not include some of the very poorest areas in the city. St James's, St Mile's, and St Paul's, which are always quoted as typical slum districts, are not only not included, but with a death-rate of under 10 per thousand appear, at least on paper, to be actually healthier than suburbs like Catton or even Eaton. It is still more remarkable to find that the parish of Lakenham St Mark,

almost on the outskirts of the city, with a death-rate of 19.7 per thousand, is with one exception the unhealthiest in Norwich. This parish is, in fact, as good an argument for town planning as could be found anywhere. The houses have been tumbled together without care or forethought, and in such a hurry that the streets have not even names to them, but are known to this day by mere numbers. They were built between 1811 and 1821, when, as we have seen, population was increasing with extraordinary rapidity. Although at the time it must have been absolutely open country, there is one whole street in which the houses on one side have actually no thorough ventilation.

The relatively low death-rate in sonic of the city parishes may partly be explained by the efforts which have been made to improve their sanitary condition. Taking the whole city, no less than 30 per cent of its dwelling-houses are still without an effective system of water carriage; and the large number of bins and privies must have a powerful effect in keeping up the death rate in many districts which are otherwise favourably situated. In the older parts of the city, moreover, there is probably a greater proportion of elderly people without young children, and the death-rate amongst children under five is always higher than in any other age group up to seventy-five. Young married people with families naturally prefer newer and better houses in the suburbs.

It is also questionable whether they make quite the best use of the advantages which such houses give. The front parlour is an almost universal cult in Norwich, jealously preserved for the sole use and enjoyment of the family Bible and the stuffed birds and miscellaneous crockery without which no man can be respectable. Except on rare occasions it is never used to sit in, still less to play in or to sleep in. By day the family overcrowd the one small kitchen, and by night the two or three tiny bedrooms, one of which is very likely partly tenanted by canaries. It is scarcely surprising, therefore, that the vital statistics of modern residential districts should sometimes compare badly with those of older, poorer, and less favourably situated central areas.

The truth is that nothing is more urgently needed than a wider popular knowledge of the most elementary principles of hygiene,

particularly as to air space and ventilation and the storage of food. Last year, when there was an epidemic of typhoid fever in Norwich due to the consumption of contaminated shell-fish, it was found that in 83 per cent of the cases affected the food was kept in living-rooms. Proper larder accommodation in the houses of the working classes is still too rare everywhere, but even so, much more could be done by tenants to obviate the difficulty if its importance was more widely realised. Here, as in the whole problem of housing and public health, it is not merely a question of providing the good things which ought to be, but of popularising the knowledge which will put them to right uses. It is easier to build palaces than to bring up people to live in them as kings.

The City Council have shown their appreciation of this fact by appointing four Lady Health Visitors to carry out a work of systematic visitation which is essentially educational in its aims. The importance of this step may be judged from the fact that in 1908 these ladies paid over 16,000 visits, in the course of which they found 1,222 sick persons and gave simple instruction to the mothers of over 2,400 infants.

No experienced social worker will fail to realise the significance of these figures. Patient and tactful visiting by trained experts is perhaps the only way in which tired and overworked women can be taught the virtue which lies in clean floors, clean food, and open windows. Simple as these things are, they have to be learnt just as much as the more ambitious arts of reading, writing, and arithmetic; and to a girl who has left school at fourteen and worked in a factory till the day of her marriage, they are probably not less difficult.

The work of the health visitors has been particularly important in connection with the medical inspection of school children. It is useless to discover defects unless steps are taken to remedy them. During 1908 over 3,000 children were examined, some 400 of whom – roughly, 13 per cent – were referred for treatment. These cases were followed up by the health visitors, who succeeded in obtaining medical treatment for 81 per cent of them, as the result of 1,700 visits paid to the children's homes. Even more valuable have been their services in connection with

infantile mortality. In the solitude of great cities, where tradition and example lose half their strength, nothing seems to be more quickly forgotten than the knowledge of child nurture, which should be every woman's birthright. A high death-rate amongst infants seems to be one of the penalties of life in cities, and the only way in which it can be avoided, even partially, is to give back to the mothers the knowledge which they have lost or never had. That this can be done effectively by health visitors may be seen in the fact that infantile mortality in Norwich, which down to 1906 was considerably above the average for the seventy-six great towns, has now fallen distinctly below it. The diagram above illustrates this fact very clearly.

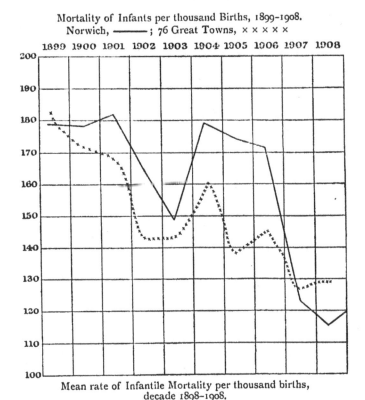

Mortality of Infants per thousand Births, 1899–1908.
Norwich, ———— ; 76 Great Towns, × × × ×

Mean rate of Infantile Mortality per thousand births,
decade 1898–1908.
Norwich, 162·7 ; 76 Great Towns, 151·2.

The fall in the rate of infantile mortality is all the more a matter for congratulation, as it is clear from the diagram below that the Norwich birth-rate is rather below the average for the Great Towns, and appears to be falling with slightly greater rapidity.

The rate of infant mortality per thousand births is, on the whole, the most satisfactory basis for comparing the healthiness of one town with another, as it is specially sensitive to changes in general environment. At the same time, the number of births and the number of deaths under one year are things about which it is possible to be quite certain. The general death-rate, on the other hand, which is more usually taken for the purpose of comparison, is likely to give rise to false conclusions, as it is affected so much by differences in the age and sex condition of the population as

Birth Rate per thousand living.
Norwich, ———— ; 76 Great Towns, - - - - -

between town and town. The relative longevity of East Anglians, for example, must have very great influence in keeping down the death-rate of Norwich as compared with other places.

Another source of error is the difficulty of making an accurate estimate of the population between each intercensal period, and this cannot be eliminated by correcting the gross death-rate to what it would be if the age and sex condition of the population was the same in Norwich as in the county as a whole. With these reservations we may none the less attach some importance to the fact that the city death-rate is low both actually and in comparison with the average mortality of great cities, and that it is steadily decreasing. In 1898, for instance, the gross death-rate was 18.9 per thousand, whereas in 1908 it was 14.1, a decrease of very nearly 5 per thousand in ten years. In the same period the 'corrected' death-rate fell from 17.6 per thousand to 13.25 per thousand, as compared with a fall from 19 to 13.25 per thousand in the case of the seventy-six Great Towns.

So far the figures are satisfactory, but looking at them a little further it will be seen that although the corrected death-rate of Norwich is well below the average of the Great Towns, it is falling rather less rapidly. Whilst the average death-rate of the latter has diminished by just under 6 per thousand as compared with ten years ago, in Norwich the decrease is only fractionally over 4 per thousand.

Two factors which help to account for this may be mentioned here. Out of every 100 women in Norwich who are either married or widows – many of whom would have dependent children – eighteen go out to work. It is natural that this should rather tend to increase the death-rate amongst children, especially under one year of age. An investigation has recently been carried out by the Medical Officer of Health as to the effect of industrial work on the health of childbearing mothers and their offspring. 'On the whole,' he writes, 'the results tend to show that in Norwich, at any rate, factory and away from home work has not affected detrimentally the healthiness of the mothers, but that it has affected detrimentally the vitality of their offspring, directly by still births, and indirectly through the relatively early

relinquishment of breast feeding, occasioned in most cases by the necessity of getting back to work.' Although the health visitors who conducted this investigation found that the working mothers visited were quite as good, if not rather better than the average, the death rate amongst their infants in the first year of life was 125 per thousand births as against 115 for the whole city.

The second adverse factor in the public health of Norwich which merits attention is the rather large amount of tuberculous disease. The death rate from this cause has remained at about the same level, just above or just below two per thousand during the whole of the last decade. Amongst tuberculous diseases by far the most important is pulmonary consumption (tubercle of the lung), which every year in Norwich exacts a toll of over 130 lives. The serious thing is not that more people, relatively, die of consumption in Norwich than elsewhere, as a matter of fact the mortality is slightly less, but that the incidence of the disease hardly shows the same tendency to diminish. Whilst the death-rate in England and Wales per 10,000 living fell during the last decade from 13 to 11, in Norwich it has stood at about the latter figure over the whole period. The low wages and the low standard of life in Norwich would partially account for this.

Another influence in the same direction must be the very limited facilities for the institutional treatment of consumption in its advanced stages. Phthisis, as is well known, is due to a bacillus which can be communicated to others by means of the sputum of consumptive patients, unless proper means are taken for its disposal, and scrupulous cleanliness is observed. In all cases, and especially where poor people are concerned, by far the most effective way of carrying out these precautions is to isolate them in a properly conducted infirmary. Merely to give out relief and nothing else is to subsidise infection at the public cost. For every patient who dies of consumption in the course of a year, there are between three and four patients living, so that in Norwich at the present time there must be at least 500 persons suffering from this disease, of whom only a small proportion receive treatment in public institutions in the last and most dangerous stages of their illness.

Short of complete treatment away from home, it is still possible to do something to prevent the spread of consumption, and this is now being done in Norwich. The danger of infection can be very largely removed if the patient and his friends understand and carry out the simple precautions which are necessary. The Poor Law medical officers have now to notify to the Medical Officer of Health every Poor Law case of consumption which comes to their notice, and in addition the City Council are now paying for the notification of cases under treatment by private practitioners. In this way the health visitors are enabled to call on the patient and give such instruction as may be necessary.

Tuberculous meat and tuberculous milk are other important ways in which infection may be spread, and it is scarcely reassuring to find that 14 per cent of the samples of milk taken last year were adulterated, or that several of the occupiers of the thirty-nine slaughter-houses in the city had to be cautioned for the filthy condition of their premises. The public control of the food supply, it must be confessed, is a problem which still awaits solution. The Public Health Committee of Norwich has no jurisdiction beyond its own borders, and however vigilant they may be it is hardly possible for them or their officials to watch the thousand ways by which unsound meat and dirty milk can be brought in and distributed to the citizens.

In the face of such difficulties, it would be unjust to conclude this chapter without a reference to the enormous progress which has been made in the sanitation and public health of Norwich during the last generation. For evidence on this point it is only necessary to turn to the reduction which has taken place in the prevalence of typhoid fever. Between 1880 and 1890 the average number of cases was 175 in a population of less than 100,000; from 1900 the average number has been 175 in a population of over 120,000. Considering the difficulties which have had to be encountered in an old city where sanitation is peculiarly difficult, this represents no mean achievement.

Local Government and Public Services

The city and county of Norwich, for it is both, and boasts of a sheriff of its own and a separate administration of justice, is governed, broadly speaking, by the mayor, aldermen, and citizens assembled in the City Council. The citizens are present in the persons of forty-eight elected councilors – three for each of the sixteen wards – and the councillors in their turn elect the mayor and sixteen aldermen, of whom half retire every third year. One-third of the councillors retire annually, and every year consequently citizens have the opportunity of expressing at the polls their approval or disapproval of the policy which has been pursued. Only about 70 percent of the electorate, however, register their votes, and the voting is on strictly party lines. So long as the great majority of citizens can only be induced to exercise their franchise by dint of strenuous and organised advertisement, it could scarcely be otherwise. The party machinery is, after all, the only effective organisation yet discovered for persuading reluctant electors to enter the polling-booths at all. If their choice is scarcely founded on cool unbiased consideration of municipal affairs, the result is probably more representative of their real wishes than it would be if only the few exceptionally zealous citizens and those with interests to serve recorded their votes. In that case a small minority of interested men might easily secure an amount of representation

out of all proportion to their numbers, whilst the vast body of citizens would find themselves practically without spokesmen. Once elected, Liberals and Conservatives and Socialists very soon discover that differences of opinion on imperial questions have little relation to the routine business of a City Council. Even in Norwich, where party feeling avowedly runs high, it is only now and then that administration is seriously hampered by the introduction of politics. If politics help to secure the services on the Council of average representative citizens, this slight drawback is a price well worth paying. In the practical business of local government, the personal character of those who represent the burgesses is a more vital consideration than any other.

It is not often realised how seldom local governing bodies are called upon to decide important questions of principle. Usually these arise on a recommendation to adopt, or not to adopt, some enabling statute, which provides for the exercise of new powers, such as the Act for the Provision of Meals for School Children. There is also room for division of opinion in the power to draft byelaws under Acts such as the Public Health or Education Acts, which are already operative.

Opportunities of this kind, however, are necessarily rare. For the most part councillors are concerned with the detailed administration of duties which have been imposed by Parliament, or have already been assumed. The City Council of Norwich could not, if it would, cease to be the education authority, the sanitary authority, the market authority, the police authority, or the road and public improvement authority, and it is hardly likely to abandon its services in the supply of electric light and power, or to refuse to maintain its public library, its museum, art gallery, or its public baths, and the citizens would probably effectively resent the Local Government Board being approached for leave to sell its parks and open spaces.

The mere catalogue of the Council's duties in itself suggests the purely administrative and detailed character of the business it is called upon to transact. Whether this street shall be remetalled, or that landlord proceeded against for failing to

remedy sanitary defects in his property, whether Mr X or Mr Y shall be appointed to a vacant inspectorship of nuisances, whether a park should be levelled by the unemployed as a city cricket ground, or the managers of an elementary school compelled to install a new system of ventilation – none of these are, in themselves, questions of vital interest or importance, yet they are typical of nine-tenths of the business which appears on an ordinary agenda paper. The decision of such questions might not seem to call for a high order of ability, though, in fact, the ideal councillor must possess a grasp of detail which, in practice, is very rare indeed. At the very lowest they demand ordinary honesty and ordinary business acumen. If these are not forthcoming in a sufficient majority of their councillors, the citizens will pay dearly for it in morals, health, and pocket. It will certainly be more disastrous than an occasional error in finding a right solution to the rare questions of great complexity and importance which occasionally present themselves. Such questions have usually to be decided on technical grounds, on the choice, for example, between alternative systems of main drainage. The councillors are almost bound to be guided by the expert advice of their officials. If they refuse to accept advice, or the advice is bad, many thousands of pounds of the ratepayers' money may easily be wasted at a single meeting. It is notorious that something of this sort occurred in Norwich, when the city was re-sewered on modern principles. But, unfortunate as accidents of this kind maybe, they arc infinitely less serious and less costly than carelessness or want of principle in the routine work of administration.

This will be clear from the most elementary analysis of the nature of a councillor's duties. His most important function is to control the actions of officials who have to obtain the authority of a formal resolution for every penny of expenditure. In the course of a year he has to give his approval to many thousand of separate items and to review in meticulous detail an outlay which amounts in the aggregate to a surprisingly large total. A little carelessness, a little laxity or favouritism, may easily be enormously expensive. In the last financial year,

for instance, the Corporation of Norwich spent something like £220,000. Happily there is no reason to doubt that every care was taken that not a penny more was spent than was actually required to carry out the policy decided on by a majority of the Council. This is harder to ensure than most people perhaps imagine. The City Councillor is a public man whose position partly depends on his ability to interpret the wishes of the electorate whose representative he is. His friends are apt to regard him as a valuable business asset, and he has at all costs to acquire and preserve a reputation for being accessible and sympathetic. It is this which electors have in mind when they vote for him, because it gives them a vague feeling that they have a man whom they can trust to remedy their grievances. We all know the posters which ask us to vote for our old friend A.B., who represents the interests of the ratepayers or the people, as the case may be.

It is here that the political club is so effective; and in a provincial city where all classes are brought together in political life, and there is some competition for the honours of public office, the nominees of political associations are prima facie likely to be qualified for their duties. But the virtue of an elected servant of the public must be of no cloistered kind. He is subject to all sorts of pressure in all sorts of ways, and the danger is often greatest when he is least conscious of it. Is it not right, for instance, in allocating contracts, to keep the ratepayers' money in the city by giving preference to local tenders? It will cost more, perhaps, but public opinion seems to demand it. Ought not those who pay the rates to be given all the assistance which is legitimately possible? Is it not right, again, in filling up appointments, especially minor staff appointments, to give the job to one who is out of work and is well recommended by such and such estimable citizens, rather than to another applicant who is only slightly better qualified and is already in a situation? The way of a public representative is hedged about by such problems in the difficult casuistry of a democratic age.

It is especially hard to tread the narrow path of duty when the dismissal of an employee is in question. In his very desire to be

just and to be guided by the evidence laid before him, without fear or favour, there lurks a danger. Nothing is harder to produce than the kind of evidence which will justify the staff committee of a local authority in recommending the dismissal of an official. The mere opinion that a man is incompetent or unsuited for his work, founded as it probably is on the unimpeachable evidence of daily contact, is not in itself enough. There must be some definite provable evidence, and failing this the most inefficient employee has little cause for alarm. He has always on his side the honest British prejudice against doing a man out of his job. There are advantages as well as disadvantages in this relative security of tenure. It is a considerable set-off against the low pay and obscure status of a municipal official, and in the long run it probably means that the public get better men and better service than they otherwise would do. But the difficulty of dismissing an official makes the responsibility of selecting him more onerous. Once appointed, an official can hardly ever be dismissed except for actual crime.

Yet the principal officers of an English county borough are hardly less its real governors than the more imposing bureaucrats of a French or German town. It is true that they are subjected to the most severe financial control, not merely by the Council, but by the various committees of the Council – in Norwich there are no less than ten – whose duty it is to discuss every item which is to appear on the agenda paper. This is a very real power, and effectually enables councillors to determine the standard of expenditure, and the exact channels in which that expenditure shall flow. If the Executive Committee in Norwich think that £1,700 a year is too much to spend on watering the city roads, they can cut down the estimate. If they think that the work could be done better or more cheaply by contract than by themselves, they can recommend the Council to advertise for tenders, and when the tenders come in they can recommend the lowest or some other tender. But as a general rule the initiative as to what shall be done, and how it shall be done, is in the hands of the officials who prepare the business for the Council and its Committees. Any member, it is true, can

give notice that at the next meeting he will move for a certain course of action, but in practice this right is not often exercised. It implies knowledge, the courage of one own's opinions, and a certain readiness of speech, which are not often found in combination. Usually there are only one or two members of any public body who originate and carry proposals of their own. More often the officer in charge of a particular committee himself brings up – it is his duty to do so – the matters which require attention. If they demand technical knowledge, and they probably do, it is then his duty to advise the committee as to the merits of alternative proposals. The Town Clerk, the City Engineer, and Medical Officer of Health have in this way great influence and corresponding responsibilities. They are the eyes and cars and to a large extent the brains of the Council. All routine business and most other business which comes before the several departmental committees is prepared and brought up by them, in order that some recommendation may be sent up for the final approval of the Council. Upon their sympathy, insight, and skill, more than anything else, will depend the well-being and good government of the city. The councillors may, and often do, prevent them doing things for which public opinion is not yet prepared, but it is very hard indeed for the wisest and most determined councillor to get things done without the concurrence and assistance of the officer whose department is concerned. The best councillors can never hope to make weight against lax or bad officials. But it is after all the Council which makes and unmakes the officials who count for so much in local government. Everything comes back to the councillors, and to the citizens who choose them. A good public body inevitably attracts good men to its service, and sets them in an atmosphere in which the standard of public duty is a high one.

It is especially in this direction that old provincial cities such as Norwich have an advantage over newer and larger rivals. London is too vast, and the great northern centres of industry too new to have much corporate life, but it is impossible to stay long in Norwich without realising the strength which comes of a great tradition handed down through many centuries

of honourable and self-sacrificing labour for the city. It is no small thing that those whose duty it now is to deliberate on the affairs of their city should meet in the very chamber and sit on the very benches where their fathers, and their fathers' fathers, sat and deliberated before them.

It remains to give, as concisely as maybe, some idea of the extent and cost of the services for which the Council is responsible. Ever since the Municipal Corporations Act of 1835, the Charter of Local Government in England, the scope and importance of the City Council has tended to grow. The School Board, whose duties were taken over in 1902, when the Council became the Education Authority, is only the last of many bodies whose powers have been similarly absorbed. Except for the administration of justice, which belongs nominally to the Crown, though the citizens pay for most of it, and for the relief of the poor, every branch of local administration is now in the hands of the Council. Each great department is under the immediate direction of its own Committee, though ultimate control rests with the whole Council, which has to sanction all expenditure. The Council's agenda, therefore, takes the form of a series of reports from committees which month by month it has to accept, reject, or amend.

A convenient way of summarising the activities of the great executive departments will be to review the last annual reports of the committees responsible for them. These are mines of information about almost every side of city life which are too little known to ordinary citizens. It is perhaps a pity that they are not bound up with the city accounts – which might well include a summary of income and expenditure – so that ratepayers could see at a glance what was spent and what they got for their money. At present they are apt to grumble, in pure ignorance of what a city without rates would actually mean. They can, it is true, study these documents in the Public Library, but how many do?

From the point of view of expenditure, the most important Committee – except the Education Committee – is the Executive, which spent last year (1908) little short of £45,000. The largest

part of this sum was for cleaning, making, and repairing the streets. The magnitude of the task may be realised from the fact that over 30,000 loads of street refuse were collected and disposed of during the year, and that, even so, some of the outer streets were only cleaned once every six weeks, and the less frequented streets in the city itself only once a fortnight. If the expenditure of the Health Committee on scavenging is included, the mere cost of keeping the city clean fell little short of £12,000. This is part of the insurance which has to be paid by a modern city against disease and premature death. It has to be set against the advantage of a falling death-rate and a longer workinglife. The £23,000 odd which the Sewers and Irrigation Committee expended on sewers and sewerage disposal must be entered under the same head. In addition, this Committee incurred heavy capital expenditure in the construction of some 6,000 yards of new sewers. This was only the last item in an already formidable sum. On March 31st, 1909, the total capital cost of drainage and sewerage in Norwich had already reached the gigantic figure of £322,000, and the tale is not yet complete. The installation of modern sanitation in an ancient city must always be expensive, and in Norwich the cost has been enhanced by exceptional difficulties and bad fortune.

But the ratepayers have to pay almost as dearly for other things hardly less essential than good drains and clean streets. The streets have to be lighted, and on this alone over £7,000 was spent by the Executive Committee, and the far higher cost of maintaining them in a condition fit for traffic may be gauged from the fact that in one year the Committee dealt with nearly 140,000 super yards of macadamised surface and 34,000 tons of material.

In addition to these duties, the Committee has a large amount of administrative work under the Building Acts. It is the duty of the city engineer to report to them on the plans for every new building and every addition to an old building, including drains and sewers. And he has not merely to satisfy himself that the plans are in conformity with the bye-laws of the city, but to inspect the buildings at each stage of erection.

Last year this involved between six and seven thousand visits by the engineer or his staff.

All these duties imply the control and supervision of a very large staff, and most of the 1,600 regular employees of the city come under this Committee. A good deal of temporary labour is also employed in exceptionally busy times, though no figures are available to show what proportion the latter bear to the regular staff. It is desirable that the proportion should be as low as possible, so that the city in its capacity as employer should not be open to the charge of increasing the demand for casual labour. Socially and economically this is perhaps even more important than the payment of a minimum wage to labourers – in Norwich 21s a week – to which more importance is commonly attached. Altogether the Executive Committee spent on wages in the year ending 31 March, 1909, over £14,000 and must be very nearly the largest employer in the city.

A large amount of general constructional work is carried out by the Executive Committee for the other committees of the Council. The Sewerage and Irrigation Committee, which has already been referred to, is perhaps the largest contributor in this way. For the Courts and Yards Committee work was done to the value of over £3,400. The City Committee, again, which is responsible for the upkeep of public buildings and open spaces, is constantly employing the City Works Department on alterations and repairs. On public gardens, which add so much to the amenities of the city, this Committee spent the very moderate sum of £3,300, whilst public buildings, including the management of the city property, the cost of organ recitals in St Andrew's Hall, and £15 4s 4d for salary and uniform of the town crier, accounted for an expenditure of £5,600. Against this the Committee received in rents £3,850, leaving a balance of £1,750. The accounts of this Committee also include a delightful example of municipal trading in an item of £18 8s 6d for the salary and expenses of the city swanherd, against receipts for the sale of swans of £12 7s 11d. The bitterest critic of municipal enterprise, however, will hardly wish to relinquish this very unprofitable business.

The Asylum Committee, which provides and controls the staff and buildings necessary for the accommodation of the 372 certified lunatics whose maintenance is paid for by the Board of Guardians, expended the comparatively modest sum of £3,305. The Committee is not responsible for the entire public care of mental disease. This duty it shares with the Board of Guardians, in whose imbecile wards at the workhouse less acute cases are confined. This curious arrangement has now been condemned by two Royal Commissions, and is certain to disappear in the near future. It has not even the advantage of separating imbecile from lunatic, as in practice the latter is usually passed on to the asylum after being under observation for a time in the workhouse.

Other spending committees of minor importance are the Burial Board, which administers the cemeteries, the Housing and Allotments, and Law and Parliamentary Committees, whose functions scarcely need further definition. On its solitary experiment in housing, the Council received after paying expenses £31, out of which interest and sinking fund had to be met.

The Public Libraries Committee and the Museum Committee occupy a special position, partly because their expenditure is limited by statute to the amount of a halfpenny rate – a little over £1,700 in Norwich – and also because both committees consist partly of co-opted members appointed by the Council on the ground of special knowledge and experience. The city is able in this way to secure valuable services from men who would otherwise be shut out altogether from public life. The principle of election is valuable and indispensable because it does ensure an administration in touch with public opinion, but success at the polls is not in itself a proof of capacity or knowledge. So long as the final word is reserved to those who have to render an account to their electors, Democracy has no valid argument against co-opting on particular committees, men and women who are exceptionally qualified for special branches of administration. A fairly free use has been made of this principle in Norwich. Besides the Committee mentioned above, the nine Conservators of Mousehold Heath, who are

appointed by the Council, include two co-opted members, and there are seven amongst the twenty-one members of the Education Committee, of whom two have to be women.

The important public services directed by the Library and Museum Committees may be conveniently reserved for treatment in the last chapter. There remain to be mentioned five committees which are all of them of vital importance, namely, the Watch Committee, the Public Health Committee, Finance and General Purposes Committee, and, most important of all, the Education Committee.

Of these the Watch Committee and the Education Committee are statutory, and they have certain rights and duties of their own. The Watch Committee is the Local Police Authority. Through the Chief Constable, its principal official, it engages and controls the city constabulary, and is generally responsible for preserving public peace and good order in the city. As the official protector of public morals, it deals with disorderly houses, indecent books, and public entertainments of an undesirable nature. It licenses public vehicles and their drivers, motorcars, pedlars, and dealers in game. It registers and inspects premises on which explosives are kept, and enforces the Weights and Measures Acts. For all these duties the Committee has at its disposal a body of 136 constables – hardly more than one to every thousand of the population. During 1908 this small force dealt with 410 cases of crime, and in 80 per cent of them discovered the offenders, of whom two hundred were apprehended. Only fifty-five of these, however, had committed sufficiently serious offences to be sent to trial, the remainder being dealt with summarily by the magistrates. During the same period 1,320 persons were proceeded against for non-criminal offences, including 182 cases of drunkenness, and 493 summonses for the non-attendance of children at school. In addition to all this the police exercised a paternal supervision over licensed houses, which in 1908 numbered 554 – one to every 250 inhabitants – and in thirteen instances took proceedings against the occupiers. Finally, they kept a watchful eye on such citizens as were known to be habitual

criminals who, in 1908, ominously enough, numbered just thirteen, and no doubt included the leading clients of the six houses known to deal in stolen goods.

The Watch Committee is also responsible for the Fire Brigade. On this and on its other services the Committee spent £14,700, but half the cost of the pay and equipment of the police is borne by the Exchequer, which contributed £5,500, and from other sources, principally fees for licenses, the Committee had an income of £700, leaving a balance of under £9,000 to be found by the ratepayers.

Compared with the expenditure of the Public Health Committee, which amounted to nearly £18,000, the protection of life and property in Norwich cost relatively little. It is rather curious that local public health services in England receive so little monetary aid from central Government. In this matter Government has simply been following the line of least resistance. Policemen and schools are not things which appeal to every ratepayer, and local authorities have had to be encouraged to reach a minimum standard of efficiency by the prospect of earning substantial grants in aids. Smallpox and typhoid, on the other hand, are almost equally dangerous to the wealthiest ratepayer and the poorest, and they are only to be guarded against by common action paid for out of common funds. The work of the Public Health Committee has already been referred to by implication in the last chapter. It has to lay down and enforce a minimum standard of sanitation, to prevent the sale of adulterated or contaminated articles of food, and to search out cases of infectious disease in order to ensure proper measures being taken against the spread of infection. In carrying out these duties the Committee is supported by very wide statutory powers. Overcrowding, dirt, and defective sanitation are legal offences for which the magistrate will enforce penalties. In addition, it has been entrusted with the weapon of compulsory notification, and day by day every case of cholera, smallpox, typhoid, scarlet fever, and other highly infectious diseases must be notified as they occur to the medical officer. It is then his duty to isolate the patient and disinfect the

premises. In small houses the only effective method of isolation is to remove the patient to a hospital which the Local Sanitary Authority has power to provide. Of such isolation hospitals the Public Health Committee in Norwich controls two – a fever hospital and a smallpox hospital. On the upkeep of these the ratepayers spent last year £6,500, including the cost of maintaining patients in the fever hospital, who numbered on an average fifty-nine. The smallpox hospital received no cases, and, in view of the high mortality from consumption, it seems almost a pity that Norwich does not follow the example of Brighton and use its empty smallpox hospital for the educational treatment of phthisis. If smallpox were to occur it would be easy to send the patients to their homes, and a few weeks in hospital would enable the Health Committee to teach a considerable number of consumptives how they ought to live so as to prolong their own lives and to prevent themselves becoming a danger to others. It would also be an effective way of securing early notification, which would then bring with it some obvious material advantage, and without early notification it is almost impossible to discover the cases which arc not too far advanced for treatment in a sanatorium.

The medical officer, who is the adviser and principal executive officer of the Health Committee, enjoys a special status, in that he can only be dismissed with the consent of the Local Government Board. It is his duty not merely to prevent the spread of disease, but to trace infection to its source. Last year, for instance, the medical officer traced an outbreak of typhoid to contaminated shell-fish, which enabled him at once to bring the epidemic under control by stopping the supply. He has also to advise his Committee as to modern developments in preventive medicine. Of late years, for instance, an entirely new view has been taken of the function of public health administration in relation to infant life, in virtue of which Norwich has adopted the Notification of Births Act, appointed health visitors, and even set up a miniature milk depot for the distribution in certain cases of a patent milk preparation. Another departure has been the gratuitous distribution of anti-toxin to medical practitioners

for use in cases of diphtheria. In all such matters the advice which the Health Committee receive from their medical officer is often decisive as to the policy which is pursued. If he fails to keep abreast of modern science, if he lacks tact and skill in conveying his knowledge to the members of his Committee, if his policy is not adapted to the time and place, the money which is spent on public health administration becomes immediately less effective. As a consequence the citizens will suffer in health and still more in pocket, because there will be more fatherless children and more sick people to be relieved by the costly machinery of the Poor Law. A good medical officer stands between the citizens and higher rates.

The Public Health Committee is concerned with the physical fitness of the citizens; the Education Committee, to which we now pass, is concerned with their equipment for life. This task is often thought of as beginning and ending with the period of attendance at a public elementary school, but the educational system of a great city is in fact based on a far wider view. It has something to offer at almost every stage of a citizen's career. It teaches him the three Rs, and it combines with them the laws of conduct, cleanliness, and good manners. It offers him secondary education, and a scholarship at the University. It provides him with technical knowledge, and will gladly teach his wife how to keep the house, cook the dinner, and even how to mind the baby, and is then ready to fill his leisure hours with as much literature, art, and science as he cares to ask for. All this implies an organisation so vast and complex that it is only possible here to give the barest outline of it. The provision which the city makes for elementary education naturally comes first, and in cost and scope it is the most important of all its responsibilities. Attendance at school is compulsory from five to fourteen years of age, and the 21,000 children in Norwich who attend its public elementary schools cost last year something over £80,006. This included an expenditure of £48,000 on the salaries of the 616 teachers – of whom 449 were women – who were required to carry on the work of ninety departments. In addition, there were three

special departments: one at Horn's Lane for blind children, and two others for the mentally deficient at Quay Side and Colman Road respectively, whilst thirty-seven children were maintained in industrial schools away from the city, and seventeen children in schools for the deaf. As part of their ordinary curriculum some thousands of children were taught manual work – carpentry and cookery – at special centres, and a few hundred were able to learn swimming. The elementary school children of Norwich have also provided for them special facilities for playing organised outdoor games. Play is, after all, an essential part of education. They have at their disposal not only the Corporation playing grounds on Mousehold Heath, and in Waterloo and Eaton Parks, but also a recreation ground of their own on the Town Close Estate.

But this by no means exhausts the catalogue of what the Education Committee undertakes for the scholars in its elementary schools. A beginning has been made with the work of systematic medical inspection, and the committee has a special school doctor of its own. Some of the facts which were thus brought to light have already been referred to, and the question of medical treatment, as the result of inspection, will come up for discussion in Chapter xi, in reviewing what has been done in Norwich in the way of public and charitable medical service. The school doctor has not merely to inspect the children themselves, but the hygienic character and suitability of the accommodation provided for them. The condition of the school buildings, particularly as to light and ventilation, has a very important influence on education. Inspection in Norwich has not yet been extended to the school buildings – or, at least, no systematic report has yet appeared on the subject. Some of he older schools, including Council as well as non-provided schools, are necessarily far from ideal in the character of the accommodation which they provide. On the other hand, the Education Committee has been eminently successful in meeting the higher requirements of the Board of Education as to space – ten feet per scholar instead of eight – by reorganising some of the older schools.

The elementary schools are sometimes criticised because they cost too much and achieve so little. No doubt there is room for criticism, but it is no small thing to have provided classrooms and books and teachers for 21,000 children, and to turn out every year something over 2,000 boys and girls, not indeed educated, but at least disciplined by nine years of compulsory attendance, and able to read well, write fairly well, and calculate more or less successfully. More could hardly be expected of a system which is only just forty years old. Up to now the main difficulty has been to provide the bare mechanism of education, and the degree of success which has been attained in Norwich is to be measured by the fact that out of every hundred children who ought to be in school on an average ninety are always present. Every year this percentage goes up, whilst the number of parents who arc prosecuted for the non-attendance of their children steadily diminishes.

Progressing the future must lie in endowing this routine mechanism with free and spontaneous life. The Education Authority can, and does, do a great deal to bring this about, especially by insisting on a higher standard of qualification in the teachers, and by giving them greater freedom. But the citizens themselves can do much. Every elementary school in Norwich has a body of managers invested, it is true, with little power of interference in the curriculum and management of the school, but with the right and duty of visiting the school during school hours. As a general rule, managers in Norwich hardly seem to make sufficient use of the opportunities which this privilege confers. School life is necessarily one of monotonous routine which is always in danger of losing all real touch with the life of the outside world, for which it is ostensibly a preparation. A good manager, by merely going into his school, puts a new vitality into the atmosphere. Amongst the many difficulties which beset a teacher, not the least is the fact that he is condemned to solitary exile within the four walls of a classroom. The ordinary course of his duties does not naturally bring him into contact with different ideas or a different kind of experience from his own. A layman, just

because he comes with an unprofessional point of view, can often be of enormous help to him. And there are many other ways in which managers can help to build up the corporate life of the school, by knowing the scholars, by taking an interest in the school games, and by organising old scholars' associations, so that there maybe some continuity in the school traditions. Again, the managers, and especially the women managers, can do much useful work in bringing school and home into closer contact with one another. The business of education goes on in both, and they must work together if the best results are to be hoped for. And especially now that Norwich has adopted the Provision of Meals Act – from November to March last an average of 767 children were fed daily – it is urgently necessary that at every school there should be one or two managers willing to give time and trouble to caring for the children who need this form of help. Last year the Act was administered by a sub-committee of the Education Committee, with the help of the teachers and the attendance officers. The committee itself can hardly have had much direct knowledge, and whilst the teachers know the children, they often have surprisingly little knowledge about the homes they come from, and the attendance officers are not the best instruments with which to fill the gap, even if they had the time. A free dinner five days a week in the winter months, and not at all in the holidays, goes a very little way towards solving the problem of a 'necessitous' child. He is the member of a family, and any treatment which pretends to be adequate must take into consideration the whole unit to which he belongs. Skilful visitation will not itself meet the difficulty, but it will often do a great deal, and is in any case an essential preliminary step. Then again, in advising parents as to suitable work for their children on leaving school, or in helping the health visitors to follow up those whom the school doctor reports as needing medical attention, there is an immense amount of useful public service which can be done by the managers of elementary schools.

There is still another direction in which managers might do more than they do. For the vast majority of children who

leave the elementary schools attendance at an evening school or at the Technical Institute is the only practicable way of continuing their education. When they first leave school to go to work it is not in human nature that they should wish for more schooling, even if the first strain of industrial life left them energy enough to benefit by it. Later on, when they might be more reasonably expected to attend evening classes, they have in many cases lost the habit and desire for study. Managers who kept in touch with the old scholars of their school might do much to revive this taste.

As things stand at present it is only a tiny percentage of elementary school children who in after years take up any branch of study. At the eight schools in which evening classes were held last year there was only an average attendance of 516. At the commercial classes held in the Duke Street secondary school there was an attendance of 299, and if the 584 students who attended at the Technical Institute are counted in as well, there were less than 1,400 students all told in Norwich attending any form of evening instruction. Two reasons may be offered in explanation of this rather disappointing total. It is the custom in most of the Norwich factories to work from 8 a. m. to 7 p. m., so that a man who wishes to attend evening school has only an hour in which to dress and have his tea. This in itself must be a powerful deterrent, but there is also another, not at all peculiar to Norwich, which is even more decisive in keeping men away. The choice of subjects is limited either to a new edition of the subjects learnt at the elementary school or to strictly bread-and-butter subjects which will contribute directly to industrial efficiency. These are excellent in themselves, and indispensable to any sound system of further education, but they are not the most stimulating or attractive form of mental pabulum. In any case the methods pursued are probably wrong. The grown man, especially the grown working man, does not want to feel himself going back to the atmosphere of his elementary school. The problem is largely one of cost. The ordinary evening class must either be conducted by a day school teacher or not at all, but it is not a satisfactory or final condition of affairs. As an alternative the ordinary man has at present the University

Extension Courses held on Friday evenings at the Technical Institute; but the fee of 7s 6d is rather high, and the subjects and the general atmosphere do not provide the artisan with quite the kind of teaching which he wants. An extension lecture is an agreeable – and an improving – way of killing time; it is hardly a serious form of study, and an able artisan, who respects himself, is not to be attracted by any kind of study which is not thoroughly in earnest or which aims at anything less than the highest kind of knowledge. He wants to enlarge his mental horizon, to equip himself with the power of arranging and expressing ideas, to learn something of human life and achievement, and the nature and structure of political society. What he requires, in fact, is access to the Humane Letters, to history, literature, political science, and particularly to the economic side of politics. Hitherto the only way to knowledge of this kind in Norwich has been along an academic road, through the secondary school and the University. This necessarily shuts out men of the artisan class, but the academic is, after all, not the only road. If a clever working man lacks the preliminary training of education at a secondary school, he has gained an experience in the hard school of life which will largely compensate for this. He is perfectly capable of entering into thing's which can be brought into relation with his own experience – which is, after all, very much wider than that of an ordinary university student. The teaching which he wants, therefore, is less formal, and less direct than that of the usual academic lecture, but it is teaching which aims at conveying the same substance in the terms of his experience. This is not an easy task, and can only be attempted with success by a teacher of high academic rank. The difficulty is to bring teaching of this type within the reach of workingmen in Norwich.

So far as higher education is concerned, this is by far the gravest problem which the Education Committee has now to face. In other industrial centres it has been solved by the device of the tutorial class, and there seems no reason why the same solution should not apply in Norwich. The tutorial class is the result of co-operation between the Universities, the local education authorities, and the working-class organisations.

In other towns this combination has been brought about with the help of the Workers' Educational Association – a society of working men to which labour and educational organisations are affiliated, formed with the object of obtaining for working men the type of higher education which they need. It is the work of the association, through its local branches, to bring the class together, and to bring them together on the distinct understanding that the selected subject is to be studied continuously for not less than three years. In practice it has been found that the class becomes unworkable if the number exceeds thirty. The association has now a joint committee, of representative working men and members of the University, at all the great Universities, including Cambridge, whose duty it is to provide suitable teachers and to supervise their work. The teachers are paid partly by funds at the disposal of the joint committee, partly by the local branch of the Workers' Educational Association, and partly by the local education authority, who also provide the classroom.

The first step towards setting up this kind of teaching in Norwich is to form a branch of the Workers' Educational Association, and this may well be the outcome of a recent effort to form a class amongst the adult schools in connection with 'Fircroft' – the Educational Hostel at Birmingham belonging to the National Union of Adult Schools The Education Committee might well encourage this movement by official recognition and assistance.

This discussion has gone rather beyond the mere description of educational machinery as it now exists in Norwich. Apart from the evening classes, including those at the Commercial School, which are designed for young business men, the most important part of the provision for further education is, of course, the great Technical Institute in Duke Street. The most lavish provision is made here for studying the science and practice of craft, from the simplest manual operations to the most abstract technical science.

As it will be necessary, at a later stage, to consider the function of technological training in relation to the question of industrial education and apprenticeship, it will be useful

to quote here, by way of illustration, from the syllabus of instruction for bootmakers. 'For the first year' the course is intended to train students in the general principles underlying the manufacture of a simple form of shoe. Every student will be expected to make one or more shoes from beginning to end. The course will therefore include instruction in Geometry, Elementary Mechanics, Pattern-cutting, Clicking, Machining and Fitting, Lasting and Finishing.' After this sufficiently comprehensive introductory course, the embryo bootmaker is expected to attend for another two years, during which he specialises in one or more branches of the trade, and completes his knowledge of general principles. At the end of this period he has an accurate and thoroughly scientific understanding of the materials and processes of boot manufacture. Men who have undergone training of this elaborate kind will be at least educated workmen, competent to take an intelligent part in the complex operations of modern industry. It may be objected that a workman does not require general knowledge of his craft so much as mere dexterity of hand in performing specific processes, although his work, in fact, is quite likely to be the oversight of delicate machinery; but the truth is that manual skill is itself a mental thing; clever fingers are only to be commanded by those who have minds properly equipped and trained.

There is one other important responsibility of the Education Committee which is dealt with by the Higher Education Sub-Committee, but which has not yet become an integral part of the provision for secondary education. This is the training of the pupil teachers destined to recruit the teaching staff of the elementary schools. These numbered ninety-four in July, 1909, and they were being trained at the pupil teachers' centre at a cost last year of over £1,600. In addition, ten bursaries of £8 a year at the secondary school are now available for pupil teachers.

Secondary education in Norwich is only partially provided for by the Local Education Authority, but as the older endowed schools become less and less able to meet the rising standard of modern education without official assistance they are gradually losing their independence. Recently a new municipal secondary

school has been built for boys on the outskirts of the city, and two small endowed schools2 are now to be amalgamated with it. The grammar school will then be the only secondary school with an independent endowment. When their new buildings are complete, the premises in Duke Street now occupied by the boys' secondary school will be added to the accommodation for the secondary education of girls. Until these arrangements are complete, the Education Committee has only accommodation for some 500 secondary pupils as compared with 22,000 in its elementary schools. It is therefore only a small section of the ratepayers who can hope to share in the benefits of the secondary education provided at their expense. The gross cost of this education last year amounted to only £4,600, but grants from the Board of Education and scholars' fees reduced the net cost to under £2,000 a year. Small as this is, it is hardly just or satisfactory that the benefits of secondary education should not be equally available to every boy of talent, whatever the position of his parents. This must involve in practice a liberal scheme of scholarships for the poorer boys. At present, despite its enormous charities, Norwich is poor in scholarships. The Education Committee itself provides forty free places for children from elementary schools, and at the end of their second year at the secondary school, offers ten bursaries of £8 annual value. Beyond this there are certain educational charities available for scholarships: Augustus's Charity provides about thirty scholarships of £10 a year open to general competition amongst elementary school children. Baldeston and Stocking's Charities provide two others, and there are five others, limited to sons of freemen, provided out of the Town Close Estate. The educational ladder is completed by the Education Committee granting bursaries to boys from their secondary school who carry off scholarships at the Universities, but this is not a very frequent occurrence.

It will be perhaps as well to surmise, by way of conclusion, what is spent in Norwich for educational purposes. Elementary education, as we saw, accounted for £80,000, and to this must be added an expenditure of £15,000 on higher and secondary education, making a total of £95,000. Less than half of this

sum, however, was found by the ratepayers, who are only responsible for £39,600, whilst the Board of Education paid in grants over £49,000. The balance of £7,000 came from fees and miscellaneous receipts.

Education is perhaps the most onerous, and certainly the most interesting department of the Council's work.

There remain to be mentioned two committees, which differ from all the others in that they are earning, and not spending committees. These are the Markets and the Electric Light Committees, the oldest and the newest forms of municipal trading. The Norwich markets have been referred to in previous chapters, and here they need only be regarded from a financial standpoint. The markets have long ceased to be regarded as an important source of revenue to the citizens, and the object of the committee which is now responsible for them is to promote the general interests of trade rather than to make a profit. To trace the slow evolution of this altered attitude would be as good a way as any other of writing the history of Norwich, for its markets must be the oldest of its corporate institutions. Nevertheless, the Markets Committee is still able to hand over a substantial balance to the revenue of the city. From the cattle-market, after expenses had been paid, there was a profit of a little over £1,000, on a gross income of £4,150. The provision market brought in a little under £500; if the profits of the fish market and the income from public weighbridges is added in, the net balance amounted to £2,600, after paying the cost of administration, including interest and repayment of capital.

The Electricity Committee earned a gross revenue of £37,000 from an undertaking which represents a capital expenditure of £347,000. Working expenses, repairs, rates, and management absorbed in round figures £19,000, leaving a balance of £18,000, of which £14,400 went in Interest and Sinking Funds, leaving a net profit of £3,600, of which £1,200 went in relief of rates, and £2,450 to Depreciation Account, leaving a small balance to be carried forward. The city gas, water, and tramways are in the hands of private companies, so that the municipalisation of public services has not gone very far in Norwich.

No account of the various services on which the City
Corporation spends a revenue of £220,000 would be complete
without a reference to the important functions of a committee
which has notyet been mentioned, namely the Finance
Committee. The Finance Committee should be to the other
departments of the Council what the Treasury is to the great
departments of central Government. Twice a year, in June and
December, it has to receive and approve the estimates submitted
by the other standing committees of the Council, and to check
any tendency to extravagance. In Norwich this function of the
Finance Committee is possibly not so much insisted on as it
might be. The committee decide what sums will be required
from the Board of Guardians, which in Norwich undertakes
the duty of collecting rates. It is responsible for the proper
keeping of the Corporation's books, and it manages the city
debt. The outstanding debt now amounts to over £800,000,
on which last year £29,800 was spent in Interest, Repayments,
and payments to Sinking Fund.

By way of conclusion something may be said as to the relations
between the Town Council and the great central departments
of State. Unlike the Board of Guardians, the Council is not
under the obligation of submitting its accounts to the scrutiny
of an auditor appointed by the Local Government Board. The
Council is in that respect very much less under control. It cannot
be surcharged by official action for expenditure on purposes
beyond its legal powers. The accounts have, it is true, to be
audited, but two of the three auditors are elected by the citizens
at large – in practice these are always qualified accountants
– and the third is nominated by the mayor.

The Local Government Board influences the policy of
the Council mainly through its power to refuse sanction to
expenditure involving loans. The Council cannot, therefore,
engage in any enterprise involving capital outlay without the
approval of the Board. This is only granted after the Board's
inspector has held an inquiry at which any ratepayer has a
right to make objections and to be represented by counsel.
But apart from its strict legal powers, a great department

like the Local Government Board enjoys a prestige and authority, which largely enable it to shape the policy of local authorities by mere suggestion and criticism. For this purpose its power to call for reports is of very great importance. Any extraordinary item in the accounts for the year would, for instance, provoke comment which would almost certainly lead to the disappearance of that entry in future. In the same way a rate of mortality from small-pox or enteric fever, which showed no tendency to diminish over a period of years, would probably lead to an inquiry and report which would effectually rouse public opinion on the matter. The ultimate power inherent in the Local Government Board of obtaining a writ of mandamus from the courts, which it can, if necessary, enforce by putting the authority of the Town Council in the hands of commissioners, is in practice never exercised.

In two departments of local administration the central authority can, however, intervene in an authoritative way. The police are under Home Office inspection, and in theory, at any rate, the grant for pay and police-clothing might be withheld if they failed to reach the required standard of efficiency. As the Exchequer Fund Account consists, in fact, of certain excise duties collected by the Corporation itself, it would be difficult to compel it to pay over the amount. Grants from the Board of Education, however, do really come from the Treasury, and they depend absolutely on the education of the city satisfying the conditions laid down. A borough, not very far from Norwich, which obstinately refused to provide sufficient school accommodation was quite recently compelled to take action by the threat of a withdrawal of the grant. Subject to these qualifications, the great County Boroughs remain extraordinarily independent. So long as they hold the power of the purse, the central authority can never compel them to adopt a course of which they disapprove, whatever the statute book may say. The balance may be altered by the increasing tendency to make grants in aid of rates, but hitherto their real immunity from outside control has grown at least as rapidly as their administrative importance.

The Rating and Poor Law Authority

Much that has been said in the last chapter as to local government in general may be applied just as truly to the Board of Guardians as to the Town Council. There are, however, certain well-marked differences between the two bodies. Political feeling on the Board of Guardians is carried to greater lengths, and not infrequently decides the action which is taken. This is, no doubt, partly due to the fact that the matters with which guardians have to deal are in themselves more controversial, and partly because the whole body of forty-eight guardians retires en bloc every third year. At each election about half the members returned are new, and there is therefore less of the give and take which invariably grows up amongst people who are accustomed to work together. The rather high proportion of defeated guardians at each triennial election may also be taken as an indication of a certain difference in personnel between the two bodies. On the whole guardians do not stand out amongst their fellow-citizens in quite the same way as the members of the City Council.

There are at present only eight members of the Board who are also councillors.

Historically the Board of Guardians is, curiously enough, older than the Town Council, which really dates in everything but name from the Municipal Corporations Act of 1832. The

Guardians, on the other hand, represent one of the very few surviving incorporations of parishes which go back to the days of the unreformed Poor Law. To this day people in Norwich speak of applying to the Court – the Court of Governors of the Poor – instead of to the Board. The incorporation originally included forty-four separate parishes, which were subsequently united by special Act of Parliament. The present constitution of the Board is determined by Local Acts obtained in 1863 and 1889. The Board is also singular in being the only rating and rate-collecting authority for the city. A proposal recently put forward by the Local Government Board to transfer this important duty to the Corporation was successfully opposed. For the present, therefore, it continues to levy, under precepts from the Town Council, the whole sum which the ratepayer is required to provide for local government. This side of its duties may be conveniently dealt with before we go on to consider the administration of Poor Law.

For the year ending 28th of March, 1908, the total sum levied in rates amounted to £188,624. This is not the total revenue of the city, as income from grants and other sources must be added. The rateable value of the city at Lady Day, 1908, was £457,247, and the amount levied in the pound was no less than 9s 10d. On this basis Norwich is one of the highest rated cities in the kingdom. The average rate per pound of valuation in England and Wales, including rural districts, is 6s 1¼d.

Local rates, however, are levied, broadly speaking, on the annual or letting value of occupied property, and the amount of rates in the pound is therefore largely determined by the general level of rents. In Norwich, as we saw in Chapter V, this is exceptionally low, and it is only to be expected that the rates should be correspondingly high. A much safer standard of comparison is the amount levied per head of population. On this basis Norwich is rather exceptionally well off. In England and Wales the average amount raised in rates per head of population in 1905–6 was £1 14s 1d. In London it was £3 5s 3d whereas in Norwich, for the year 1908, it was only £1 10s 9d – less than the average for all urban and rural districts. It is possible that

the population has been slightly over-estimated, which would have the effect of making the amount per head slightly less than it ought to be, but the margin of error cannot be very great. In 1901, when the census was last taken, the Rating Authority raised £156,082, which represents an amount per head of £1 7s 11d.

Another interesting comparison which throws some light on the financial condition of the city may be drawn between the increase in rateable value and the increase in the amount of rates levied per pound of valuation. In 1885 the rateable value of the city was £274,881, and the rate stood at 8s 2½d in the pound. In 1908, the last complete year for which figures are available, the rateable value was £457,348, and the rates were 9s 10d. If rateable value and amount levied in the pound in 1885 are expressed as a hundred in each case, comparison with 1908 yields the following result:

Year	Rateable Value	Rate per £ of valuation
1885	100	100
1908	168	120

From this simple set of index numbers it appears that rateable value in Norwich is increasing very much more rapidly than expenditure from rates. The following diagram expresses the same fact in a slightly more detailed way. The year 1890 has been taken as the base year, as it is from about that time, taking the country as a whole, that rates began to increase faster than rateable value. In Norwich the exact opposite has happened, partly because in former years rateable property was rather under-assessed, but also no doubt because the city is really growing wealthier with extraordinary rapidity.

The administration of the Board as a Poor Law Authority hardly needs description in detail.

One board is very much like another and their general characteristics, up and down the country, have been made sufficiently familiar in the reports of the Royal Commission.

All that need be attempted here is a very brief statement of the problem as it presents itself in Norwich.

xxx = Rateable value. ———— = Rates in the pound.

The accompanying chart (*opposite*) illustrates the history of pauperism in Norwich from 1870 to 1908.

By the regulations of the Local Government Board every union has to make a return showing the total number of persons in receipt of relief on the first of January and the first of July in each year.

The mean of these totals is then taken as the average number of paupers in receipt of relief during the year. It will be seen that on this basis pauperism was highest in 1871, fell rapidly through the next decade, and more slowly until about 1885, since when it has been rising steadily until the present time, except for a sharp fall between 1898 and 1901. The number of paupers is now almost exactly the same as in 1870. The population in the meantime has been steadily increasing, so that the number of paupers in every hundred persons shows a

marked diminution. Whereas in 1870 four people out of every hundred in Norwich were dependent on the rates, in 1908 there were only two. The cost of relief, on the other hand, measured per head of population, has decidedly gone up. In 1870 the cost of pauperism per head of population was 7s 4¾d, and in 1886 it fell to 5s 2¼d, but from that point it has risen continuously to 8s 11d. The average cost in England and Wales is 8s 2¼d, but this is for rural as well as urban districts. Comparative data for the five largest towns in the eastern counties may be taken from the last Report of the district inspector. They are as follows:

Name of Town.	Cost of Relief per head of population.[1]		
	Total.	Indoor.	Outdoor.
	s. d.	*s. d.*	*s. d.*
King's Lynn	5 10	2 2¼	3 7¾
Yarmouth	5 4	2 9½	2 6½
Norwich	4 9½	1 10¾	2 10½
Ipswich	4 4¼	2 7½	1 8¾
Colchester	3 9	2 2	1 7

[1] Net cost exclusive of administrative expenses.

These figures bring out the highly significant fact that whilst Norwich spends less on indoor relief than any other town in the district, the expenditure on outdoor relief is the highest but one on the list. The explanation is to be found in the fact that until the new infirmary buildings were put in hand, no effort had been made in Norwich to provide adequate indoor accommodation for the sick poor, whilst, on the other hand, outdoor relief has been given with a lavish hand.

None of the figures given so far, however, throw much light on the character of the problem with which the Norwich Guardians have to deal. They merely enable students of such matters to measure the extent and cost of pauperism in comparison with previous years and other places. Yet in the

ordinary way this is practically all the official information which is available to the general public. The Norwich Guardians, who are responsible for an annual expenditure of over £58,000, render no real account whatever to the citizens who elect them of the way in which this large sum is applied. It is true, no doubt, that the meetings of the Board are reported in the Press, and that a bare financial statement is printed showing receipts and expenditure for each half-year. Neither of these, however, can be regarded as a substitute for a properly compiled report containing an account of the more important business transacted during the year. A review of the character and distribution of the total pauperism of the year under its various heads is particularly desirable. It would then be possible to judge over a term of years as to the wisdom or unwisdom of the policy which was being pursued. As things stand at present neither the general public nor even the Guardians themselves are in a position to know how far and in what direction their administration is proving adequate or otherwise. It is impossible to believe, for instance, that such an important matter as the overcrowded and insufficient accommodation at the infirmary would have been tolerated so long if the facts had been fully realised.

Fortunately the sort of information required can to some extent be obtained from the evidence collected for the Royal Commission. There is, in the first place, an invaluable return showing the whole number of separate individuals relieved in the twelve months ending September, 1907. The statistics quoted above only showed the mean number in receipt of relief on two days in the year. This obviously gives no indication whatever of the numerical extent of the class who are wholly or partially dependent on the ratepayers for their support. Every day some people come on the relief lists and others go off.

In 1907 it was ascertained that the number of separate individuals relieved during the year in Norwich was 11,259. That is to say, instead of there being only 2 per cent of paupers, there were, as a matter of fact, in every hundred of the population ten or more who become dependent at some time

during the year. Most of these no doubt, are always on the verge of requiring assistance. Compared with other urban unions the pauper class in Norwich is quite exceptionally large. A similar table to that given above will make this quite clear:

TOTAL NUMBER[1] OF PAUPERS AND RATE
PER CENT TO POPULATION, 1907

	Total number relieved.	Rate per cent to population.
King's Lynn . .	1,261	6·7
Yarmouth . .	2,936	5·8
Norwich . . .	11,259	10·1
Ipswich . . .	3,412	5·1
Colchester . .	2,349	6·1
London . . .	339,256	7·1

The presence of this enormous number of dependent or partially dependent people cannot be entirely explained on administrative grounds. It is not merely due to the fact that out relief is relatively easy to obtain in Norwich. In London, in the famous unions of Whitechapel and St George's-in-the-East, where no out relief at all is given, the ratio of paupers to population is even higher, and is just as high as it is in comparable districts, like Poplar and Bermondsey, where out relief is given even more freely than in Norwich. It may therefore be safely taken as confirming the conclusion which was suggested by our analysis of industry that there is in Norwich a very large under-employed, and therefore semi-employable class who are always on the verge of destitution. Bad times, old age, widowhood, sickness, and any of the normal accidents of life leave them absolutely without resources.

This vast pauper host of 11,000 people has, however, to be split up into its component parts before the essential nature of the problem can be laid bare. The return from which the figures just quoted have been taken will still help us here. The enumerated paupers were classified in five ways,

according to whether they were children or adults, heads of families or dependents, according to the nature of the relief given, its duration, and the number of occasions on which it was granted. From the figures thus obtained some important information is to be gleaned.

Adults (persons over sixteen) were found to number 6,663 – 2,921 men and 3,742 women.

Children (persons under 16) numbered 4,596. It is not always realised to what an enormous extent the Poor Law is concerned with those who are only beginning life. How the Guardians in Norwich discharge this duty will appear immediately.

Heads of families numbered 2,245 and their dependents 5,754, whilst 3,260 persons were relieved singly.

Classified according to the kind of relief, Indoor Relief only was given to 1,234 adults and 323 children. Outdoor Relief, and in some cases medical relief as well, was administered to 2,910 adults and 2,151 children, whilst outdoor medical relief only was received by 2,375 sick people. Those who received both indoor and outdoor relief were so few that they may be safely neglected. Practically there are two distinct groups of paupers, those who receive only indoor relief and those who receive only outdoor relief. The first class is very much the smallest; only about fourteen out of every hundred paupers in Norwich receive relief in the workhouse or infirmary.

The Norwich Guardians speak of their workhouse with pride, and it is officially regarded as being in some ways a model institution. Its special feature is the care which is taken to classify the old people according to character and behaviour. These constitute, of course, by far the largest proportion of the inmates. Deserving old married people occupy a row of cottages apart from the general body of the house and come and go at will. Next to them are the privileged old people, who have a dayroom rather more comfortably furnished than the ordinary. There are armchairs, for instance; and below them again are those whom it is necessary to keep under rather stricter discipline. As far as possible, each class is kept by itself, so that in Norwich a real effort is made to do away

with the worst hardships of a workhouse life. The respectable old person is not driven to associate with the kind of people whom he or she has never associated with before. How far this experiment is really successful a stranger is hardly in a position to say. In spite of everything, the indescribable workhouse atmosphere is just as all-pervading in Norwich as elsewhere. Any attempt to deal with all classes of people, old and young, good and bad, sane and insane, under the same roof is inevitably doomed to failure more or less complete.

Different workhouses fail in different ways, but failure in some direction there is bound to be. Next to the aged, the most important class, numerically, to be found in workhouses is the feeble-minded. In Norwich it is the custom to keep in the imbecile wards all paupers of unsound mind who are not actually dangerous. It is cheaper than sending them on to the asylum; but to treat every type of mental disease in the same wards and in the same way and under the supervision of the same workhouse doctor is scarcely a satisfactory way of dealing with the problem. Much the same sort of criticism applies to the treatment of the so-called able-bodied. Everyone under sixty who is not actually sick is regarded by the Poor Law as able-bodied, but included in this category are those of every degree of capacity and incapacity. It is a miscellaneous assortment of humanity in which it is quite exceptional to find a really able-bodied man in health. Whatever they are they must be set to work; but it is absolutely impossible in the same building and under the same officers to enforce any reasonable standard of effort amongst a horde of paupers who differ so widely from one another in ability and willingness. Whatever their taste it tends to be a demoralising sham, rather attractive than otherwise to a certain type of character, and admirably calculated to destroy any latent capacity which individuals may chance to possess. Whatever a man is when he goes into the workhouse, he will inevitably have sunk to the level of the rest when he comes out.

It is mainly in this way that the Poor Law manufactures the dangerous type known as the 'ins and outs'. The paupers

enumerated in 1907 were classified according to the number of times relief was granted during the year, and in Norwich those who came on relief five times and upwards numbered 479. Of these between two and three hundred, on a moderate estimate, would belong to this class. Whether in the workhouse or outside of it, they simply prey upon society, coming into the workhouse for brief intervals of recuperation whenever they grow tired of a predatory life outside.

Except for these and for the tramps, of whom there are always between sixty and seventy in the casual wards, the population of the workhouse in Norwich is not on the whole very migratory. The building, which is good and fairly modern, is certified to accommodate 800, and there are always over 700 inmates, including upwards of 160 or 170 sick people in the infirmary. In 1907, apart from children and vagrants, under 1,300 people all told received indoor relief, so that it is evident that the larger proportion of workhouse inmates are there permanently. This is even true to a large extent of the infirmary, which is largely given up to those who have grown too old and feeble to remain in the body of the house.

On the other hand, the consumptive patients, who perhaps constitute the most important class who come direct to the infirmary for treatment, are always apt to take their discharge immediately fresh air and regular nourishment have effected a slight improvement. In this way they shorten their own lives and endanger the health of the community. Until quite recently the infirmary was so bad that they could hardly be expected to take any other course. The small and overcrowded wards of the old building made satisfactory nursing almost impossible. Now that a new block has been erected, it is to be hoped that progress will become possible in many directions. Hardly anything has such an important influence on public health as the administration of the Poor Law infirmary.

We have still to speak of the way in which indoor relief is administered to children in Norwich. As we have seen, there are only a very small percentage of the total number of pauper children in the city. Out of more than 4,500 children in 1907,

only a little over 300 received this form of treatment. The Norwich Board is honourably distinguished by the fact that no children are admitted to the workhouse. They are sent in the first place to a receiving home, and from thence they are disposed of in three ways. Younger children are sent to two scattered homes, one for boys and one for girls, which each accommodate about ten children, and a third home is now to be added for children of both sexes. As an alternative, they may be boarded out with foster parents in Norwich, who receive a weekly payment of 5s; about thirty children are dealt with in this way. The difficulty of this plan is to find suitable foster parents and to supervise them. The Board has now appointed a lady relieving officer who undertakes this duty, and the system is said to work satisfactorily. Elder children are maintained in two larger homes: one for girls accommodating thirty-two, and a boys' home with room for about forty. The children remain here until they go to work, and the girls usually go out to service. The boys are apprenticed out of the funds of a charity, and the Guardians supplement their wages during the first years of apprenticeship. They leave the home, however, as they necessarily must do, as soon as they cease to be chargeable, and live in lodgings which are in the first place found for them by the Board. It is hardly a satisfactory thing that boys of fourteen or fifteen should be living independent lives in this way without its being the duty of anyone in particular to take friendly interest in them. There is very great need of a properly organised After-Care Committee in Norwich to undertake this work. As things are it is very much a matter of chance whether the boys, at any rate, spend the first critical years of their working life under good influences or not.

It remains to indicate the main lines on which out relief is administered. This is by far the most important type of relief in Norwich, both financially and otherwise. In the year ending 28 March, 1905, whilst the whole cost of indoor relief amounted to £9,938, outdoor relief cost the ratepayers £16,800. It is also the most important numerically. In 1907, 9,700 people received this form of treatment. Put in another way, whilst

there are never more than 1,000 indoor paupers, including children, there are always 3,000, and sometimes considerably more, receiving outdoor relief.

In the administration of out relief the relieving officers arc all important. All applications are made to them; they have to investigate and report on each case, and they are the eyes and ears of the Board in seeing that relief, if granted, is adequate, but not more than adequate, and is properly applied. That is to say, they have not merely to investigate all new cases, but to keep in touch with all cases on relief, whether new or old. It is one of those astonishing facts about English Local Government that this difficult and delicate work is left to be discharged by anyone whom a Board of Guardians may choose to appoint. Guardians, after all, are human, and the right of nominating a relieving officer is a very attractive piece of patronage.

Of these officers in Norwich there are seven, one of whom is a lady. She has no district assigned to her, her duties being partly to deal with maternity cases – a very wise provision – partly to superintend the boarded out children, and partly to inspect homes in which children are taken in to nurse. Of these about 190 have been so far registered in Norwich. Under the Children Act these homes have to be registered and inspected. The six district relieving officers have consequently each at least 500 cases to deal with. There are unions in which one officer has as many as 2,000, but even 500 is more than one officer has time to deal with properly. The Poor Law is everywhere hopelessly understaffed. It is impossible for one man, however able and well trained, to deal in any helpful, constructive way with hundreds of cases, each of which has special features and requires a special form of treatment. The only plan possible under the present system is to give relief in small doles in the vain hope that it will be too small to attract other applicants. In Norwich, as in all out-relief unions, the duration of relief is often very short. In 1907 more than half of the cases dealt with were relieved for one month or less. In nearly 2,000 cases the period of relief was a week or less. In these cases, at least, it is quite safe to say there was no

attempt to deal with the causes of distress. The applicants were merely tided over, and sooner or later they will come again, needing more relief. Indeed, the statistics prove this. In 1907 alone over 4,000 paupers were relieved on more than one occasion. The worst of this is that while it is easy to acquire the habit of coming to the Poor Law for assistance, it is a very difficult habit to unlearn.

The two most important types of out-relief cases, however, are those of the old and of widows with young children. In Norwich these cases are dealt with according to a regular scale. A widow with children receives 2s for herself and 2s for each child; a single person under seventy, living alone, receives 3s, and if over seventy, 3s 6d; but an old person whose rent is otherwise paid for, receives 6d a week less. In granting relief the Guardians take into consideration earnings, charities, and general circumstances, but a Board which is divided on political lines cannot hope to make this adjustment in a very impartial or consistent way. It is doubtful, indeed, whether any board of amateurs, however constituted, could do this work satisfactorily. It needs special training and a judicial mind.

However this may be, there is no doubt that out-relief in Norwich differs extraordinarily as between case and case. This is particularly so as regards widows. Sometimes the Board gives less because there are children earning – this is the rule perhaps – in other cases these earnings are not taken into account at all, and 2s is given for each child under fourteen, irrespective of the total income. A case is recorded, for instance, in which a family income of 51s 6d for nine people, rent 4s 6d, was supplemented by 5s a week poor-relief. On the other hand, cases of this sort occur:

Mrs. B., widow, earns charing 3s a week. She has seven children, one earning 3s 6d a week, total income 6s 6d a week; Guardians allowed 5s a week and flour. The case was reported to the Society for the Prevention of Cruelty to Children, as the children appeared neglected. The society's inspector, after investigation, came to the conclusion that the only cause was the insufficient relief from the Guardians.

It is because cases of this kind are of daily occurrence everywhere that the reform of the Poor Law is of such tremendous importance. In Norwich alone there are at any time considerably over 1,000 children whose parents arc on out-relief, many of whom, as matters stand at present, have not the vaguest chance of growing up into efficient citizens. Where children arc concerned there is absolutely no alternative between giving really adequate out-relief, including adequate supervision, or of refusing all except indoor relief.

Sufficient out-relief to widows has not been given hitherto, partly on the ground that it might lower wages. This danger has probably been hopelessly exaggerated. Under the Outdoor Relief Regulation Order, outdoor relief may not be given to able-bodied men, except in return for taskwork, so that it is only women's wages which could possibly be affected. Outdoor relief is freely given in Norwich; yet in December, 1906, when this matter was specially investigated, there were only 163 mothers and 104 daughters who were earning wages and were also in receipt of relief or belonged to households into which relief was going. These women were distributed over thirty different occupations, and in no case did it appear that they were receiving lower wages because they were getting an allowance from the Guardians. Even if this had occurred in isolated instances, the whole number of possible subsidised wage-earners is so small that they could not affect the general level of wages. All told, there were but 266 of them, as against 18,000 occupied women.

The objections to out-relief as it exists at present are mainly that it is so often inadequate and that it is always unconditional. It is given without any regard whatever to the kind of surroundings in which people are living or the kind of lives they lead. Very occasionally out-relief is stopped on the ground of immorality or drink; but mere dirt or insufficient accommodation is practically never made a reason for reconsidering the grant of relief. Out-relief therefore tends to become everywhere a gigantic subsidy in aid of the worst housing and the lowest standards of life. In Norwich, for

instance, no less than 38 per cent of the whole amount goes to people who are living in the courts and yards of the old quarters of the city, where most of the least desirable cottage property is to be found.

In the majority of cases in this area relief is going to old people. On any one day about half the total number of persons in receipt of relief are over sixty, and most of these are over seventy. There cannot be less than 700 or 800 old people over seventy in receipt of out-relief in Norwich. How many of these are living alone in dirt and misery, slowly starving on their pittances of 3s or 3s 6d a week? It was stated in evidence before the Royal Commission by a Norwich clergyman that many old paupers in his parish had less than threepence a day to live on.

It is unnecessary here to say more about this subject. It is not altogether the fault of the Guardians, though some of the worst cases might certainly be avoided if there were any attempt at co-operation between Poor Law and charity in Norwich. At present the Guardians not only do not endeavour to co-operate with charity, but they even refuse to give information as to the relief which they are themselves giving. At the same time there can be no doubt that the Guardians often justify the grant of what they know to be inadequate relief because they presume that something more will be forthcoming from charitable sources. This does not always happen, and does not even then make the relief adequate. In any case, the lack of any systematic interchange of information between those responsible for the two kinds of relief puts an enormous premium on fraud and imposition.

But this is not the whole case against out-relief.

There can be no doubt that the occasional dole of out-relief, like doles from any other source, tends to extend the number of people who can just manage with this help to pick up a living in the casual labour market. But the Norwich Guardians, not content with this, have gone a step further by creating a kind of labour which is even less desirable in its social effects. Able-bodied men with families in Norwich are relieved in the woodyard, where in return for so many hours of wood-

chopping they receive an allowance in kind proportioned to the size of their family. The woodyard is not opened occasionally in times of exceptional distress; it is always open, and a certain number of men find permanent employment there. Others regularly have recourse to it at certain seasons of the year. It is impossible to enforce any proper standard of work, and the men all tend to sink to the same level in character and efficiency. Whatever a man maybe worth when he first goes there, he very rapidly becomes no better than his neighbour. No better way of manufacturing incapables could easily be invented.

The woodyard naturally brings us to the whole subject of the unemployed, but this must be dealt with in a separate chapter. Historically, of course, relief works came into existence because the new Poor Law completely failed to provide anyway of dealing with the average industrious labouring man who fell into distress through lack of employment.

The Unemployed

The subject of unemployment in Norwich has a long history, and one which would well repay careful study. Many of the causes which help to make unemployment such a serious evil today are as old as the city itself. Its metropolitan position as the capital of East Anglia, its isolation from other great cities, and its industrial character have always given this problem a leading place in Norwich. A good deal has already been said on this head and the point need not be laboured further. For the purpose of this chapter the history of unemployment may be said to begin with the adoption of the Unemployed Workmen's Act in the autumn of 1905. Previous to this it had become a settled custom for the mayor to raise a fund for the benefit of the unemployed whenever distress became acute, which was usually distributed in doles. In addition, the spending committees of the Town Council in bad times put special work in hand for the benefit of the unemployed; that is to say, the men were taken on not because they could do the work, but because they were in distress. Both plans led to abuse and waste, and in the winter of 1904 an attempt was made for the first time to deal with the problem in an organised way. In December of that year the committees of the City Council were instructed to put as much work in hand as possible, and a conference was held between the Town Council and the Guardians, as a result of which a

special committee was appointed to deal with the question. The mayor raised a fund which reached nearly £2,000, and a registry was opened which received 759 applications. The committee provided work on Mousehold Heath, and the Guardians, in addition, employed eighty-one men in their woodyard, whilst the Corporation found work for 300 or 400 more. The work on Mousehold Heath was given in spells of three days a week.

As a result of their experiment the committee reported that the result of the work on the whole had been unsatisfactory: 'the payments in some cases being scarcely worth calling payments for work, but merely a mask for charity.' They recommended 'that should the problem arise in future years, there should be provided a nucleus of a special staff with the necessary offices and other conveniences; and that as far as possible the men should be placed upon piecework ... When good workmen are mixed with bad the majority of the good men soon become reduced to the level of the indifferent.' The Joint Committee found that work which under normal conditions should have cost £16 per acre, cost £43 per acre when it was carried out by unemployed labour.

The difficulties which were encountered in Norwich were common to all experiments of the kind, and it was in order to provide some permanent and more effective machinery to deal with them that Mr Long carried his Unemployed Workmen's Act, which established the distress committees. The purpose of the Act was twofold. They were to supersede the municipalities in the relief of unemployment, and they were to establish proper machinery for administering this relief according to definite principles. Ever since 1886, when Mr Chamberlain invited municipal authorities to provide extra work, in the nature of relief work, so as to prevent respectable unemployed men being driven to the Poor Law, it had been usual for local authorities to spend money for this purpose. They were not relief authorities, and they had neither the machinery nor the experience which would enable them to carry out this duty efficiently. There had been no method of selection, and no standard of supervision, with the result that a great deal of money had been spent without

benefit, either to the ratepayers or to the respectable workmen referred to in the circular of the Local Government Board. The distress committee was intended to take away the burden and responsibility of employment relief from the Town Council by the creation of a specialised and semi-independent authority on whom this duty would devolve. The new authority is, in form, a committee of the City Council, but with independent powers; it is composed partly of councillors, and partly of representatives of the Board of Guardians, with the addition of a certain number of members co-opted by the Council, who must have had special experience in the relief of distress. It was to be the task of these rather anomalous committees to direct and organise the employment relief, which had hither to been provided in a haphazard, spasmodic way by the local authorities. They were entrusted with power to pay the cost of this organisation out of public funds, up to the amount of a halfpenny rate; but the expense of providing work undertaken by themselves, or of contributions towards the cost of work provided by other authorities, was to be met by voluntary funds. In practice the latter course has been usually adopted: the Distress Committee contributing towards the cost of relief work provided by the City Council. As voluntary subscriptions have proved insufficient for this purpose, Parliament has each year voted a small sum to be allocated by the Local Government Board in grants to the committees. The committees were to register and investigate applications for work from the unemployed, to enquire and report on the existence of distress in their districts, and if they thought fit to set up labour exchanges separate from the register of unemployed. In addition, they were authorised to pay, out of public money, the cost of emigrating or moving applicants to other districts provided that they could secure work for them, and that they did not exceed the limit of a halfpenny rate.

In selecting applicants for relief the committees were to give preference to men who had been regularly employed, who were of good character, and who were not out of employment through any fault of their own, but owing to special and temporary causes. Applicants who had received Poor Law

relief, or who had been assisted in two successive periods of twelve months, were to be disqualified. These regulations were framed with the object of concentrating the energies of the new committees on men usually in steady work who were in distress owing to depression of trade. The needs of such men would be met by temporary work, which would serve to tide them over until trade revived. The duration of employment relief was therefore limited to a maximum of sixteen weeks in any one year, it was not to be given for more than two years in succession, and it was to be given consecutively and for not less than four days a week. It had been found that the practice of employing men in short spells for two or three days a week or for alternate weeks was demoralising to men who were accustomed to regular work, whilst it was very attractive to men of a thriftless and casual class. To safeguard the relief still further the rate of pay was to be below that obtained for ordinary unskilled labour in the district.

In actual administration the Unemployed Workmen's Act has failed to achieve almost all the objects for which it was designed. On the other hand, its failure has been enormously instructive. It was the first real attempt to deal with unemployment as such, and as a result it has been possible to collect for the first time sufficient data for an adequate analysis of the problem. The Act was designed to assist the thrifty men, the members of trade unions and friendly societies, who were normally in constant employment. But in Norwich, as everywhere else, this class has very rarely applied, and the Distress Committee was swamped from the first by applications from casual labourers. In the first year of administration, out of 1,589 men who registered no less than 777 – nearly half – were labourers. Of the rest, 137 belonged to the boot trade, 126 were painters, and 127 bricklayers. £2,700 was spent in wages, and work was offered to over 1,000 of those who applied. In the following season 1,593 applications were registered, of whom 659 had applied the previous winter. The labourers numbered 825, of the rest nearly 400 were connected with the building trade, and another 218 came from the boot and shoe industry. Work

was found for about the same proportion of applicants as
the year before. This was in 1906–7. In 1907–8 the number
of applicants again increased and reached a total of 1856, of
whom 58 per cent were casual labourers. The chronic distress
of those who applied was again illustrated by the fact that 786
had registered the previous year, and of these no fewer than 215
were disqualified under the Act on account of having received
employment relief for two years in succession. Last year the
number of registrations once more went up, and totalled
2,734, an increase of 878 over the year before, and again over
50 per cent of the applications came from unskilled labourers.
Of the remaining applicants about one-third belonged to
the boot and shoe trade, and another third were connected
with building. The cost of administration has grown with the
increase in number of applications; this may be conveniently
set out in tabular form. Col. 3 gives the sources from which
the voluntary fund came. The Corporation has power to pay
for work done, so that part of it comes, in fact, from the rates.

EXPENDITURE OF THE NORWICH DISTRESS COMMITTEE IN EACH OF THE LAST THREE YEARS

Year.	Rate Account.	Voluntary Fund.	Sources of Voluntary Fund.
1906–7	£999 3 4^1	£3886 9 1	Mayor's Fund £1450 0 0 Queen's Unemployed Fund 200 0 0 L. G. B. . . 2000 0 0 Committees of Council . . 138 7 6
1907–8	£726 1 3	£3775 10 11	—
1908–9	£926 11 11	£7040 16 9	Mayor's Fund £2013 10 0 J. & J. Colman 228 16 6 Committees of Council . . 2013 0 0 Local Government Board . 3100 0 0

No one will dispute that these figures, and especially the progressive increase in the number of applications, merit very careful consideration.

If the latter is to be taken as a measure of unemployment, it might well seem that the condition of Norwich is becoming steadily worse, and that last winter something under S per cent of the occupied males of Norwich were unemployed. This figure would correspond very closely with the 9 per cent of trade unionists in the United Kingdom who were returned to the Board of Trade as taking unemployed benefit during the same period. It would be dangerous, however, to base any statistical conclusions on these figures. The Labour Party in Norwich avowedly make special efforts to induce everyone who is out of work to register with the Distress Committee; and the startling increase in the number of applications last year is no doubt to be partly attributed to their efforts. This element of political agitation inevitably makes the statistics of registration unreliablefor purposes of comparison with other places, or with previous years, when it may have been less persistent and successful. In any case, they are rather evidence of the existence of distress than an accurate measurement of its extent. To say that 2,700 unemployed men registered during the year, obviously does not mean that there were at any one time so many men out of work. A man who registers himself one day may find work for himself the next, and there are always some men who refuse employment when it is offered them by the Distress Committee on this ground. Last year, for instance, 1,300 men reported that they had found work for themselves.

Minimise them as we may, however, the condition of things revealed in these reports cannot be lightly put aside. Not only do more men apply every year, but there seems to be a growing class who are permanently dependent upon relief work in the winter. The number of applications for the previous three years have been given above, but a table which appears in the last report of the Committee is still more convincing, and may be quoted here. The total number of applications was 2,734, of whom 1,235 had registered in previous years.

NUMBER OF MEN APPLYING FOR FIRST TIME, AND
NUMBER WHO HAVE APPLIED PREVIOUSLY

Applicants registered 1908–9 ONLY	1499
Applicants registered 1908–9 and 1907–8	994
Applicants registered 1908–9, 1907–8, and 1906–7 . .	493
Applicants registered 1908–9, 1907–8, 1906–7, and 1905-6	277

When 45 per cent of the applicants are asking for relief for
the second or third or fourth year in succession, what has to
be dealt with is clearly not the temporary distress which was
contemplated by those who framed the Unemployed Workmen's
Act. The man who comes every winter to the Distress Committee
is not likely to be helped by an occasional dole of relief work.
The disability under which he suffers is evidently not due to
the mere ebb and flow of good trade and bad trade, but to
permanent causes which require some more radical treatment.

What these causes are may perhaps be made to appear by
a further analysis of the case papers. The applicants are not
limited to men belonging to one or two trades only. In the winter
of 1906 it was found that seventy-three different occupations
were represented in the lists of the Distress Committee, but
general labourers, bootmakers, and builders are, as we have
seen, in an overwhelming majority. Obviously no one cause or
set of causes will account for all the applications; indeed, each
one has peculiarities of its own, just as one individual differs
from another; but if we can discover why from 40 to 60 per
cent of them come from general labourers, and another 40 per
cent are divided pretty evenly between boots and building, we
shall have gone a long way towards solving the problem.

So far as the first are concerned, it is not difficult to discover
what underlies the distress which makes them always so ready
to apply for relief work. All we need do is to take a few typical
case papers. Here are half a dozen selected at random.

H. F., aged thirty-one, average earnings when last in work, 23s 4d, navvying; G. M., age forty-nine, average earnings 16s a week, is also a canary exporter, has been doing odd jobs for twenty years. Three other men were last employed in a mineral water factory during the season; two of them are quite young men. M.K., on the other hand, gives his age as seventy; he has been earning a living by odd jobs in gardens, for which he gets 2s 6d a day. It is noticeable how often gardening appears in these papers. Out of a hundred case papers eight give gardening as their last employment.

This list might be extended indefinitely. General labour is a vague term which includes all sorts of unexpected means of livelihood. Out of a hundred cases examined, fifty-two applicants thus described themselves. One of them, an old soldier, described himself alternatively as a musician. His last engagement was a day at Gorleston by which he earned the princely sum of 3s 6d. On his case paper there is a significant note to the effect that 'Mr. M–, bandmaster, would employ him more, only it stops him on the Guardians workshop.' Several other applicants put down 'wood-chopping for the Guardians' as their last employment. The gardeners have already been referred to; some of them are jobbing men, others work in market gardens from spring to early autumn, and appear to be out of work for the rest of the year. The list includes as well two or three hawkers, a brickmaker, a quarryman, a beer bottler – a lad of nineteen, who earned 10s a week – several labourers in ironworks, and a good many men who would be more properly described as builders' labourers.

Only a few of these nondescript labourers come from permanent situations. Industrially the great bulk of them evidently belong to the group of casual odd jobmen whose functions were described in the last section of Chapter III, and they are the lower fringe of this group, the men who by reason of age, ill-health, character, or general inefficiency, are no longer able to command a sufficient share of work. The battle is to the strong, and these are the victims of the contest. But they have not yet fallen out of the ranks altogether, and this is

the important point. Their services are still wanted every now
and then. Even the musician was wanted for one day in the
year and, according to his own statement, on other days as
well, when he was occupied in chopping wood at the public
cost. Presumably his place in the band had to be filled by
another player, who was perhaps brought into the profession
by the chance, as he might well think it, of earning a living
on exceptionally easy terms. The net result, if this hypothesis
represents the facts, would be that there arc now two men
where there was formerly one – one wholly depending on
public support, and the other just subsisting on such work as a
musician at 3s 6d a day is likely to obtain. This last man, be it
observed, is not unemployed; if he goes away someone will be
wanted to replace him, but he is more or less seriously under-
employed. If a dole in the nature of relief work is offered him he
will be glad enough to get it, and relief work may at least delay
the fatal demoralisation which comes of too little work and
insufficient pay. Even about this, as we shall see immediately,
there is room for doubt, and there is no doubt at all that relief
work in itself is simply so much more casual labour. This
would not matter so very much, perhaps, if applicants to the
Distress Committee were not so largely of the casual class we
have been describing. The actual labour these men perform is
the least part of their work. Just because they form the reserve
which is needed to meet the daily and hourly fluctuations of
modern industry, it is an essential part of their functions that
they should stand and wait. And it is a reserve, as we saw
in a former chapter, which in a sense is unnecessarily large,
because every employer tends to have his own section of it. It
is not a reserve common to the whole industry or even to large
divisions of it. When A and B and C are busy, and the men who
look to them for casual work are fully occupied, X and Y are
often slack, and the men on whom they are accustomed to rely
in times of pressure are correspondingly idle. In the best times,
therefore, there is always some part of this reserve which is idle,
and in the slackest times there are always some casual reserve
men who happen to be well employed. That is to say, perhaps

they are working as many as twenty days a month, or eight or nine months in the year. But there are always some days and some months when they are unemployed in the sense that they are waiting until their employers have work for them. At such times if there is a Distress Committee to provide employment relief it is inevitable that they should apply for it. In Norwich, even in a relatively good year like 1907–8, there were 831 of these 'general labourers' who filled up applications for employment. To employ such men on relief work might not perhaps be a bad thing if it was possible to ensure that whilst they were employed in this way they would not be required in the ordinary market for their labour. But this is just what no relief works ever can do. It is useless to pay a lower rate of wages, it is impossible to make them so low that they will not attract the lower fringe of the industrial reserve. Whenever relief works exist on a large scale, it must inevitably happen that a percentage of men employed on them are wanted by their ordinary employers for casual services; if they are not there, the work has still to be done, and other men will, in fact, be brought into the casual labour market to fill the gap. Relief works to this extent must, in the long run, simply add to the circle of distress. They are no longer extraordinary abnormal things, which only happen occasionally, when times are bad; every winter relief works set up a demand for casual labour just as effectively as the cattle market does every Saturday, and in the end demand and supply will adjust themselves at precisely the old level.

For proof in support of this view, it is only necessary to ask what happens to the 40 per cent or 50 per cent of applicants who get no assistance from the Distress Committee. They do not go to the Poor Law. There has been no extraordinary rush of able-bodied men to the wood-yard or the workhouse; in 1907–8, out of 1856 applicants, of whom half had registered the year before, only 56 were disqualified by the receipt of Poor Law relief. They had managed to exist somehow on the resources normally open to them. This does not mean, of course, that they were not in distress: far from it, but their

distress was not due to temporary unemployment, but to the chronic and permanent under-employment which results from bad industrial organisation.

In a good many cases the man is not the only wage-earner. B. M., for instance, who describes himself as a casual labourer earning 5d an hour, has children whose earnings are set down at 15s weekly. Like relief works, these supplementary earnings in the long run simply add to the number of men who can just maintain themselves in the market for casual labour.

Relief works, considered as a remedy for unemployment, are rather like opiates in medicine, the more they are used the more they are wanted. But this is not the whole danger. Already, as far back as 1904, the predecessors of the present Distress Committees, as we have seen, noted how difficult it was to maintain a decent standard of work amongst the men employed. The best men quickly fell to the level of the rest, and the amount of work accomplished for a given expenditure was about one-third of what it would have been under normal conditions. It is clear that employment of this kind hardly tends to promote efficiency amongst the men engaged on it; on the contrary, it may have a fatal influence on industrial character, so that employers will be reluctant to engage men who have become too well accustomed to relief works.

It was hoped that this difficulty might have been overcome by careful classification of the men who applied. With this object Distress Committees were enjoined to fill up an elaborate record paper for each applicant which they were to test by scientific investigation. Something has been accomplished by this; the mere idler and wastrel is brought to light and left to his own resources and the Poor Law. But the principle has never been pushed to any logical conclusion. Different men require different treatment. Amongst the 100 men whose cases were examined, there were only three who were totally worthless, but there were at least twelve others whose characters, moral or industrial, were so indifferent as to require special treatment. In five cases the foreman reported that their work for the Distress Committee had been only

'moderate', in another it had been definitely 'bad', but this man was nevertheless given work again last year; two others had to be discharged. Three men had lost their previous employment through drink, and another through losing time. Mere relief work will not give to these men the stimulus which they evidently need to make them industrially efficient.

The Distress Committee, if they undertake relief at all, and some of these cases were left unrelieved, mete out the same treatment to good and bad alike. It is easy to blame them, but in truth they can hardly do otherwise. An amateur committee with untrained officials and hopelessly inadequate resources is not the body from which to expect careful investigation, or just and sympathetic classification of cases. Public opinion looks to them for the relief of distress, and the less thoughtful members, always the majority on any Board, are perhaps well content to drift with the tide and let the manner of relief very much take care of itself. The result has been that the Distress Committee has made very little improvement on the employment relief which was formerly given by the Corporation without any Committee at all. It is still municipal work, and it is still organised and supervised by the city engineer and his staff. The only practical difference is that voluntary subscriptions which used to be distributed in monetary doles now go towards the cost of providing the relief work, and the rates are relieved to that extent. On the other hand, there is very much more relief work than formerly, and this has had, according to the emphatic testimony of the city engineer, a disastrous effect on the Corporation's own employees. It is not only the men employed by the Distress Committee who tend to fall to the level of the least efficient man in the gang, but the same contagion affects those who organise and supervis them.

In the last Report of the Distress Committee the city engineer writes:

As a result of work organised by me in your behalf for the distress season of 1908–9, I think it my duty to again direct your attention to the great disorganisation of the regular

work of my department arising from the control of distress operations being thrust upon me. Whilst I have always been and am still willing to do all I can to facilitate the distress operations, I feel I should be lacking in my duty if I failed to direct your attention to the really serious loss falling upon the City by the disorganisation referred to. If any reasonable value is to be obtained from the work carried out under distress conditions, the services of thoroughly good foremen in sufficient numbers to properly supervise and control the men is essential. It stands to reason that I cannot transfer men of this class from the regular operations of the Corporation without interfering therewith. Whilst at an interview with the President of the Local Government Board, that gentleman said there were plenty of good foremen available, this is not my experience. It scarcely matters how good a foreman may be, if he is not accustomed to the system of working in any particular place the value of his services is greatly discounted until he becomes conversant therewith. Norwich is not an easy place in which to find or keep good foremen. My experience has been there is no certainty of retaining the services of men of this sort, as almost invariably they are of enterprising character, and go to places where conditions are more favourable immediately opportunities arise. Whilst it is probable that amongst the large numbers of men for whom I have had to find occupation this season there are many who would be competent foremen, it is impossible in the large masses which have to be employed, and under the conditions generally, to find the suitable men, consequently I am forced back on to the regular staff, and of these I can only take men whose removal from their usual sphere of work is likely to cause the least loss.

I desire to strongly reiterate the opinion I have frequently expressed that no official who is responsible for the proper and economical handling of work should have any responsibility in connection with providing distress work.

After this it is hardly necessary to say more as to the effect of relief work on Norwich. Nothing could be more eloquent.

Except as regards the direct effect of employment on relief works which applies to all classes of applicants, what has been said hitherto has referred more particularly to the class of men who are officially described as labourers. We have still to deal with the men connected with boots and building, but before we come to these it will be convenient to dispose of the 20 per cent of applicants who come from miscellaneous industries. Most of these, so far as industrial character is concerned, are not essentially different from the labourers described above. Going back to the case papers referred to before, this group is represented amongst others by a coal porter of fifty-seven, who has done 'droving and odd jobs, and has seen the inside of the workhouse.' Rather curiously this is the only case paper, out of the hundred of which the writer took notes, in which droving is definitely referred to. This may be accidental, but the explanation given was that the drovers belonged to a rougher and less deserving class than the ordinary type of applicant. In any case there would be a tendency for men to give as their ordinary occupation some more respectable form of work. Other miscellaneous cases are those of a lead glazier, aged thirty-three, who has worked for the same firm off and on for two years, and has done odd jobs besides; a brushmaker, who has lost work through ill-health; a cabinet-maker of fifty-eight, whose last master employed him for only three weeks; and three carters, who state that they have been working 'off and on'. All these men evidently belong to the industrial reserve.

In a rather different category perhaps is a coach painter of thirty-nine, who had been regularly employed for two years up to within a few months of applying to the Committee, at a wage of 22s a week, when he was dismissed because trade was slack. Coach-building has been seriously affected by the introduction of motor-cars, and this man will probably find a difficulty in getting employment in his own trade. He is to some extent a specialist, so that he will find it hard to adapt himself to some other kind of painting, and he is most likely, as the line of least resistance, to fall back on casual labour.

Unskilled work for the Distress Committee would of course encourage this tendency. Even if his trade was likely to revive, a man who has been a long time in one place cannot very readily adjust himself to the needs of a new master. Accordingly, every change in the organisation of industry, the introduction of a new process, a bankruptcy, the arrival of a new master, even the normal expansion and contraction of trade, sets up a downward tendency amongst the men who are affected by them and have in consequence to find new work and new places. The mechanism of industry, that is to say, is more elastic, and yields more readily to change than does labour, which is apparently the least flexible of all the elements of production. The unemployment and distress 179 which results from this lack of mobility in labour is not to be dealt with by a mere process of tiding over, which is all that a Distress Committee can aspire to. What is wanted are measures which will give labour the flexibility and readiness and ability to accept changes which it now so often lacks.

The 40 per cent of applicants to the Norwich Distress Committee who come from the building and boot trades provide a good illustration of this. Some account of these trades has been given in a previous chapter, but it is necessary to refer to them again because they present certain peculiarities in connection with unemployment which will repay discussion. The building trade may be dealt with first. This trade, and constructional work generally in Norwich, are obviously overcrowded, and the only remedy is to reduce the over-supply labour. Since the men cannot move away themselves – and we have seen that they cannot – they must be helped to move. This is not such a simple process as it seems. The powers of the Distress Committee to give assistance in the form of migration and emigration have in practice proved ineffective in face of the practical difficulties which arise. A Distress Committee can only undertake the removal of unemployed persons and their families to another locality if they are satisfied that regular work is to be obtained there, and that the persons for whose removal they are responsible will not become chargeable to the

poor rate. In the absence of a national system of Employment Exchanges, or its equivalent, neither of these conditions can be readily satisfied. In the case of emigration there is a difficulty of a different kind. It is comparatively easy to secure employment for men in the colonies – especially in Canada – provided they are able and willing to work on the land, under new and strange conditions, far away from the town civilisation to which they are accustomed. It is not every man, however, still less every man's wife and family, who possess the qualities which make successful emigrants. In 1905–6 and 1906–7 the Distress Committees emigrated many thousands of families, and amongst these was a party of fifty-three men, women, and children who were sent from Norwich, in February, 1906, to Toronto at a cost of over £400. It is pretty clear that emigration on a scale large enough to have any perceptible effect on the labour market would be enormously costly. In any case, wholesale subsidised emigration through Distress Committees has for the time being broken down. Two years ago trade in Canada met with a severe set-back, and partly owing to this, and partly because of the type of emigrant sent over by the English Distress Committees, measures were taken to restrict the number of new arrivals. In consequence Distress Committees for a time almost completely suspended their activities, but last year again the Norwich Committee sent out 102 persons, and as a contribution towards the cost the Local Government made a grant of £700. Amongst these emigrants was a bricklayer's labourer, a plasterer, and seventeen general labourers, not all of whom, however, would have been connected with building. Since 1905 the Norwich Distress Committee has emigrated exactly 182 persons, of whom less than thirty came from this overcrowded trade.

In the light of these figures it is hardly possible to put forward emigration as an easy solution of the difficulty, valuable as it may be in dealing with individual and carefully selected cases of distress. How necessary selection is may be seen from a case which occurs amongst those noted, in which a single man, a factory labourer of thirty-one, was emigrated in February,

1906, and subsequently came back to Norwich and reapplied to the Distress Committee in January, 1909. Shortly afterwards this man was prosecuted by the police for being drunk and disorderly, which may perhaps explain the reason of his failure.

On account of its cost and the necessity of careful selection, wholesale emigration is therefore put out of court. Even if the fact were otherwise it would not meet all the needs of the case. Building is a trade which proceeds by short periods of extraordinary activity, followed by long periods of depression. If labour which was not wanted during a time of relative inactivity had been got rid of by emigration, when trade revived again the demand would tend to call out a new supply, and the process would have to be repeated. The remedy must be found in a better organisation of demand and supply. If private individuals must have most of their building done in one or two years of a decade, there is no reason why Government and other public bodies should not deliberately reserve their demand for new buildings and new works of construction for the lean years. This would help to create a steady demand for work, and the national system of Labour Exchanges which is now coming into existence would have a similar tendency. About these something more will be said below. It must be remembered that much of the unemployment in the building trade with which the Norwich Distress Committee has to deal is very like the unemployment amongst ordinary casual labourers with which this chapter has been so largely concerned. That is to say, it is the underemployment of a reserve. There is always some demand for the labour of bricklayers, masons, painters, plasterers, excavators, and the various kinds of builders' labourers, but more is wanted at some times than at others. Building, and especially decorating, are seasonal trades. They are busy in spring and early autumn, and slack in winter, and labour has to be kept in readiness to meet this seasonal demand. That is to say, emigration fails for the same reasons that relief work itself fails. It takes away one under-employed man only to see his place taken by another equally under-employed and equally in distress.

The remedy is to be found largely, though not entirely, in the device of the Labour Exchange. If every builder, or other employer of casual labour, engaged his men through an Exchange, it would no longer be necessary for each one to maintain his own reserve. The demand would be concentrated, and the services which arc necessarily performed by casual workmen could be done by a smaller number, since the Exchange would hand men on from one employer to another. This would be possible, of course, only in so far as one employer is slack when another is busy; it would not meet the difficulty created by seasonal trades. But different trades have different seasons. Brickmakers, for instance, are wanted in summer, and gas stokers in winter. A Labour Exchange would make it much easier for men to pass from one trade to another, as to some extent they already do. No doubt, as the result of this higher organisation, a certain amount of the casual and seasonal labour which is now underemployed would become entirely unemployed. But it would be a definite and recognisable surplus with which it would be possible to deal effectively.

Under an Act of last session, a complete system of Exchanges under the control of the Board of Trade is in process of formation for the whole kingdom. These will be in communication with one another, and any unsatisfied demand for labour anywhere will at once become known. This in itself will immensely simplify the task of dispersing any local surplus of labour like that which exists in the Norwich building trade. Then, again, the national system of Labour Exchanges will give workmen and employers the benefit of a recognised market for the hire of labour. For the men from permanent situations, who are often handicapped in looking for work, through sheer lack of knowledge, this would be an enormous advantage. It would at the same time prevent needless anxiety and disappointment: there is nothing so demoralising as the unorganised search for work. Finally, Labour Exchanges, if they succeed, will for the first time bring the labour power of the State within the compass of organisation and direction, and without these no real progress is possible.

But will they succeed? Norwich had for some time a Labour Exchange controlled by the Distress Committee, and this Exchange last year registered 174 persons, and found work from private employers for exactly 119. But this Exchange shared the premises and the staff of the Distress Committee, and received applications from identically the same men – the men of the industrial reserve. These are not the type which an employer wants except when he is hard put to it, and this fact amply accounts for the failure. The new Labour Exchanges will start under better auspices. Still, it is well to admit that success is only possible if employers and workpeople can acquire the entirely new habit of using an Exchange, and everything depends on the development of healthy public opinion on this head. If the facts of employment and unemployment have been correctly represented it will become just as much a part of good citizenship to use the Exchange as to pay rates or obey the magistrates.

Whatever the event, Labour Exchanges will not fail for lack of being talked about. Indeed, there is some danger that too much is being expected of them. Indispensable as they are, they will not do everything. They will make it easier for labour to move about from town to town and from trade to trade; they will help to disperse the stagnant accumulations of under-employed labour in great towns, but they will not make work for those who are thrown out by a reorganisation of the labour market; these will naturally be the least efficient, the weakest in mind and character. Such men need obviously not so much work as the means of fitting themselves for work – the maintenance and training which has been suggested by the Royal Commission on the Poor Law. Nor will they abolish the unemployment which is due to trade cycles, or succeed in completely dovetailing the slack times of one trade with the busy times of another. This kind of unemployment is a normal incident of industrial life, and can be provided against by a scheme of insurance: trade unionists already have such a system in their out-of-work benefit, and this must be extended to other classes of labour. Finally, Labour Exchanges do not

solve the problem of the skilled and semiskilled workman, who has been superseded by changes in character of the demand for labour. This happens not only because processes change, but for all sorts of reasons. The action of a trade union in raising wages, for instance, may force employers to raise their standard of efficiency. This problem, and some others consequent upon it, may be illustrated by the men who come to the Norwich Distress Committee from the boot trade. The introduction of machinery has, as we saw, had the effect of making work for the older men, who cannot readily adapt themselves to factory processes, very irregular and precarious. They are mainly employed by the garret masters, whose business is almost entirely seasonal in character. As the old type of garret master dies out, there is less and less work for them to do, so that they are not only reserve men, but reserve men who are rapidly being superseded. The effect maybe seen in the age distribution of the bootmakers who apply to the Distress Committee. Out of twenty case papers, selected at random, of bootmakers who applied last year to the Committee, nine, or nearly 50 per cent, were men of forty-five and upwards. If the garret masters use the Labour Exchange instead of distributing their work amongst all the men who look to them for employment, the Exchange would naturally send them the best workmen available. Since they are not all equally busy, even in busy times, this would have the effect of concentrating the available employment on the most efficient to the exclusion of the rest. These would become totally unemployed. They have grown up in the boot trade, and they are not suited for any other kind of work, not even for the work of unskilled general labourers. What is to be done with them? This is one problem, but further analysis reveals another, which is more serious still. Out of our twenty cases, whilst nine were over forty-five, seven, or 35 per cent, were under twenty-five. The presence of such a large proportion of young men is probably to be explained in this way. In a modern boot factory, where subdivision of labour is pushed to the utmost, there are many operations requiring little skill, in which it is

usual to employ boys. Heel-making is an example which will occur to everyone. At work of this kind fairly high wages can be earned without special training. But it leads to nothing, and a heel-boy, if he is anxious to improve himself, moves on to another process, involving slightly more skill or allowing more scope for learning higher branches of the trade. Except in the clicking-room, where boys are generally, but not invariably, indentured, this method of progression is the ordinary way of recruiting labour for the trade in Norwich. It is the modern substitute for apprenticeship, and it serves the purpose better perhaps than critics are sometimes willing to allow. On the other hand, it is not a complete system of industrial education. The men, for instance, who work their way up through the lasting team, beginning as the boys who lace uppers together ready for attaching to the inner sole, have only a knowledge of certain processes. They want to supplement this practical but overspecialised and fragmentary workshop training by a comprehensive course in theory and practice at the technical school. Unless they do this they can scarcely hope to make themselves really competent workmen. But work in a boot factory begins at eight in the morning and finishes at seven in the evening, and it is only an exceptionally industrious boy who is prepared to devote still more hours to boot-making in the technical school. Most young operatives are content to rely on good luck and native common sense to enable them to pick up a sufficient knowledge of their trade. If they are rather below the average in quickness and observation, particularly if they have spent too much time in doing merely boy's work, they may find themselves needing a man's wages before they are properly equipped to earn them. This danger is greatest in the more skilled divisions of the trade, especially perhaps in the clicking-room, where a good many boys, indentured and otherwise, seem to pick up a crude knowledge of their trade in an unsystematic kind of way. They learn enough at least to call themselves clickers, and to do rough work in return for low wages. So long as it was open to an employer to pay these low wages this class of man had a fair share of work.

But there is now a recognised minimum wage for each class of operatives, and no employer can be expected to pay 26s a week to men who are only worth 20s or less. The result has been to throw the less competent out of work, and the young men have suffered as much as the old.

Labour Exchanges will scarcely help these men, and relief works, in the ordinary sense, would only leave them less efficient than before. But they are in distress from unemployment and it is the duty of the Distress Committee to assist them if it can. Under the Unemployed Workmen's Act the Distress Committee of a county borough has power to provide or contribute towards any work 'which shall have for its object a purpose of actual and substantial utility.' But all experience goes to prove that work of actual or substantial utility in the ordinary economic sense is not to be got from Distress Committee labour. It always costs more than it is worth. Last spring, for instance, when the relief works were closed some of the men employed on them were transferred to the construction of new sewers which was then in hand. In order to make the work go round the men were divided into two shifts, one working in the morning and the other in the afternoon. It is estimated that the extra cost involved of employing these men was not less than £2,000. The normal characteristics of relief work inevitably asserted themselves. The object was to afford relief, and therefore the work could neither be organised in an ordinary economic way or a proper standard of efficiency maintained by dismissing incompetent men. There is no work of 'actual and substantial utility' which is unskilled in the sense that any man can do it. When men of all trades and of none are set on, as they must be if it is to be relief work, the results must inevitably be ludicrously inadequate compared with work under normal conditions.

This is now so well recognised that the Local Government Board would probably raise no objection to a new interpretation of actual and substantial utility. The idea should be not to produce anything, but simply training and discipline. The man who gets thrown out of work is the less efficient man,

and what is wanted is not merely to save him from complete demoralization by starvation and idleness, but to give him the industrial qualities which he lacks. The Royal Commission on Poor Law have appreciated this so thoroughly that they recommend a whole series of training institutions for different classes of unemployed. Obviously these must be provided by some larger authority than a mere Distress Committee. But in the meantime, as an experiment, why should not the Norwich Distress Committee show the way by setting up a school for the unemployed boot-makers? The expense need not be very large and the help of the technical school could no doubt be enlisted. In lieu of wages a maintenance allowance would be given to students as long as they attended to the satisfaction of the teachers.

The curriculum should not be too easy, and it must be so arranged as to keep students really hard at work for ten, or even twelve, hours every day. Physical culture might well enter into it very largely, and it should not be over technical in the narrow sense. The object is not so much to make the students better boot-makers as to arouse and develop their capacity by every kind of stimulus, moral as well as mental. They would then be fit to take their places in any sort of labour which might be offered to them through the agency of the Labour Exchange, at which they would, of course, be registered.

With this suggestion, the problem of unemployment in Norwich so far as it affects the Distress Committee may be dismissed. An attempt has been made to show that the problem here, as elsewhere, is essentially one of under-employment of a reserve, consisting mainly of unskilled labourers, but including some of the less efficient men from all grades of workpeople. It is true that last year the committee claimed that 48 per cent of their applicants were 'skilled' men, but skill is a difficult thing to estimate, and much depends on the personal idiosyncrasies of those who classify the papers. Wages provide as good an indication of industrial standing as any, and on this basis the number of skilled applicants has probably been put too high. The wage of a skilled workman in Norwich is certainly not

much less than 25s a week. Arranging the weekly rates from one hundred unselected cases so far as they are given, in the form of a median table, the result is as follows:

Lower Quartile	Median	Upper Quartile
14s	18s	22s

This is not quite conclusive, as there may have been an unusually small percentage of skilled men amongst these particular cases; though it is not likely, and we may fairly assume that the really skilled applicants were considerably under 25 per cent.

Under-employment is not to be remedied by doles of relief work, but in the first place by organizing the demand for casual service through a Labour Exchange, which would also facilitate the disposal of surplus labour in the building trade. The Labour Exchanges would also promote the dovetailing of one seasonal trade with another. At the same time it would help all classes of labour to respond more freely to the endless changes of industry which are constantly displacing one type of labour for another. The further question as to what is to be done with the men who will still, for one reason or another, remain out of work has been lightly touched upon, except to insist that any steps which are taken should not be in the nature of 'making work' (though public work may be regulated to meet cyclical fluctuations), but should be frankly educational. Distress Committees have none of the varied powers – including powers of discipline – or the experience and command of money which are necessary for this task, which must therefore devolve on a larger and probably a national authority. In the meantime there is an opportunity of making experiments on a small scale, which progressive committees ought not to overlook.

Boy Labour and Industrial Education

It will be abundantly clear from the last chapter that unemployment is partly a problem of education. Half the difficulties arise because labour is not properly equipped to face the stress and change of industrial life. Labour Exchanges will remove some of the external barriers to the healthy movement of labour, but mobility, after all, depends partly on qualities inherent in the individual himself. A half-trained or untrained man cannot adapt himself easily and rapidly to the endless changes of production under modern conditions. Compare the fate of old sailors with that which befalls so many old army men. For instance, in 1905-6 there were no less than 147 ex-soldiers amongst the Distress Committee's cases, or 10 per cent of the whole number, but the sailors could be counted on the fingers of one hand. The sailor is a trained man, a specialist, and yet a man who can turn his skill to many kinds of work of which he has no previous experience, but a soldier apparently seldom has this kind of ability. He has been drilled too much, and had too little opportunity of meeting unexpected difficulties outside his own resources. It is just this kind of training which a skilled trade provides and it is the training which industrial life requires. A man who has once learned to apply skill and judgment in any kind of work is never likely to be quite at a loss, whatever happens to his

particular trade. His labour will be in demand in more than one market.

It is this which many people really have in mind when they tell you that the remedy for unemployment is a revival of apprenticeship. They have an instinctive and perfectly right feeling that the one thing needful is to set a limit to the enormous number of men without skill or training, who drift into casual labour because they are not fit for anything else. But for most industries, apprenticeship as a method of industrial education belongs to a condition of things which has long since passed away, and where it survives at all, it is no longer the same thing. In the old days it was the custom to give and take a premium with apprentices, and in return masters gave board and lodging and taught the mysteries of their craft. Premiums are still given, it is true, in Norwich, but that is largely, as will appear below, because pious benefactors have left funds to pay for them. Masters no longer board their apprentices, nor, except in a few handicraft shops, do they personally undertake to teach them. That is left to a leading hand in the workshop – who does not get the premium and who, in any case, hardly feels the same responsibility. Sometimes, where piecework rates are paid, the apprentice is handed over to a workman for a definite period to make what use he can of. What he loses during the first part of the time he makes up later on, when the boy becomes accustomed to his work, as the output of the latter is added to his own. This is the custom in some cabinet making shops in Norwich and is said to work well. When the lad has a sufficient grasp of his trade he works for his master, who thus recoups himself more or less for his outlay in wages. In Norwich, cabinet makers' apprentices earn 3s 6d a week, rising by annual instalments of 1s during the first two or three years of indentures, which are usually for five years.

Unless there is some arrangement of this sort, the mere signing of indentures, with or without the payment of a premium, does not necessarily ensure that an apprentice gets any more systematic teaching than any other boy who does odd jobs

about the shop. Indeed, one employer, who was interviewed by the writer, frankly confessed as much. His business is a typical modern one, combining many special processes, and, as he rightly pointed out, it was quite impossible to find among his leading hands anyone who had either time or knowledge to give the boys an insight into the whole trade. If they were clever they picked it up, and any non-indentured boy who did the same had just as good a chance of employment later on. The only privileges which indentures seemed to give in this factory, which is an important one in Norwich, were security of tenure, and if a premium had been paid – and it is only forgone in exceptional cases – a slightly higher rate of wages. It is not that this particular firm take no trouble in the matter; on the contrary, they are keenly interested in their boys, particularly in the direction of encouraging them to attend the technical school, for which they allow time off. It is simply that apprenticeship cannot be fitted in to a modern workshop, where every man and every machine must be used with a single eye to the largest possible output from each unit employed. The employer just referred to takes about twenty apprentices a year, and with each of them he has a premium of £15. As his business is rapidly growing and represents a comparatively new trade in Norwich, he would have to take the boys in any case, in order to ensure a sufficient supply of labour. Under these circumstances, it is hard to see why a premium should be paid at all, except that parents are anxious to put their sons in the trade, and the apprenticeship charities can always be applied to for the money.

Where the old personal relationship between master and apprentice is no longer possible, apprenticeship can rarely be satisfactory. A lad who is working at the bench with skilled workmen will no doubt after a time pick up the practice of his trade by sheer rule of thumb. But this is not trade education in any real sense; it implies no knowledge whatever of underlying principles, and a man so trained will be completely baffled by anything out of the ordinary course. If a capacity to face difficulties is what is meant by an educated workman,

and nothing less is worth having, it is only to be got by some such combination of workshop and technical school as was described in Chapter VI. This is true even of the handicraft trades, into which subdivision and machinery have scarcely entered. It applies still more forcibly to the skilled machine processes, like engineering, or to the great factory industries, like boot making, where the apprentice learns only one part of the whole process. Would it not be better to recognise this, and to divert the very considerable sum which the Norwich charities now spend on premiums into maintenance scholarships for students attending day trade classes at the technical school? The present system of attending evening courses after the fatigue of a day's work cannot surely be regarded as in any way a final or satisfactory arrangement.

The Day Trade School proposed would not, indeed, be concerned with the special technique of particular trades, but rather with the elements of theory and practice which underlie all skilled work. Nor is it suggested that the school should be open all day or every day. As a beginning, perhaps it would be sufficient to have three afternoon sessions each week, from two to six. Attendance would be compulsory for two years from the time a boy leaves his elementary school until he reaches his seventeenth birthday.

The usual amount of an apprenticeship premium in Norwich is £10. This would give a maintenance scholarship of £5 a year for two years. The income from charitable endowments now available for apprenticing is £448 12s 7d, administered by six separate bodies of trustees. In the scheme for amalgamating the city charities under one body of trustees, this amount is increased to an annual sum of £500, which would provide for fifty scholarships. The building and apparatus is already to hand. If Anguish's Boys' Charity, which now spends £600 a year in boarding out orphan boys who would otherwise, it is reasonable to suppose, be supported by the Guardians, were appropriated to the same use, the number of scholarships might be augmented to at least a hundred. The scheme, therefore, involves no financial difficulties.

When not occupied in school the boys would work for their masters as at present. No doubt the broken time would make their services less valuable, and employers would diminish their wages in consequence. At present, indentured apprentices, if no premium has been paid, earn 2s 6d instead of 3s 6d. The wages of pupils attending the Day Trade School would fall to this level, and possibly below it, but whatever the loss, there would be the value of the scholarship to set against it.

The boys should be selected in their last year of attendance at the elementary school by a joint committee of the Education Authority, trustees, and employers, on the nomination of head teachers. In making their nominations the teachers would be guided by a candidate's general suitability for instruction at the Trade School, and by the fact that he would be unable to obtain it without the assistance of a scholarship. This plan would meet two possible and quite reasonable lines of criticism. The boys would be still poor boys, so that there would be no question of shutting out those whom the donors of apprenticeship charities intended to benefit. So far as the payment of a premium ensures higher wages, it is already in an indirect way an allowance for maintenance, and in this respect there would be very little change.

The other objection which may be raised is this: However excellent it may be in theory to combine attendance at a day trade school with ordinary industrial work, it may be urged that the scheme is not possible in practice, because no employer would engage boys whose time was thus partially taken up. In any case, he would not care to give him indentures for nothing. But this line of argument leaves out of sight the fact that those boys would have been carefully selected – at present there is no principle of selection – that they would be specially educated in order to promote their efficiency as workmen, and that attendance would only be obligatory for two years. In their own interests employers would be anxious to employ such boys. Where it is now usual to give indentures, the custom might even be strengthened by the change, and masters would feel more confident of securing apprentices

whose services were worth having. At present boys are often apprenticed in Norwich not so much because they are likely to become skilled artisans, as for the entirely irrelevant reason that they happen to know a trustee who can command the necessary premium. This does little good, and probably does some harm, because it must sometimes result in preventing. the most promising boys from entering a skilled trade at all. There are only a certain number of vacancies to be filled, and it is really important to fill them with the best material available. If this is not done, the average efficiency of skilled labour in Norwich in the future will be to that extent lower than it might have been.

The proposal to abolish charity premiums altogether is thus not so inimical to the system of giving indentures as might appear. Premiums are not essential. In the clicking room, for instance, one of the only two departments of the boot trade in which apprenticeship survives, premiums, as we have seen, are very seldom asked for, and never in the case of the girls who learn machining. These are always given their indentures, and they are bound – generally for two years – without fee of any kind. In other trades, where premiums are generally given, masters are always ready to admit that they do in practice indenture boys without premium if their services are worth securing. Besides, the giving of indentures has some real advantages from the master's point of view. It seems to be a general opinion amongst Norwich employers that the formality of indentures makes a boy feel more interested and responsible in his work, and it also means that they do not lose him directly he begins to be useful. On the boy's side, the benefit is mainly that he cannot leave just when he likes, so that for five years at least he has the opportunity of picking up things which will be useful to him later on. No one who has not actually seen it can easily realise how lightly boys move from job to job, and what a bad effect on their character these constant changes have. It means that they never learn anything and never acquire habits of steady and continuous work. On the other hand, it must be owned that some masters say that

the knowledge that they will not be dismissed makes the boys lazy, and there is, of course, always a danger that the trade to which a boy is apprenticed may be absolutely superseded by some new invention. The latter is certainly a good reason why he should not be asked to pay for the privilege of entering the trade. It is not an argument, however, although it is sometimes brought forward as such, for abolishing indentures altogether. If a boy has learned anything between fourteen and twenty-one, his time has not been wasted; the real problem is that so many boys learn nothing.

We may pretty safely assume that, so far as apprenticeship is a living thing in Norwich, the abolition of charity premiums in the way proposed would leave the system of indentures unaffected. At the same time, it would almost certainly lead to the complete disappearance of the custom of giving premiums. The premiums which are now paid out of private pockets in Norwich must be a very small proportion indeed. Employers who take apprentices because they really want them would find that it was much easier than they thought to do without premium; and the kind of employer who takes apprentices for the sake of 10 or 5 no one wants to encourage.

The survival of a premium system has not been a good thing for Norwich. It has tended to put unnecessary obstacles in the way of Norwich boys who desire to enter certain skilled trades. In printing, plumbing, carpentering, and mason's work, it is a rule of the trade, enforced in the case of printing and carpentering by definite agreements between the masters and the trade union, that all boys should be properly apprenticed. Generally speaking, masters expect a premium, and unless a boy is fortunate enough to get the money from a charity he is absolutely shut out. It may be said that in fact he always does get the money. As is well known, the trustees of apprenticeship charities in Norwich experience considerable difficulty in finding masters at all who are willing to give indentures. But even so, boys may be shut out. It is not everyone who cares to apply for a charity premium, and the boys who do are not always the most suitable. In any case, it is impossible to make

certain that the premium is forthcoming just when it is wanted. Instead of encouraging parents to put their sons to trades, the apprenticeship charities, by bolstering up the premium system, may, in fact, actually lead independent and self-reliant parents to send their boys to other work.

By way of completing what has been said about apprenticeship, it maybe as well to mention the trades to which apprentices mainly go in Norwich. The most important have been already given. From 1901 to 1906 the largest apprenticeship charity in Norwich found premiums for seventy-five boys. In thirty-six instances the premiums amounted to £15, and to £10 in the remaining thirty-nine. In seven cases, or 10 per cent of those dealt with, it was necessary to reapprentice boys, owing to masters failing in one way or another to observe the conditions stipulated for in the indentures, a figure which is certainly not without significance; 16 boys were apprenticed to the printing trade, 12 as carpenters, 9 as plumbers, 5 each to organ building, masonry, and cabinet making, 3 to plasterers, and 2 to watchmakers, whilst the staple trade of Norwich is represented by 5 clickers. The list includes thirteen other miscellaneous trades, which each took one apprentice, viz. boot and shoemaking (hand), grocers' assistant, butchers, chemist, tailoring (retail bespoke), tailor's cutting, book-binding, electrical wiring, iron-moulding, pattern making, school furniture making, cycle making, and range making. To this list may be added from other sources tin-plate manufacture, which takes a fair number of apprentices, electrical engineering, and for girls millinery and dressmaking. The most usual period for which indentures are signed is five years, but six is fairly common, and in printing and organ building it is seven years. In some of these trades premium apprenticeship is comparatively rare. In millinery, for instance, the usual practice in Norwich is for girls to give two years' service, either without wages or for a very small payment. In all, or nearly all of them, as already stated, indentures are sometimes given without premium, either to sons of employees or to lads of exceptional promise,

so that the premium system, even with the charities behind them, is not universal. How far it happens that Norwich born men enter the trade without being indentured at all is more difficult to say. It certainly happens fairly often in the less organised trades, such as tailoring. In any case, tradesmen who come into Norwich – artisans of the building trade, for example – find no difficulty in securing employment even if they have not been formally indentured. The trade unions in their own interests are glad to recognise them as members. The system of indentures and the idea generally accepted in Norwich that indentures involve the payment of a premium by keeping some suitable boys out of the handicraft trades may easily encourage an unnecessary influx of labour. That is to say, whilst apprenticeship in any form can no longer be regarded as a complete system of industrial education in the modern sense, premiums apprenticeship in Norwich presents some features which are definitely undesirable. Further than this the apprenticeship trades, with the one exception of electrical engineering, are all relatively small and unimportant. The clicking department of the boot trade, which might be advanced as an instance of the contrary, is the only department which has hitherto withstood the encroachment of machinery; and even there machines are now being introduced which will severely limit the number of boys whom it will be possible or desirable to apprentice. This is only symptomatic of the whole trend of industry. Every day the old methods which require manual skill and long practice arc being superseded by the progress of mechanical invention. 'Skill', in the old sense, is no longer what is wanted, and any attempt to revive apprenticeship is doomed to failure by that obstinate economic fact. There never was a time when apprenticeship provided for the industrial education of all labour, and the proportion is now so small, even in Norwich, which is old fashioned in such matters, that it might almost be disregarded. In these circumstances there is nothing unreasonable in the suggestion that charitable endowments left for putting poor boys into trades should be diverted to a purpose which would really help

the class whom they were intended to benefit. Apprenticeship nowadays is only for the few, but a trade school would be open to any boy who could profit by it. Some of them, no doubt, would be apprentices in the handicraft trades, but others would come from the much vaster field of industry to which apprenticeship is absolutely inapplicable. Fifty or one hundred and fifty scholarships would not do much towards solving the great problem of how to turn van boys and errand boys and factory boys into efficient reliable workmen, but they would have immense value as a pioneer effort. They would help to set public opinion in the only direction in which a solution can be looked for.

Of this problem, the boy labour problem par excellence, it is now necessary to speak. The subdivision and simplification of processes has made it possible to employ boys and girls in many directions which were formerly reserved for adults. The work is usually of a mechanical, uneducative kind, which leaves no scope for self-improvement during working hours, and the hours are long. For young persons from fourteen to eighteen inclusive, the Factory Acts permit a working day of ten hours, of which five may be in one spell, and this in the most critical years of adolesence. If they are not employed in factories and workshops there is not even this limit. Van boys, errand boys, domestic servants, and many other categories of young workpeople are left entirely unprotected. Van boys especially suffer from long and irregular hours. Fortunately this is not a very large class in Norwich – perhaps there are not more than two hundred of them altogether; but a boy of fourteen who is paid from 5s to 6s a week may have to work from seven in the morning to ten or eleven at night. How is he to grow up an efficient workman under these conditions? Yet van boys in Norwich are a good deal better off than most other classes of boy workers. Many of them work for railways who are said generally to be able to find work for them as men either as carters or in some other capacity. His school mates who go out to work as errand boys or into factories have no such good fortune. In the boot factories they may indeed be

able to work their way up to a man's wage, but a very large proportion of those who go into other factories or start life as errand boys cannot hope to find work as men. As soon as they are too old for a boy's work and a boy's wage they will be discharged, to find themselves not merely without work, but without any training which will fit them for work. It is this want of training and efficiency which seems to lie at the root of the problem; modern industry, in its anxiety to secure cheap labour, destroys the potential efficiency of those who must some day recruit the ranks of adult labour. The unemployed and the unemployable are manufactured in the first stages of life. Individual employers can not perhaps help themselves very much, though they can do something, and they have to bear their share with the rest of the community in the ultimate loss of productive power which this waste involves.

The gravity of this problem in Norwich may be illustrated by a few statistics. The life histories of 128 young men who had applied to the Distress Committee were entered on special forms for an enquiry into boy labour made for the Royal Commission on the Poor Laws, and in 121 cases the history went back to the work which the boy had gone to at fourteen when he left school. Of these, 4 had entered skilled work, or a little over 30 per cent; another 4 became clerks; 29, or 24 per cent, went to low skilled work in factories other than boot factories, which accounted for 23, or 19 per cent; 2 became van boys; 21, or 17.4 per cent, went into other unskilled work, 37, or 30.7 per cent, began life as errand boys; and 1 other went into the Army. We may assume, perhaps, that he came from the Guardian's Home. Out of fifty-two whose histories were recorded to the age of twenty, only 2 were in skilled work, 5 were factory labourers, and no less than 27, or 52 per cent had become casual labourers. These significant facts are expressed in a more graphic way in the chart below. The boys have been classified at each year of age from fourteen to twenty according to the character of their work in eight groups which are represented by the spaces between the lines. The size of the latter changes at each year of age as the boys

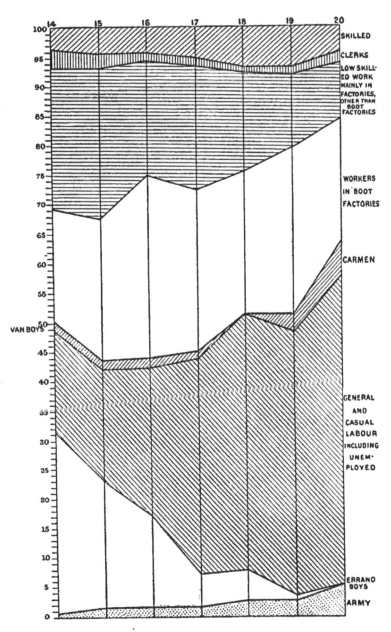

NORWICH BOYS' OCCUPATIONS (128 CASES)

move from one group to another. The space allotted to boys in boot factories is about as large at the age 19-20 as it is at the age 14–15, showing that, on the whole, boys who go into these factories remain in them as men. Errand boys and boys in factories other than boot factories, on the other hand, have evidently gone into casual labour.

It is evident that a Norwich boy who begins his working life as an errand boy, or as one of the many hundreds who do low skilled work in mustard and starch factories, runs a very good chance of becoming an unemployed casual labourer at twenty. Another set of figures extracted from the Census Tables can now be given to show the proportion of boys who enter these and other occupations.

The following table sets out the number and percentage of the 5,827 occupied boys in the age group 10-14 entering certain trades in 1901:

OCCUPATION.	NUMBER.	PERCENTAGE.
National Government (Telegraph boys)	19	1˙66
Law Clerks	14	1˙22
Clerks	73	6˙39
Carmen	16	˙39
Messengers	333	29˙6
Engineering.		
Ironfounders	3	—
Smiths	5	—
Fitters	2	—
Others	2	—
Miscellaneous.		
Wire Tinplate	42	3˙65
Railways	12	˙04
Carpenters	9	˙78
Other Builders	22	1˙92
Furniture	42	3˙65
Printers	46	4˙02
Tailors	13	1˙13
Boots	176	15˙21
Food Workers	67	5˙83
,, Dealers	44	3 85
Shops	7	—
Street sellers	26	2˙26

Adding together the percentages for messengers, National Government, food workers, and street sellers, who are certainly not doing work of any educational value, we get a total of 39 per cent of all occupied boys at ages 10–14. It would be not unsafe to assume that at least half of those who enter the other trades went to unskilled work, which would give a rough total of 70 per cent. This figure may be compared with a table given in the last report on the medical inspection of school children giving the stated destinations of 500 boys about to leave elementary schools. From this it appears that 17 per cent were going into skilled handicraft trades, 6 per cent into retail trade, whilst 7 per cent intended to become clerks. Assuming that 'retail trade' in a good many cases meant jobs as errand boys, this would bring the percentage of boys going into work which offered some prospects very close to the 30 per cent suggested by the Census Tables. Of the remainder it may be noted that 45 per cent had no plans whatever.

The problem which has to be solved is how to prevent industry employing these boys as mere wage-earners without any thought of fitting them for their after careers as grown men. When he leaves school at fourteen a boy has only begun his education, and as things now are he begins to unlearn very often the moment he passes the factory gates. The remedy is certainly not to be looked for to any large extent in a modification of the work they are now required to perform in the sense of making it more skilled and interesting. The whole tendency of progress in industry is against that. Whatever is done must be done from outside. Since the educational element is lacking in their work, educational opportunities must be provided for them in another way. One way which has been suggested is to raise the age of compulsory school attendance from fourteen to fifteen. The last two years of school life might thus be used in definite preparation for industrial life. This plan would have the very great advantage of limiting the amount of juvenile labour available for industrial work. An alternative is compulsory attendance in the daytime at the kind of trade school which has been described above. Sooner

or later both these plans must be adopted as the economic importance of education is more fully realised. Much boy and girl labour is at present parasitic; as wage-earners they do not earn sufficient for their adequate maintenance without other help, so that employers get work done at something less than the real cost. It is to their interest, therefore, to assign as large a share as possible to this cheap adolescent labour, whereas the community is mainly interested in adolescents as future citizens. Nothing can be more expensive than the boy and girl labour which turns potentially good material into bad and inefficient citizens.

This subject is specially important in Norwich where there are so many trades which thrive on the cheap labour of women and children. How important it is may be seen by a very significant fact which is brought out by analysing the age distribution of applicants to the Distress Committee. The Committee, as we have seen, has to deal mainly with the distress of an under-employed industrial reserve. We should therefore expect to find a comparative preponderance of elderly men. The reserve is a residual class which naturally tends to recruit itself from amongst those who have for one reason or another fallen out of regular employment. Of course, amongst the unemployed, as in other groups selected from the general population, there are many young men; the point is that these are fewer compared with the proportion occurring amongst occupied males generally.

In London, for example, for every hundred occupied males between 20 and 24 inclusive there are 87 at ages 25–34, whilst for every hundred unemployed at ages 20-24 there are 131 unemployed at ages 25–34. In Norwich the exact opposite is the case. Whilst for every hundred occupied males at ages 20-24, there are 87 at ages 25–34; for every hundred unemployed at the first group of age there are only 77 in the second, i.e. the Norwich unemployed are younger than the normal population.

These facts are set out in detail for successive age groups in the following table:

LONDON.		NORWICH.	
Occupied Males.	Distress Committees.	Occupied Males.	Distress Committee.
Ages 15–19 90	21	122	40
20–24 100	100	100	100
25–34 87	131	87	77
35–44 65	119	74	52
45–54 45	75	54	44
55–67 25	29	29	25

These figures are curious and may admit of more than one explanation, but they would be fully accounted for if there is in Norwich an exceptionally large class of under-employed reserve men, recruited at an exceptionally early age. As we have seen, both these hypotheses are probably true. The cattle-market, the conditions of retail trade in a large county shopping centre, the abnormal conditions of the building trade, the changes in the boot industry, all make such a thing very probable, and in addition the supplementary earnings of a large number of women workers would help to spread the large demand for casual labour over a very wide circle. It is thus inevitable that boys discharged at seventeen from uneducative factory work should quickly succumb to the fatal attraction of casual labour. They have been fitted for nothing better; all the more so perhaps if they have passed another three years in the army.

It may be said on the other side that blind-alley trades for boys are not directly responsible for the fact that casual labour is wanted in Norwich, and this would, of course, be true. But no attempt to organise casual labour out of existence is likely to meet with success unless steps are taken to limit the supply. Why should an employer use the Labour Exchanges if young men who are not worth regular employment are always knocking at his gate? The character of the supply of labour must always react on the nature of the demand for it. When Norwich boys have the training which makes efficient workmen, capital may be trusted not to overlook the fact that it will pay to employ them in the most effective way – the way of high wages and regular work.

Charities

No attempt to summarise the more important factors which underlie social conditions in Norwich would be complete without some account of its famous charities. These have already been described in detail by investigators for the Royal Commission, and the present chapter is concerned rather with the problem of their ultimate effect on life and labour in the city.

At the outset it is important to put the matter in its right perspective. The charities of Norwich are often supposed to be a good deal more important than they really are. The endowed charities have a total income from all sources of £15,536 18*s* 9*d*, and voluntary charities, including congregational offerings, amount to an annual sum of £11,178. These figures give a total charitable expenditure of £26,708 18*s* 9*d*, which is hardly more than half the legendary £50,000 a year which popular imagination assigns to the endowed charities alone. It may be urged that this total by no means exhausts the possibilities of getting something for nothing in Norwich. There is the £16,800 spent by the Guardians in out-relief, and if this is to be included, the £20,000 distributed from national funds by the Pension Committee of the City Council can hardly be left out. This brings the total revenue available in Norwich for the relief of poverty, in round figures, to £63,500. The ordinary man may certainly be pardoned if he concludes without further analysis that such

an enormous expenditure has some very direct and perceptible influence on general economic conditions. According to his knowledge and temperament he will probably argue either that poor men in Norwich are £63,000 better off than they would be otherwise, or that some part of this money at any rate has gone in subsidising wages, with the result that no one has gained except possibly the employers of cheap labour.

There are reasons for supposing that neither view puts a correct interpretation on the facts. This will be made clear by an examination of the purposes to which the money is actually applied. Before attempting this, however, it maybe useful to make a comparison between the annual sum available for relief and a very conservative estimate of the amount which the employers of Norwich spend every year in wages. In September, 1906, the average weekly earnings of all classes of workpeople, male and female, in the boot trade amounted to 16s. The average for all industries in Norwich would be somewhat less than this, and would not perhaps come to more than 14s weekly. In 1901 the total occupied population numbered 50,500 men and women and children. Deducting professional and business men, including clerks and shopkeepers, the total is reduced to 42,015. On this basis, and making no allowance for the increase of population, the wages bill of Norwich for one year is £1,529,326. This estimate maybe checked by another calculation based on the number and average income of working-class households. In 1901 separate occupiers numbered 25,000. Deducting 12 per cent for the professional, business, and residential class, there remains abalance of 22,000. The average weekly income of a working-class household in Norwich may be estimated at £1. The total wages bill is, therefore, £1,144,000. The truth lies somewhere between these two figures, and may be put at £1,250,000. The whole sum distributed in relief is £63,000 (excluding medical charities), or an addition of 5 per cent to the total income from wages.

Even if this 5 per cent was used to level up wages as the rates were used by the Overseers before 1834, the effects would evidently be so small as to be almost negligible. Whatever may

be wrong and foolish about the administration of relief in Norwich, it is not dangerous in this sense. It is necessary to point this out because the social and economic importance of relief is often exaggerated. No doubt the amount of money involved is only one factor out of many, but it is still a very important one.

We may now proceed to discuss the various ways in which this £63,000 is spent, and to discover if we can what influence, good and bad, may reasonably be attributed to it.

Very nearly a third of it is spent in Old Age Pensions to some 1,300 people over the age of seventy. Even in Norwich, where the average duration of working life is exceptionally prolonged, there must be very many old people over seventy who could not compete in the labour market under any circumstances. Those who do, can hardly affect the demand for able-bodied adult labour. There are few kinds of work in which an employer can in practice put on two or three old men at low wages in the place of one man of average health and strength. If it is outdoor work it costs too much in time and supervision, whilst in the case of a factory, with heavy standing charges, it is essential that every inch of working space should be filled with the most efficient labour procurable. Manufacturers who keep on their old men to that extent penalise themselves. The labour market for those who are past the age of physical activity may therefore be fairly regarded as distinct in itself. Pensioners who want to supplement their income must compete with other old persons, who have not yet reached the pensionable age, or are for some reason disqualified, for the miscellaneous tasks of watching and minding which fall within their capacity. In this limited sphere it is no doubt theoretically possible that wages may be lowered by the advent of pensions. Old women, for instance, who mind babies for mothers working in the factories, are paid 1s per week, the mother providing milk. It is conceivable that a pensioner might be found who was willing to take less. It is not likely, however. Payments of this nature are very largely customary, and the receipt of 5s a week from the Post Office would not be a sufficient inducement for cither side to the contract to desire or consent to a change in rate. Old Age Pensions do not in any case add to the

available supply of labour in the restricted market which requires it, except possibly in a very few instances of people whom they keep out of the workhouse. To counterbalance these, there are others whom pensions just enable to leave off work altogether.

There remains the case of the old age pensioner who is living with wage-earning children. Here there might be a danger of subsidising wages when the pension is a clear addition to family resources, which have previously been sufficient for all purposes, including the maintenance of aged relatives. The wage-earning members of the family, it might be argued, would be willing to accept slightly lower rates because of the extra 5s which was coming in. It is part of the same argument that any national pension scheme, by making it less necessary to provide out of wages for old age, would have a similar tendency. This line of reasoning is really based on the assumption that wages must always fall to a level which will just support the ordinary standard of comfort of the classes affected. It is no doubt generally true that wages cannot fall below this level, but the standard of comfort is not fixed and immutable, and it is affected by many other things besides earnings. The social environment of modern English life, including compulsory education, is continually giving rise to new wants. Medical inspection of school children, to quote an example, will enormously stimulate the desire to consume things which are primarily necessary for ordinary health and cleanliness. The prudence and foresight which induce men to save for the time when they can no longer work is equally likely to make them anxious to spend money on the extra housing, clothing, food, soap, and toothbrushes, which school doctors, teachers, and health visitors assure them are necessary for the well being of their children. When influences like these are brought into the scale, the difficulty authoritatively expressed by Lord Rothschild's Committee on Old Age Pensions, and quoted, apparently with approval, in the Majority Report of the Poor Law Commission, that the benefit of pensions would be transferred to employers of labour, becomes startlingly unreal. Even if it were true that pensions actually did relieve the pressure of wants upon spending power

to a perceptible degree, i.e. raised wages by diminishing the number of things which have to be paid for out of them, the standard of consumption is fully elastic enough to absorb any difference.Concrete evidence in support of this view is afforded by the pension fund at the Carrow Works of Messrs. Colman. Under a scheme established in 1899, this firm give, without contribution, a pension of 8s a week to employees who reach the age of sixty-five. In 1907, there were ninety-seven old employees receiving pensions under this scheme. This firm pay the highest wages for unskilled labour given by any private employers in the city, so that in this case, at least, pensions have not depressed general wages.

The whole argument has now been met, because where there is a clear addition of 5s per week to the income of a family which is, or might be, supporting an aged relative without other help, individual members of it will to that extent be free to satisfy some of the new wants which society is always pressing on them. In any case, the number of families in which pensions have in fact increased the net income must be so small, compared with the whole number of wage earners, that they may be safely neglected. At the present time there are some 1,300 pensioners in Norwich to be distributed amongst 25,000 households. Many of these are, of course, themselves separate householders, though this would not affect the argument so far as they might have been supported by allowances from children. In some cases the pension has probably replaced other outside sources of income, though in Norwich there is reason to suppose that this has not happened in many instances. If it is merely a substitute for precarious earnings, or an allowance from old employers, the pension could hardly have the effect of subsidizing wages. Nor, again, do pensions increase the net income if they just enable children to support parents who would otherwise go on the Poor Law. Under those circumstances they merely replace less adequate out-relief. In Norwich, where earnings are exceptionally low and out-relief lavish, this must be a common case. The writer, for example, came across one instance in which a boot-laster earning 25s per week, with a

wife and five children, had offered a home to his mother-in-law from the county and refrained from applying for out-relief because she was eligible for a pension. The extent to which this occurs is not, however, at present reflected in the statistics of non-able-bodied pauperism, which include paupers over sixty and those receiving medical relief. The average for the last six months is rather higher than for the corresponding period a year ago. These figures are influenced by so many factors, that it may still be true that there are fewer people over sixty-nine in receipt of relief than formerly. On this point it is not possible to obtain exact information.

Sooner or later Old Age Pensions will certainly diminish the number of old people who depend upon the ratepayers. Just before the Act passed into law there were 1,131 persons aged seventy and over in receipt of poor relief. On January 1st, 1905, the last year for which figures are available, out of a total pauperism of 3,795, 1,859, or 49 per cent, were aged sixty years and upwards, being 18.5 per cent of the whole population over sixty. Assuming, as we may, that the age distribution of paupers over sixty remains fairly constant, something like 60 per cent of them have reached the pensionable age. Even if the pauper disqualification were not to be abolished, there would be a considerable number of old people who would somehow manage to exist without help from the Poor Law in order to qualify. In the probable event of the disqualification being abolished, so far as existing paupers are concerned, it may be estimated that something like forty out of every hundred persons over seventy in Norwich will be able to claim pensions. In 1901 there were 4,136 persons aged seventy and over, and now they cannot number less than 4,500. Something like 1,300 of these are already in receipt of pensions, and another 1,100 are being assisted by the Guardians, which brings the total to over 50 per cent of the whole group, but an allowance of at least 10 per cent must be made for those old people who for one reason or another would continue to receive assistance in the workhouse and infirmary. In their case pensions, if paid at all, would go directly in relief of rates.

So far as Old Age Pensions merely replace allowances from the Guardians, they will clearly have much the same kind of influence on general economic conditions. The sternest critics of out-relief have never been able to show that it was likely to demoralise the labour market so long as it was confined to old and non-able-bodied people.

As we have seen, the case against out-relief is social rather than economic in the narrow sense. In this respect at least Old Age Pensions will effect a considerable improvement. They will take the old people out of the contaminated circle of pauperism altogether, and will thus solve the difficulty which now confronts every Board of Guardians, that relief to one member of a family is apt to react badly on the character and independence of all the others. It always tends to bring the weakest elements of society into undesirably close association with one another, and it makes poverty a valuable asset which can be turned to good account by an application to the Board. Pensions are given as a matter of right to all who satisfy the statutory conditions – to the man who is relatively well off as well as to his poorer neighbour – and there is nothing essentially demoralising about the atmosphere of a post office. They degrade no one, and they effectually meet the pitiful case of solitary and respectable old people who prefer to endure any degree of suffering rather than ask for help from the Guardians or a charitable committee.

Nothing which has been said here of course really affects the ultimate question as to whether non-contributory pensions are good things in themselves. All that has been attempted has been to show that they do attain the objects which those who promoted them intended. So far as 5s a week can increase the sum total of human happiness at three score years and ten, they achieve that end, without setting up any of those dangerous economic tendencies which are sometimes attributed to them. Whether this particular need of life should be provided for socially instead of individually – through a contributory system, for example – need hardly be discussed here. It is a question of social principle which Parliament has already settled for us.

This disposes of £20,000 of our £63,000. The £16,800 spent on out-relief has been dealt with in the section on the Poor Law. We need only emphasise the fact in passing that money spent in relief of old age, childhood, sickness, and widowhood, can have only a very indirect influence on the earnings and conditions of independent labour. We now pass on to the £26,700 which comes from Endowed and Voluntary Charity. Of this total, Endowed Charities account for £15,500, from which, however, the very heavy cost of administration has to be deducted.

There are sixty separate bodies of trustees to administer the affairs of 163 charitable foundations. Under such conditions there must inevitably be waste, confusion, and unnecessary duplication of machinery. Nor is this all. Most of the charities are relatively unimportant, and this, added to their multiplicity, effectually prevents the general public from gaining any real knowledge of the way in which these funds arc applied. Instances have been given of charities which have been lost sight of altogether, because all the trustees have died, and no one has troubled to secure the appointment of successors; in other cases trustees have applied funds without reference either to the intention of the founder or to the schemes of the Charity Commissioners. Sometimes there is no real audit of accounts, and valuable deeds and occasionally the property itself disappears because there is no one to enforce proper responsibility for them. In March, 1906, there was a Public Enquiry into the administration of Charitable Endowments in Norwich which was reported in the Press. One typical example of the dangers inseparable from the present chaotic condition of affairs may be quoted here. The facts relate to endowments attached to the Countess of Huntingdon's Charity. When the Commissioners asked to see the deeds referring to a house intended for the residence of the minister of the church, he was told that the original deed conveying the property was missing. 'One of the trustees went to America, and several deeds were missed about that time.' Evidence as to the administration of various small gifts was given by Mr.–, a venerable old gentleman who appeared to be the only surviving trustee. He

said he had been appointed because he was a connecting link between the past and the present. On his accounts being asked for he stated that they were not audited except by themselves, and the Commissioner on examining them could hardly have been surprised to find that the accounts of the almoner and the treasurer did not correspond. Another charity belonging to the same church, which had originally amounted to £420, had, it appeared, been reduced to £167 through the bankruptcy of a former trustee, and the present trustees had lost another £70 over a bad investment. Incidents of this kind afford a powerful argument for some sweeping reform of the whole system.

This applies, of course, more particularly to the smaller charities. The two large and important bodies of trustees who administer the General Municipal Charities and the affairs of the Great Hospital are not likely to fritter away their resources through mere carelessness. Between them, these two bodies administer more than two-thirds of the whole income available from endowed charities. Except for five small apprenticing charities, producing under £100 a year, about half of which is applied in paying premiums for Poor Law boys, the trustees of the Great Hospital are exclusively concerned with the institutional relief of old age. They are eleven in number, of whom four are representative trustees appointed by the City Council, the remaining eight being co-opted, and they administer a total income of £8,800. The trustees of the municipal charities number fifteen, of whom seven are representative and eight co-optive. The various charities for which they are responsible have an aggregate income of £4,223, of which £1,498 is applied in pensions and maintaining almshouses, whilst the greater part of the balance is accounted for by the semi-educational charities of Robert Anguish. Beyond this they control a small annual sum of £87 for apprenticing, another £78 which is lent out in free loans to small tradespeople, and £48 besides is spent in an annual dole of 1,600 loaves of bread and twenty-four pairs of blankets. These are distributed by the trustees by means of tickets.

Apart from these and Anguish's Charity, of which something will be said later, this body of trustees also, it will be seen, is

concerned with the relief of old age. This being so, it is rather hard to see why it should not be possible to amalgamate the two. Their work is so much the same that there seems no sufficient reason why it should be necessary to maintain two separate organisations which must perceptibly increase the cost of administration. When it is added that the personnel of both bodies consists largely of the same people, it is still more difficult to understand why there should be any insuperable obstacle to carrying out this reform. It is certainly to be regretted that the Charity Commissioners in drawing up their scheme for centralising the administration of endowed charities have been obliged to leave out the Great Hospital, which is the largest and most important of them all.

This is no doubt due partly to the ties of old and historic association with which everyone must sympathise. The Great Hospital – it is scarcely indiscreet to assume that the opposition came from this side – is bound up with all that is most ancient and dignified in the history of the city.

Its pensioners themselves, in the calm repose of their surroundings, are not unworthy types of the decay and tranquillity of the capital of East Anglia.

There is, moreover, a certain difference in the methods of these two bodies. The 188 alms people maintained in the Great Hospital are nominated by the trustees in rotation. Their names are afterwards posted on a notice board, and in the absence of any objection they are formally appointed at a meeting of the Board. Except for this, and the filling up of a printed form to prove that applicants fulfil certain conditions of the trust, the appointments are entirely in the hands of individual trustees, who thus enjoy a valuable right of private patronage. No enquiry officer is employed, and trustees are left to make as many or as few enquiries into the character of their nominee as they think proper. The system in practice works well, though out of fifteen cases which were investigated by Messrs. Kay and Toynbee there are perhaps three instances in which the pensioners had fallen into poverty under circumstances which hardly make them specially suitable candidates for exceptional treatment in old age. Since the privilege of maintenance in the

hospital can only be given to a few, it is only just that these should be selected strictly according to merit.

So long as the present method continues it is hardly possible to make sure of this. As things are, everything really turns on whether the individual trustee whose turn it is to nominate happens to know the particular deserving old person who has the best claim for appointment. In former days it is acknowledged that trustees used their right of nomination in favour of personal dependents of their own, or even to forward their interests at election times. 'Promises of nomination used to be very plentiful before an election.' With less scrupulous trustees than the Hospital enjoys at present, these or similar abuses might easily recur. The system is not really defensible, even though it may not work badly in practice, and to judge by the protests which were made, somewhat unreasonably perhaps, at the Public Enquiry in 1906, it does not even now command the complete confidence of the public.

Appointments to Doughty's and Cooke's Hospitals, which are controlled by the Municipal Trustees, are not open to the same criticism. Vacancies are publicly advertised, and applicants must fill up a form, so far not unlike that used by the Great Hospital, showing that they are over sixty-five years of age, of good character, and have resided in Norwich for the past three years at least. In addition, they must not, during that time, have received poor relief, or be able to support themselves. The Great Hospital makes no stipulation in regard to the receipt of relief, and candidates may possess property up to £12 a year; in practice allowances from friendly societies are not counted as property. The chief difference, however, lies in the fact that the Municipal Trustees employ a paid investigating officer, and that elections are made by vote at a meeting of the whole body. It is not therefore in the same sense a matter of nomination and personal favour. On the other hand, the forms on which the investigating officer reports are rather meagre, and it is a pure chance, so far as the information before them goes, as to whether or no the Trustees actually select the most deserving applicants. They could only hope

to do this satisfactorily, if in addition to the present form of application there were fairly elaborate case-papers for each applicant. This would involve a great deal more care and labour, but it is the only way in which there is a reasonable certainty of making a just selection according to merit.

Doughty's Hospital contains accommodation for thirty-two pensioners, including eight old married couples. Eight of the almshouses are occupied by inhabitants of the parish of St John's Sepulchre, in consideration of an annual payment of £150 from a parochial charity; six others belong to the Freemen of the city, and are maintained out of the Town Close Estate. The number of Freemen is diminishing, and the time will ultimately come when it will be difficult for qualified applicants to fill up these vacancies. This would apply also to a number of out-pensioners who receive allowances from this charity.

The Great Hospital and Doughty's Hospital together provide complete and adequate maintenance, including nursing and medical attendance, for some 250 old people, out of a gross annual income of nearly £10,000. In addition, the Municipal Trustees control two other small almshouses, Pye's Hospital and Cooke's Hospital; in the latter, however, they share the right of nomination turn and turn about with the trustees of Trappet's Charity. Cooke's Hospital provides accommodation for eight women, who receive stipends of 23s per month, 26 cwt of coals annually, and nursing attendance. This is under 1s a day, and is rather less than the allowance of 5s 6d a week received by the inmates of Doughty's Hospital, and much less of course than the freeboard and lodging and 1s 6d a week pocket money which is given to the pensioners of the Great Hospital. Pye's Almshouses accommodate six inmates, but the endowment of £6 10s a year is insufficient to meet even the cost of keeping the buildings in repair, and they are maintained by out-relief, help from relatives, and doles. This applies also to the small almshouses attached to the parishes of St George's Colgate and St Andrews, which provide house room for eleven and five old people respectively. The parochial charities of the former provide an admirable

illustration of the way in which charitable endowment may be frittered away to no purpose.

The Endowed Charities of St George's Colgate have a gross yearly income of £89, chiefly in old cottage property. The outgoings, including repairs to the almshouses, are heavy, and reduce the net income to no more than £16 10. The trustees, twelve in number, apply this sum in distributing annually 1 cwt. of coal to 280 poor families. A small dole of this sort cannot be of much use to anyone. It is either not required at all, or it is totally inadequate. At the same time, the eleven old almspeople arc provided with no more than a roof over their heads, and, failing other resources, they have to depend on an allowance of 3s or 3s 6d a week from the Guardians. This is not a sufficient income even without rent to pay, and common sense would seem to suggest that the whole amount brought in by the charities would have been better used in providing the nucleus of an adequate pension. Under these circumstances it would have been possible to dispense with help from the rates altogether. At present neither the Guardians nor the trustees are properly responsible for the wellbeing of these old people, with the result that it is a pure matter of chance whether they have or have not enough to support a decent way of life.4 In the strongest possible contrast to this slovenly and unsatisfactory method of meeting the needs of old age are the charming modern almshouses belonging to the parochial charities of St Swithin, which provide rooms and a weekly allowance of 5s for six inmates.

The Endowed Charities of Norwich, beyond this institutional provision, find the means for paying weekly allowances to a number of old people living in their own homes. The most important charity of this type is that mentioned above, belonging to the City Freemen. An endowment attached to St Mary's Baptist Church, bringing in about £46 a year, is applied in small monthly allowances, and there are two city parishes, St Swithin's and St Peter Mancroft, which have funds available for regular pensions. In both these cases the receipt of poor relief is considered a disqualification, but Blackhead's Charity

in the latter parish only allows from 1s to 2s 6d weekly, which is too small to be of any great value.

Altogether the Endowed Charities of Norwich spend on almshouses an annual sum of £10,158 11s 7d, and on out-pensions £481 12s 7d, making a total of £10,640 5s 2d. If the much larger expenditure on National Old Age Pensions cannot be regarded as influencing the general economic conditions which determine the supply and reward of labour, it is clear that the pension charities are not likely to do so either. When all has been said, they only benefit about three hundred old people. There is this, however, to be urged on the other side, that the charities do not come to anyone as a matter of right, but through the favour and patronage of various bodies of trustees. Many people in Norwich certainly think that they tend to encourage a dependent habit of mind, and so long as they are organised on their present basis it is difficult to disprove this. It is not a healthy thing if it is possible for anyone to feel that the prospect of his getting charitable help in old age depends on his standing well with some of those who fill the office of trustee.

Certain other problems arise in connection with these charities which seem to call for discussion. Some of them arc restricted to particular parishes in the old part of the city, and to that extent make it worth while for possible applicants to come and live in them or to continue living in them. In other cases the endowment does not bring in enough to provide adequate maintenance. Both these difficulties point very forcibly to the advantages which would accrue from a well considered scheme of amalgamation. It would have this great advantage at least, that there would then be no necessity for divided responsibility between trustees and the Board of Guardians. Finally, the introduction of a National System of Pensions has created an entirely new situation. Many of the charities – Doughty's Hospital, for example – expressly stipulate that pensioners should be unable to maintain themselves, but the old person who has reached the age of seventy, if he has no other resources and is not disqualified, has at least 5s a week.

This does not of course mean that the charities have become entirely unnecessary; 5s a week is not in itself an adequate income, though many people in Norwich, living in one room for which they pay 1s or 2s a week, have to subsist on even less. Ten or twelve instances of the kind occur amongst the seventy-five cases investigated for the Royal Commission. These old people who starve on miserable pittances are a powerful factor everywhere in keeping alive a standard of comfort which is dangerously below what is merely necessary for health and decency, and the community has to pay dearly for it. It is a drag on the whole class from which they come. At the same time, 5s a week, supplemented by help from relatives and friends, ought in Norwich to be sufficient for an independent life. The charities should be applied to assisting old people who are past work but have not yet reached the pensionable age, or who have no friends or relatives on whose aid they can rely. Old Age Pensions were not intended to supersede the ordinary duties and responsibilities of children to parents, but to make it really practicable for everyone to assume the burdens which these responsibilities impose. A man no longer has to choose between food and house room for an aged parent and necessaries for his children; 5s a week is enough, when thrown into the general income of the family, to meet any additional expense which the care of old age need involve. And an old couple with 10s between them have sufficient to support a separate household of their own.

Unfortunately there seems a tendency for trustees to regard the pensions – so far as they have any policy at all – merely as a subsidy in aid of their endowment. The trustees of the Great Hospital, and of Doughty's and Cooke's Hospitals, for example, have reduced their allowance so as to enable the almspeople to qualify for National Pensions, and propose with the money thus saved to increase the number borne on the Foundation. There is much to be said for this course, but it hardly goes far enough. In selecting candidates for almshouses it seems reasonable enough to suggest that trustees should endeavour to choose those who either have no relatives or

are too infirm to be cared for in an ordinary working class household. Administered on this principle, the almshouses belonging to Endowed Charities in Norwich ought to prove sufficient for nearly all the old people of decent character in Norwich who need institutional care. The Guardians, or whatever other authority succeeds them, would then have to deal only with those whom it is necessary so keep under rather stricter discipline.

Under these circumstances, the money which is now applicable for out-pensions could be used in providing allowances, according to the needs of each case, for worn out old people who had not yet reached the pensionable age. If the vested interest of the City Freemen in the Town Close Estate must be respected, there is at present only about £230 a year available for use in this way.

We have still, however, to discuss what is done with the balance of the income from endowed charities, from which it should be possible to supplement this sum. Anguish's Boys' Charity and Anguish's Girls' Hospital account between them for an income of £2,432. The Boys' Charily provides maintenance grants for forty boys between five and fourteen years of age, of from 3s to 5s a week, according as they are boarded with a parent (who may also be receiving out-relief) or strangers. Clothes, boots, and medical attendance are also given. The homes are carefully supervised by an officer who is also Master of Doughty's Hospital, and, so far as it is possible to judge, the charity is exceedingly well administered. The only point which calls for comment is the method of nomination, which is exercised by each trustee in rotation. This is particularly undesirable in the case of aboard which consist largely of town councillors. In addition, this foundation provides between £600 and £700 a year for scholarships. These have already been referred to in the section dealing with education. It is perhaps questionable whether it would not be more useful to apply the whole income in this way. There are now two 'boarding-out' authorities in Norwich – Anguish's Trustees (the Trustees of the Municipal Charities) and the

Board of Guardians, dealing in some cases with different children in the same family.

Anguish's Girls' Hospital is an institutional charity. The Board of Education, under whose jurisdiction these charities come, has recently drawn up a new scheme, under which it will become a residential school of housecraft for forty-six girls. The girls are to be appointed between nine and thirteen years of age, and the only condition as to eligibility is that they should be the children of poor inhabitants, except that two are to be selected from the parish of St Stephen. They are to receive their general education up to fourteen in public elementary schools, and in addition systematic training in housecraft from a properly certified teacher in this subject. Children not resident in the school may be admitted to this teaching, so that there is nothing to prevent the school becoming a centre of domestic economy for the whole city. Resident students may remain till they are sixteen, or in exceptional circumstances up to seventeen, and provision is to be made for carrying on their general education after they have left the elementary school. The trustees are to appoint an advisory committee of women, and may spend part of their income in equipping students when they leave for any employment, or in securing additional technical education for them.

The Apprenticeship Charities have been already dealt with, so that it only remains to dispose of the Dole Charities. These are set out below:

Doles not restricted to particular parish areas
In money, £164 9s 10d, distributed by nine bodies of trustees.
In kind, £212 13s 6d, distributed by five bodies of trustees.

Doles restricted to particular parishes
In money, £87 17s 3d, distributed by ten bodies of trustees.
In kind, £1,008 8s 1d, distributed by thirty-seven bodies of trustees.

The gross income from endowed charities applied in doles reaches a total of £1,473 8s 8d, but the net income is, of course,

considerably less. Multifarious as they are, their character as at present administered may be sufficiently illustrated by a few typical examples. We may begin with the non-parochial charities, of which Roberson's Charity is a rather favourable instance. It is administered by six trustees appointed by cooption. It has an income of £97, of which £30 is divided amongst the trustees and given to poor widows in sums of 4s to 10s, and each trustee has the right to apprentice one boy annually, which absorbs the residue of the income. Fawcett's Charity, on the other hand, is administered by one of the partners in a brewing firm, and provides a great coat and 1s in money to each of ten old men who have been weavers. More curious still is Baker's Charity, which is for poor butchers of Ber Street Ward. The two acting trustees meet annually in a public-house and distribute the income of £30 to the butchers of Norwich generally, as there are not enough in Ber Street, in sums of 2s 6d to £2 10s. There are also charities attached to various Nonconformist churches. Those belonging to the Old Meeting may be selected as an example. The pastor and deacons have an income of £48 which they distribute in coals and small weekly gifts, and there is another £8 which the pastor distributes himself. Amongst the cases investigated by Messrs. Kay and Toynbee referred to above, were several belonging to this church, of which one may be quoted here, as it illustrates the curious tendency of trustees to make their endowment as useless as possible by spreading them over too large a number of recipients. The case is that of an old woman of eighty-three, formerly in better circumstances. At the time of investigation she was living in a cottage of three rooms for which she paid 2s 10d per week. She had no children, and was in receipt of 3s 6d a week out-relief. To supplement this she received doles from the chapel to the value of 1s 6d a week and 1 cwt of coals at Christmas. Once a year she had another dole of 2s 6d and a 2d loaf from the parochial charities of St Saviour's. Apparently this solitary old woman had to live on 5s a week, of which more than half went in rent. Another pensioner of the same church, living with a single son and a grandson of

eighteen whose joint earnings came to 27s 6d a week, was receiving a similar 1s 6d. It is difficult to understand why it was not thought better to give both the one and sixpences to the first case. The truth is that no small body of trustees is strong enough to resist the pressure which is brought to bear upon them by everyone who has the shadow of a claim to participate in the benefits of the charity.

This is peculiarly true of parochial charities. As an illustration, the parochial charities of St Benedict may be cited. In 1881 the Charity Commissioners formulated a scheme in order to abolish the old system of indiscriminate doles. Despite this, however, the whole income, amounting to £33 6s 8d, is distributed in tickets to the value of 1s or 1s 6d for groceries, meat, bread, and milk to 600 different old people. Another small charity in the same parish, with an income of £3 13s 4d, is accumulated until it amounts to about £10, when it is applied by the church wardens in doles of bread to every poor family in the parish. In the neighbouring parish of St Giles, to quote another case, the endowed charities are worth about £100 a year. The three trustees of Balliston's Charity, which has an income of £20 a year, distribute the whole amount in doles of 6d worth of bread, 1 cwt of coal or 3 yards of flannel, to about 200 recipients. Goodwin's Charity, which is worth £76 a year, is applied in the same sort of way. After £14 or £15 has been spent in providing twenty old people with a gown or cloak, the residue is expended in indiscriminate doles to every householder in the parish with a rental of £10 or under.

The rector of this parish stated in evidence before the Royal Commission that, as the result of this distribution, every Christmas time there was a regular influx of poor families from other parts of Norwich,[1] who went away again when there was no more to be had. One effect of this winter migration had been to provide tenants for a number of undesirable houses, and to that extent the owners were encouraged to leave their property as it was without attempting to improve it.

It has often been alleged that the Dole Charities, which belong almost exclusively to the old city parishes, have had

the effect of raising rents for cottage property in the central area. This is perhaps doubtful. The parish of St Giles is rather exceptional in this respect. In many parishes some effort is made to see that the people who receive the doles have lived in the parish for a definite time – generally one or two years. On the other hand, there is a general concensus of opinion that they do encourage people to remain in the city parishes who would otherwise move out of them, and to that extent they may help to tenant houses in courts and yards which would otherwise remain unlet and would in course of time be pulled down. But the doles are only one influence among many which tend to keep people in the courts and yards. They arc convenient for certain classes of labour; drovers, for instance, congregate in Ber Street area. The people are accustomed to living near the busy thoroughfare, and dislike the quiet and respectability of the suburban streets. The Guardians encourage this by their want of policy in administering out-relief. The investigators for the Royal Commission drew up a table in which they showed that city parishes, in which there had been no recent building, with a population of 29,180, or 26 per cent of the whole population, received 38 per cent of the whole out-relief given by the Guardians, or £5,385 out of a total of £14,118. In the same parishes £1,480 was distributed from endowed parochial charities and another f463 from church offerings, making a total of nearly £2,000. £5,000 of out-relief given without any condition as to the kind of houses in which recipients live is bound to concentrate poverty in areas of bad and therefore cheap housing. The charities merely strengthen this tendency.

Before attempting to summarise the other influences on social life which may be attributed to this type of charity in Norwich, it will be convenient to say. Something about Voluntary Charities. Probably the most sinister thing about the Dole Charities is that they seem to have infected the character of all other charity in the city. The ascertained income of churches and chapels in Norwich for sick and poor funds from voluntary sources amounted in 1905 to £1,313. Except in three or four parishes which have relief committees

and endeavour to meet cases of distress in an adequate and thoughtful way, the great bulk of this sum is spent in tickets for relief in kind in very small amounts. In addition, there are two societies, the Sick Poor Society and the District Visiting Society, which endeavour to relieve distress on a similar plan. In 1907-8 the Sick Poor Society had an income of £1,068 4s 3d, and spent in relief £701 10s 1d. The relief is distributed by visitors attached to the Society, who are also in many cases district visitors in their parishes. Relief is given at the rate of 1s a week for six weeks, and may then be renewed for another six weeks, but not for longer without special sanction from the Committee. The benefits are confined to sick people, and are very largely used in winter time to supplement the out-relief allowed to old people by the Board of Guardians. The Society also 'gives milk in maternity cases, and 184 poor mothers were assisted in this way last year on the recommendation of the medical officer of health. This form of help is probably very much more useful than the weekly shillings. In 1906 these doles were given to nearly 2,000 families.

The District Visiting Society has an elaborate constitution and works nominally through sixteen local committees, but in essence it is an organisation on its relief side – it has other activities which are referred to below – for the distribution of sixpenny tickets to the value, in 1907, of £200, and as a rule not more than two tickets a week are given to one family. The almoners are usually workers connected with various churches including the clergy. Last year the Society undertook the distribution of soup to the 'Unemployed'. The Society is composed of all denominations, and in each district tickets are issued for distribution to a Churchman and a Nonconformist, and as they do not always consult one another, there must be a good deal of overlapping.

It is safe to say that all the money spent in doles of one form and another in Norwich, amounting to something like £3,600 annually, achieves absolutely no permanent good whatever. It merely endows poverty, it does not cure it. It is worth something to be poor in Norwich. There is always a visit to be looked for

from the 1s lady or the 6d parson, and beyond them is a whole army of trustees with coal tickets and meat tickets, blankets, coats, and loaves of bread and delectable half-crowns. It may be pleaded in condonation that a good many of these things go to old people who are already pauperised by receiving out-relief. But it is just here that the system does such cruel harm. The Guardians give inadequate relief in the hope that something more will be given by charity. There is no co-operation between the Poor Law and those responsible for the administration of charity – indeed, the Guardians are said to refuse to disclose the names of those on relief, so that there is no certainty that the inadequate assistance given by both goes to the same people. This only happened sometimes, and the result even then, as we have seen in the cases quoted above, is often only sufficient to make semi-starvation a little more bearable. An occasional dole is no substitute for an adequate regular allowance. At the same time, it may easily happen that the doles actually increase pauperism by encouraging habits of dependence and breaking down self-respect. So far as the old people are concerned, it would be an obvious step forward to concentrate the help which is now given on fewer individuals and to assist them in a more constructive way. Much more could be spent on nursing, or, as we have suggested, in allowances to those who are past work but have not yet qualified for pensions.

But the doles do not go exclusively to old people, or to widows with young children. The sixpenny tickets especially go very often to the families of the unemployed casual labourers. In some parishes about half the cases relieved appear to be of this type. In the long run this must simply add to the problem of under-employment with which the city has to deal. Even without this the effects are bad enough. As one clergyman put it, the people are always thinking and talking about what they may hope to get out of the parish, or, as a working man trustee expressed it, 'they will wear out a shilling's worth of boot-leather to get a sixpenny ticket.'

On every ground, therefore, the system cries out for reform. The scheme of the Charity Commissioners now before

Parliament will meet the situation as regards endowed parochial charities. It provides for the amalgamation under one body of trustees of 140 charitable foundations. These do not include the Great Hospital or charities belonging to Nonconformist churches, or specifically educational charities such as Anguish's and Norman's. Even endowments belonging to extinct congregations like the Dutch and French Church Charities have been left as they are. In the case of the Dutch Church, which has an income available for the poor of about £35 a year, only £8 is at present being applied, so that some arrangement will have to be made in the near future. The most reasonable plan would certainly be to pool the charities belonging to these extinct churches with the rest, reserving a preference for applicants of Dutch or French descent. The new body of trustees is to be composed of twenty-four members, consisting of the mayor for the time being, fifteen representative trustees, and eight co-optative trustees. The net income, after meeting all expenses of management, is to be applied in the following way:

1 An almshouse branch with a net income of £1,600.
2 An apprenticeship branch with a net income of £500.
3 A pension branch with a net income of £600.
4 A poors branch to be provided for out of the residue of the income accruing from the endowments.

No almsperson or pensioner is to be appointed without previous public notice, and vacancies must be filled up at a special meeting of the trustees; and it is specially laid down that full investigation must be made into the character and circumstances of applicants, who are disqualified if they have received parish relief other than medical relief in the previous twelve months. The poors branch is to form a fund, out of which the trustees may pay for practically anything which will be of benefit to poor people either generally or in particular cases. Thus they may contribute towards the cost of providing nurses and medical necessaries or to meet the expense of convalescing poor patients, or in temporary relief, by way of loan or otherwise,

'in case of unexpected loss or sudden destitution.' They may subscribe to hospitals or similar institutions, or to any provident club for supplying coal and clothing, or any duly registered friendly society. They may not, however, assume permanent responsibility for the upkeep of an institution.

This scheme will effectually abolish the bad old system of parish doles, and all the begging, cringing, and imposture which they inevitably bring with them. Though, whether under the s 'poors branch' of the United Charities a new system of doles may not grow up must depend on the wisdom or unwisdom of the new trustees and the growth of public opinion. Parliament can do no more than provide the necessary machinery for reform. At the worst it will do away with the fatal results which come from the association of the doles with the ministration of religion in the old city parishes.

As one clergyman observed, at a meeting of trustees held to consider these proposals, 'Charities' are 'the greatest curse to every parish which has them'; and his remarks were rather piquantly illustrated by another gentleman on the same occasion, who protested against the proposed changes on the ground that 'they ought not to set the working classes and the distressed more against religion than they were to-day.' This strange idea that religion is an unpalatable medicine which people can be bribed into swallowing is far too common everywhere. One who would justly be described as 'an active Christian worker' representing a large undenominational mission in a poor district of Norwich told the writer that he gave away 200 or 300 bread and soup tickets every month 'because the people would not be influenced by him unless he did.' The Christianity which propagates itself by these means is in danger of alienating not merely 'the working classes and the distressed,' but all honest men.

For this reason, if for no other, it is necessary to set the voluntary as well as the endowed charities of Norwich on a healthier footing. Before suggesting a way in which this might be done, it will be useful to review the field which is now covered by voluntary charities. The important organisations which distribute tickets and trifling sums in cash have been

already mentioned. They include, of course, much of the charity dispensed by parish clergy. It is difficult to understand why this type of charity has survived so long in Norwich. Is it because there is still a lingering idea that to give a little, particularly if that little takes the form of a promise to pay for goods delivered to bearer, somehow avoids the difficulties which beset all charity? Nothing could be more fatal. If a man is to be helped at all, it is simply an outrage on his self-respect to give him a sixpenny ticket; if he is not to be trusted to use money well, a ticket is no substitute for the discipline and mental and moral stimuli which his case evidently needs. These are only to be given at the cost of thought and knowledge and real self-sacrifice. There is no charity which does not involve spiritual as well as monetary service. Without that even the most elaborate organisation defeats itself.

But its tickets are not the only way in which charity in Norwich has grown out of date. There is a soup society, a coal society, and a bedding society, which all aim at providing the poor with the necessaries of life at something below the normal cost. These things represent an expenditure of time and energy in attempting to evade the ordinary laws of supply and demand of rather doubtful utility. The same ends would be served for all reason able purposes by encouraging people to join the Co-operative Stores. The soup tickets are particularly objectionable. They entitle recipients to two quarts of soup for a penny, and are largely used by a sisterhood working in some of the city parishes, Because a small payment is involved they have a deceptive air of not pauperising, whereas they are a peculiarly dangerous kind of dole. Families who grow too familiar with the soup kitchen will soon discover what a valuable thing it is to be poor. Unless they are very carefully safeguarded, and there is not much evidence to show that they are, cheap coal, cheap clothes, and cheap soup may demoralise whole sections of the population because they make life possible on too low a scale. Like the subsidised lodging-houses of Whitechapel, where a man can live in luxury for 6s a week, they may end by creating a class which cannot live without them.

This is not, perhaps, a serious danger in Norwich. The whole expenditure in donations and subscriptions for these purposes is under £400 a year.

To some extent the coal and bedding societies may also be regarded as a form of subsidised thrift. They give a bonus for saving. This is also one of the activities of the District Visiting Society. Last year thirty-five visitors collected £1,745, which was all returned at the end of the year with an additional £35 in premiums. In the same period thirty-seven other people sold 2,177 cheap blankets for £653 2s. The blankets are bought wholesale, and in this way the Society is able to sell a 7s 6d blanket for 6s. This is in addition to the operations of the bedding society already referred to. No doubt it is a good thing to encourage thrift, and the visitors deserve credit for their work, but there is a danger even here. People who save because the lady comes to their door every week for the money, and who get a premium and a cheap blanket at the end of it, may lose the power of regulating their expenditure without this help. In any case, it is rather a pity that the money must be taken out at the end of the year whatever the circumstances are. It makes the District Visiting Society on its thrift side a form of dividing society with an element of patronage thrown in. This is all the more to be regretted, because there are so many other forms of visitation in connection with children and school management and health which are comparatively neglected in Norwich.

There remain the various organisations for meeting special forms of distress. It is here that a fissiparous tendency which is characteristic of all charitable effort in Norwich becomes specially noticeable. There are many small organisations which seem to rival and weaken instead of strengthening one another. There is a Police Court Mission and a Discharged Prisoners' Aid Society which do not appear to co-operate in any systematic way. There are three separate Rescue Homes, at least two of which admit different classes of girls who certainly ought not to mix with one another. There is also a committee of ladies to assist girls in the workhouse, known as the Poor Laws Girls' Aid Association.

Yet another association, the Norfolk and Norwich Association for the Care of Girls, maintains the St George's Home as a residential club for working girls in connection with a girls' club. The club has room for thirty boarders, and the weekly payment is for lodging 1s 3d, and for board 3s 6d. This is not sufficient to cover the expenses, and the deficiency is made good by donations and subscriptions. A girl living at home in Norwich pays 5s a week to her mother, which is more than she would have to pay at the club. Knowledge of this fact must have a tendency to lower the amount contributed to the family income by wage-earning girls living with their parents, which is probably too low already. It is also alleged that employers excuse themselves from paying more than 8s a week on the ground that a girl can live well at the club for 5s On the other hand, the club is intended for girls with unsatisfactory homes, who may be beneath the average in earning capacity, and if this object is kept clearly in view and made a condition of residence, there could be little objection to it on economic grounds.

A Labour Home maintained by the Church Army is open to criticism from a rather different point of view. The 'labour' provided is chopping firewood, which is afterwards sold for 3s 6d a hundred bundles. This is not work of a very inspiring or educational character, and there is a danger of unfair competition with independent labour. There was an adverse balance on the year's working of £195 to be made up from charitable sources. During the year ending 30th September, 1909, forty-two men passed through the Home, of whom ten obtained situations. What happened to the others is set out below:

Emigrated, 1.

Joined Navy, 1.

Restored to friends, 5.

Went into hospital, 2.

Left to seek work, 17. (It is known that some of these got work.)

Left, time expired, 2.

Dismissed, 4.

Until it becomes possible to provide compulsory detention colonies for hopeless failures it is perhaps unfair to judge the success of these homes by the proportion of men who leave them to become independent labourers. A better test is the general atmosphere of the house, and in any case 25 per cent of men put out into situations is a creditable number considering the material which has to be dealt with. A much more disputable feature in the activities of this Home is the practice of making work for unemployed fathers of families who are recommended by the parochial clergy and others. Last year 195 men were provided with 2,067 days' work. It is claimed that the labour yard assisted many men at a critical time, and helped them along until they were eligible for employment by the Distress Committee – it was, in fact, another dole of relief work, and must ultimately have precisely similar results. The best that can be said of it is that it may have kept a few respectable men from the degradation of the workhouse or the Guardians' wood yard. So long as the Poor Law is the only alternative, charities of this type have unanswerable arguments to put forward in reply to their critics.

The only other institutional charities which need detain us are the Asylum and School for the Indigent Blind and the Orphans' Home. Both of these take a majority of their inmates from outside Norwich, and in many cases they are paid for by Boards of Guardians, including the Norwich Board. The Asylum for the Blind teaches a variety of trades suitable for its inmates, and provides employment for those who continue to live in Norwich after being taught. The average earnings of the out-workers, of whom there were nine at the time of Messrs. Kay and Toynbee's investigation, is 6s a week, and as they can earn by begging as much as 18s a week, it is difficult to persuade them to go into the Asylum. There are few problems which demand more careful and sympathetic handling than this of finding occupation for the blind. It is hardly possible in any case to make them self-supporting, and the trading account of the Asylum shows a loss of £278. Its total income amounted to £2,946. This amount, plus £340 received by the

Orphans' Home, ought, strictly speaking, to be deducted from the total expenditure of voluntary charities in Norwich, as they are mainly not local charities at all.

Before going on to suggest a plan by which these numerous voluntary charities may be brought into some organic connection with one another, there are four societies which provide temporary assistance in money which it would be well to mention here. The Benevolent Association for Decayed Tradesmen expend about £350 a year on this purpose, and three military charities – the Royal Norfolk Veterans' Association and the Norfolk Patriotic Association and the Soldiers' and Sailors' Help Society – spend another £260 or £270. It seems rather unnecessary to have three different organisations to dispense such a small amount. It is another instance of the tendency to multiply agencies which it is important to arrest if the large sums collected for voluntary charity in Norwich are to be laid out to the best advantage.

At present there is no means whatever, either of ensuring co-operation between voluntary and endowed charities and the Poor Law, or of guarding against overlapping. If a man prefers not to earn his living in Norwich, there is at present absolutely no reason why he should not maintain himself on charity for the remainder of his days. It may be useful to give one or two instances which have come under the writer's notice. The first is that of a married man and his wife, both in the prime of life, with three children under ten years of age. This family lived in Norwich for sixteen months, flitting from one furnished room to another. The man occasionally took out a barrel-organ, but their chief resource was the wife's begging. From various charities and from private donors she was able to get enough assistance to keep them from starvation. Their children were neglected, and the case was taken up by the NSPCC, who were unable to take effective action, as charity enabled the parents to keep away from the Poor Law and the police.

In another case, a young couple with a child two years old, also suffering from neglect, lived on the sale of clothes given by charitable individuals and societies and by small gifts of money.

In both these cases it is quite clear that charity was simply enabling people of weak character to live under conditions fatal to themselves and still worse for their children. Yet in both instances the circumstances were perfectly well known to the agency which was dealing with their children. If there had been a common centre of information, to which all those who were applied to for help could have gone, it might have been possible to devise some common plan of action which would anyhow have protected the children. Lacking this, isolated individual charity was simply perpetuating evil.

But this is not the only difficulty which arises when there is no recognised machinery for securing co-operation. Not only is money wasted, but valuable time as well. For instance, in one case recently it was discovered that the same family was being visited at the same time by five different people. The visitor from the Invalid Children's Association went to see a crippled child, a club manager was calling on a sick girl, the health visitor was inspecting the baby, a district visitor was calling to watch over the spiritual welfare of this much-visited family, and the representative of the Parochial Relief Committee came to enquire into the circumstances of the father, who was out of work. A little organisation would have enabled one visitor to have discharged at any rate most of the functions exercised by the other four. There is a real danger of injuring self-respect and self-reliance by over visitation, and at the same time of leaving much valuable work undone for lack of people to do it.

A remedy for this wasteful and injurious state of anarchy is to be found in a system of registration. If every family which was being visited and every case applying for or receiving assistance were notified to a common registrar, it would be possible to avoid the overlapping and misdirection of charitable effort which is at present unavoidable. The proposal is not ideal or Utopian: it is already in practical operation in other places, notably in Hampstead and in Chelsea. Registration implies nothing more than taking a very little extra trouble; it involves no interference with the form in which individuals or societies choose to give assistance, and it can be regarded as absolutely

confidential. At Hampstead no one except the Registrar ever has access to the register, which is in the form of a card index, and is kept under lock and key. All that happens is that the Registrar, on being notified of a case, informs his correspondent whether that particular individual or his family are, or have previously been, in receipt of relief from some other quarter. It is then left to the parties concerned to co-operate or not as they prefer. As a matter of fact, they usually prefer to take action in common, and what would otherwise be a useless dole becomes, by combination of money and knowledge from many sources, adequate and constructive help.

But registration can only be successful if it is undertaken by someone who can inspire general confidence as the representative of a neutral and impartial body. The Charity Organisation Society, which is admirably equipped for this task, can hardly be said to occupy a position of neutrality. In Norwich, as in other places, it has become identified with a particular body of social doctrine which is not equally acceptable to all shades of opinion. No review of social activities in Norwich, however, would be complete which left out of account the important work which this society carries on. It is the only school of training in Norwich where those who are anxious to serve their less fortunate fellow-citizens can equip themselves with knowledge and experience in a practical and sympathetic way. No one who has worked for six months with the society will be content to deal with distress in any way which is not thoroughly adequate and painstaking. At the lowest they will have learnt the value of persistent hard work. And laying all controversy aside, the society is a centre of enthusiasm and enquiry into social problems which has won for itself a distinct place in the life of the city. As a relief agency the C.O.S. must, injustice, be regarded as mainly a bureau of information, and last year it sent out over 400 reports on cases referred to it for investigation; in addition, assistance was organised for 160 cases at a cost of £250. Outlay on other purposes amounted to £280. The society, therefore, is serving a definitely useful purpose, and no one would wish to see it superseded. At the same time, it must be confessed that

this work needs supplementing. It provides no common ground on which men of diverse views can meet on equal terms, and without this it is hopeless to look for co-operation. Until people know and respect one another they are not likely to discover on how many things they can agree.

What is wanted is a Representative Social Council to which all the social agencies of Norwich might send their nominees. Churches and chapels, endowed and voluntary charities, the Public Health Committee, the Education Committee, the Distress Committee, and the Board of Guardians, should all be invited to elect representatives. It is particularly important that the official agencies for relief should be brought into contact with the others. There are many ways in which official action is strengthened by association with voluntary enterprise: it lessens the danger of divided responsibility, and it makes for healthy citizenship. Local government, like any other kind of government, is largely concerned with the education of opinion, and it is easier to convert people by giving them work to do than in any other way. It would be one of the functions of the Council by discussion and experiment to discover ways in which the City Government mightutilise unpaid service, particularly in connection with school children and public health. Its second function would be to organise and superintend the work of registration. Finally, and more important than all, it would be a meeting place where all sorts of questions of practical importance to the city could be freely discussed. Out of this would grow the strength which conies of mutual knowledge and forbearance, and the solid progress which is founded on the greatest common measure of agreement.

With this suggestion this chapter may be brought to a close. We have still to complete our survey with a review of medical charities, but these may be conveniently made the subject of a chapter to themselves.

Provision for the Sick

This chapter will not be exclusively concerned with medical and nursing charities; the object is rather to bring into one view the various ways in which the citizens of Norwich provide for themselves in the event of sickness.

The most important fact may be stated at the outset. There are in Norwich fifty medical men in active practice. Assuming, as we may, that each of them has a professional income on the average of not less than £300 a year, Norwich spends on mere doctoring something like £15,000 annually. This sum, of course, does not measure the whole cost of sickness in out-of-pocket expenses. When nursing and other incidentals have been added in the total will be doubled or trebled. It will be well within the mark if the whole amount is set down at not less than £40,000. This figure is an estimate merely, it has no claim to statistical accuracy, but it will serve to bring out the relative importance of charitable and rate-aided provision against sickness. The expenditure from charitable sources on relief of sickness, including hospitals, dispensaries, and nursing charities, amounted last year to approximately £12,113. This sum is made up as shown in the table below:

Name of Institution.	Cost of Maintenance.	
Eye Hospital	£1009 14 8	
Jenny Lind Infirmary . .	£2376 5 0	
Norfolk and Norwich Hospital[1]	£6820 11 5	
Fletcher Convalescent Home .	£400 0 0	
		£10,606 11 1
Norwich Dispensary . .	£258 0 0	
Norwich Maternity Charity .	£406 19 0	
Norwich District Nursing Association	£751 15 1	
		£1416 14 1
Total . .		£12,023 5 2

These figures do not include the Provident Funds of the Dispensary and Maternity Charities. To this total of £12,000 must be added the cost of treatment paid for out of the rates.

The Town Council spent on its isolation or small-pox hospitals, excluding expenditure on the City Asylum, £6,421 1s 70d; on health visiting, £300; on milk and anti-toxin, £109; total, £6,830. The Guardians publish no detailed account of their expenditure, so that it is only possible to estimate how much is spent by them on medical relief. If we take an arbitrary sum of £5,000, which is approximately half the total expenditure on indoor relief, the margin of error is not likely to be very great. This would include salaries of medical officers, drugs, medical extras and nourishments, and maintenance of infirmary.

This brings the total expenditure from rates to £11,830. Adding this to the £12,000 found by charity, the total collective expenditure on relief of sickness in Norwich comes to £23,430.

The £10,000 spent on hospitals is applied mainly in three ways. In the first place, the hospitals provide highly skilled treatment, especially operative treatment, for patients who cannot provide this for themselves in their own homes in the event of grave illness. This is not entirely a question of income. There are many men relatively well-to-do who are yet unable to make suitable arrangements at home for a serious

operation. If they cannot afford the expense of a nursing home they must have recourse to a hospital. Last year the Norfolk and Norwich Hospital received on behalf of patients donations amounting to £110, and in forty instances the sum was £1 and upwards. In the second place, hospitals provide for accidents and casualties. Of 2,151 in-patients admitted to the Norfolk and Norwich Hospital during the year ending 31st December, 1908, 1,279, or more than half, were of this character, and in the out-patients' department accidents and casualties accounted for 6,128 attendances out of 11,237. Even at the Eye Hospital there were 151 casualties treated during the year.

Finally, the hospitals through their out-patients' departments give the poor man an opportunity of securing medical treatment when either he cannot afford a private doctor, through a friendly society or otherwise, or his disease needs the attention of a specialist. In the former case, however, if the patient is already destitute and is in receipt of poor relief, it is usual to refer him to the Poor Law doctor.

The hospital, that is to say, is not a substitute or an alternative to the medical treatment paid for by the Board of Guardians. On the other hand, the medical officers of the Guardians can always refer a patient to the hospital if the case is exceptionally difficult or calls for special treatment.

In actual administration this separation of function between hospital, Poor Law, and private practitioner is only realised, at all completely, by the one hospital in Norwich which has as yet appointed ah almoner. Neither the Jenny Lind Infirmary nor the Eye Hospital has taken this step, and it is possible that both to some extent undertake work which is not properly theirs. At the out-patients' department of the former in Pottergate Street 2,557 children were treated last year, so that the matter is of some importance. The number of patients whom it is possible to treat efficiently in this way is strictly limited, and it is hardly reassuring to find that the number increased last year by little short of 500. In the interests of the patients it is worth while making sure that the hospital is not undertaking work

which could be done under less pressure by the Poor Law or by private practitioners.

The Eye Hospital need scarcely be referred to in detail, as it is to be amalgamated with the Norfolk and Norwich Hospital as soon as money has been raised to complete the necessary buildings. This will effect a very desirable unification. Norwich is too small a city to support a number of special hospitals.

By way of illustrating the way in which hospitals at present stand to other branches of medical service, some excerpts may be usefully made from the Almoner's Report at the Norfolk and Norwich Hospital.

The gross number of separate individuals who applied for treatment to the out-patients' department was 3,120, or an average of sixty new patients every week, the vast majority of whom were city patients. The whole of this number were seen at least once by a member of the medical staff. In about six cases out of every hundred out-patient treatment was not continued. These patients, who number 204, were discharged or referred to other sources of treatment as follows:

Needed no further treatment	35
Referred to other departments of hospital	62
Eye Hospital	4
The Jenny Lind Infirmary	4
Club doctors	33
Poor Law doctors	12
Army doctor	1
Their usual medical advisers	21
Invalid Children's Aid Association	1
Kelling Sanatorium	5
Medical Officer of Health	1
Quay Side School for Deficient Children	1
Guardians' Homes	1
The Poor Law Infirmary	1
Parochial help	1
Came for advice only, but registered as out-patients	14
Withdrew	8

It is clear from this table that the almoner materially assists the work of the department by keeping it in touch with other sources of aid, medical and otherwise. The Report goes on to say: 'In cases where it seems possible for Patients to make provision for Medical Aid, either by contract or private attendance, their circumstances and means of maintenance are reported by the Almoner to the Medical Officer who is treating them, the second time they attend the Hospital, and all further responsibility in checking the attendance of unsuitable cases rests with him.' There is therefore no danger that cases in need of urgent treatment may be turned away merely because they have no claim to gratuitous services.

Cases which are considered suitable for hospital treatment arc further defined as follows:

Suitable cases are :
1. Those sent by doctors for special advice or treatment.
2. Casesin whichthe patientis, andalwayshasbeen, ineligible for a club, and cannot afford to pay for private attendance, but is able to maintain himself, or be maintained without resort to the Poor Law.

Unsuitable cases are :
1. Patients who have made satisfactory provision for contract attendance, unless some special advice or treatment is required which can only be given at the hospital.
2. Patients whodepend on Poor Law relief, but with the same exception.
3. Patients who can afford to pay for private attendance.
4. Patients who could provide for contract attendance, but havefailed to do so through neglect.

From this it is evident that the aim of the hospital is to meet a need which is quite exceptional, either from a medical point of view, or more rarely from the point of view of the economic situation of the patient. No alternative policy can be reasonably pursued by any institution which depends on

the gratuitous services of an honorary medical staff. This must always be a decisive factor in determining the function which can be assigned to voluntary hospitals. On the other hand, it is also true that positions on the staff of a great hospital confer peculiar opportunities for professional advancement, while the general public get a very real return for their subscriptions in the progress of medical knowledge which benefits all classes alike. No money is better invested than the £12 millions which is spent annually on the up-keep of voluntary hospitals.

We have now to deal with the other items which make up the collective expenditure on sickness. The Poor Law may be dealt with first.

The policy pursued by the Board of Guardian in the administration of medical relief is not altogether unlike that of the voluntary hospitals, in the sense that it is only offered, at any rate in theory, to a strictly limited class – the class who cannot or have not made independent provision against illness. It is not offered to all and sundry, and it is not made too pleasant. No one who has an alternative is likely to choose the Poor Law, and except in very urgent cases, medical attendance from the Poor Law doctor is only to be obtained after application has been made to one of the relieving officers for a medical order. Notwithstanding these conditions, there are a considerable number of these orders. In 1909, the only year for which exact figures are available, they were issued to 2,375 persons, and this total does not include those who received non-medical as well as medical relief, or those who received indoor medical relief. If these classes were included the total would be considerably increased. These figures do not, of course throw any light on the amount of sickness which remains untreated by other agencies. They merely record the number of people who, by reason of their need or lack of independence, were ready to apply to the Poor Law in spite of the deterrent conditions which attach to it. So far as the Poor Law is concerned, no one need be doctored if he prefers to do without it. The only important exception is in the case of parents who are bound to apply for treatment if they cannot

otherwise provide adequate care for sick children; they are also under statutory penalties to have their children vaccinated unless they get an exemption order from a magistrate on the ground of conscientious objection. In Norwich last year over 1,600 of these orders were made, with the result that less than a third of 3,100 children born during the year were vaccinated.

The Town Council, which in Norwich spends as much or even more on medical treatment than the Board of Guardians, stands in a completely different relation to the problem of disease. The responsibilities of the Guardians only begin when an application has been made to them. It is no part of their duty to search out disease or to prevent the spread of infection, and they are exclusively concerned with treatment. The Council, as the Public Health Authority, is concerned primarily with the prevention of disease. It cannot wait, therefore, until the patient suffering from small-pox or scarlet fever applies to the medical officer for help; on the contrary, it has elaborate machinery for detecting every case of notifiable disease at the earliest possible moment, and notification is followed up by compulsory and gratuitous treatment in the Isolation Hospital. More than this, the Council, through its health visitors, is attempting to ensure that no citizen's health is impaired by ignorance and carelessness in infancy, and this principle has now been carried a step further by the systematic medical inspection of elementary school children.

The fact that there should be two public authorities spending the ratepayers' money on free medical treatment, without any systematic cooperation in practice, and on principles which are perfectly distinct and irreconcilable in theory, raises a very important problem. The respective spheres of Public Health and of Poor Law in relation to sickness cannot be separated on any logical and consistent ground. It is entirely a question of degree and of social expediency. The Public Health Authority treat some classes of disease and not others on the ground that they are specially infectious and therefore specially dangerous. But all disease is dangerous to some extent. Why, for instance, should the poor mother whose child is suffering from measles

go to the Poor Law doctor, while her next door neighbour, whose child has scarlet fever, comes under the jurisdiction of the Medical Officer of Health? As a matter of fact, more children die from measles than from any notifiable disease, largely through ignorance. If, however, the Public Health point of view is applied to all disease, and the Town Council undertakes the whole provision of medical treatment from the rates, it will be no longer possible to make this service deterrent. The public health is best served by inducing people to apply for doctoring at the earliest possible moment. Whether they could or should pay for it must, under these conditions, be a secondary question which could only arise after treatment had been given. There would consequently no longer be the same penalty on those who might provide against sickness by their own efforts but have failed to do so. To that extent there would be less inducement for individual thrift, and the immediate cost to the public would be proportionately greater. Whether this is to be regarded as a valid argument against the consolidation of public medical services under the Health Authority must depend largely on the view which is taken of the nature and importance of individual responsibility. There is real point in the contention that a Health Authority, armed with powers of compulsory treatment, might effectively insist at least on the duty of keeping well.

Citizens who impaired their physical health or their chances of recovery from disease by an improper course of life would no longer be allowed to do so with impunity. In any case, so long as thrift and prudence are encouraged by making medical relief deterrent, the community has to pay for these virtues by being rather less healthy than it might be. If the individual is expected to meet the cost of his own medical treatment, the State cannot in justice insist on the amount or the nature of this treatment. Advanced phthisis cannot be isolated; the solitary old persons too feeble to keep themselves or their surroundings clean, must, if they prefer it, be left to their dirt and the solace of a bottle of medicine; the man who drinks too much must be left to consume the drugs of his club doctor and

more beer. This would not matter if onlythe individual affected suffered, but they arc each of them more or less a focus of disease, and therefore a source of danger to all who come in contact with them. The principle of individual responsibility as it is commonly interpreted may still be so valuable that it is worth paying a high price for it, but it is well to recognise that the price must be paid. Perhaps there is no royal way of escaping the penalty which society has to pay for the lapses of its members.

There is at any rate one direction in which the public provision of medical treatment is bound to grow in the near future. We saw in chapter v that medical inspection revealed the fact that rather over 13 per cent of elementary school children in Norwich required medical treatment. Out of 400 cases referred for treatment in 1908, 81 per cent secured proper medical advice; in the remaining cases, either nothing was done at all, or the children were attended by chemists, which is possibly less satisfactory still. Of the children who secured the necessary medical attention, 130, or 40 per cent, were treated by private doctors, whilst the hospitals were responsible for the rest. The way in which thiswork was distributed may be tabulated as follows:

Norfolk and Norwich Hospital	94
Jenny Lind Infirmary	77
Eye Hospital	33

Medical Inspection has only just begun, and the results have already made themselves felt in a distinct pressure on the accommodation and resources of thevoluntary hospitals. This is bound to grow in the near future, and sooner or later the hospitals in sheer self-defence will be driven to revolt. In the main, children who are brought to hospitals as the result of inspection are suffering from quite minor ailments which could be adequately treated in much less expensively equipped institutions. In the public interest, as well as their own, the hospitals wisely endeavour to limit themselves as much as

possible to the cases which lie outside the resources of ordinary routine practice. The community may not unjustly ask the medical profession to give their services, either for no payment at all or for a very lowpayment, so longasthislimitationis enforced. Once this principleis allowed to dropoutof sight, the whole basis on which voluntary hospitals have been organised breaks down. The general practitioner will then have a right to complain that the State is getting work done for it without making a fair payment in return. It is no answer to point out that medical inspection has, as a matter of fact, created an entirely new demand for the services of medical men which is met to a large extent already through the usual channels of private practice. The 130 children in Norwich who were attended, as we have seen, by the ordinary medical advisers of their parents, probably would not have been so attended, if the need for it had not been disclosed by the medical inspection atschool. But that is, after all, no reason why the treatment given to the remaining 60 percent at voluntary hospitals should not be paid for too.

In London and elsewhere this difficulty has been met by the Education Authority making a grant to the hospitals who have appointed a paid medical staff to carry out the work. This is strictly in accordance with the policy at present advocated by the Board of Education, but the majority of a special Committee, appointed by the L.C.C. to examine the question, recommended an entirely different course. They found that the need disclosed by medical inspection was not at present being met by voluntary hospitals, largely because the kind of treatment required could not be suitably given, without special arrangements, affecting premises as well as staff. If these were to be provided the Education Authority would have to pay for them, and in the long run it would cost no more, and involve infinitely less friction, for the Authority itself to undertake the administration of cliniques. Operative treatment other than dentistry, would still be left to the hospitals, whilst the cliniques would deal with ringworm, and the morbid conditions of eyes, teeth, and ears which at present go untreated.

Such an arrangement would have the further advantage of avoiding the financial confusion which must ensue when voluntary institutions are subsidised from publiefunds. On these grounds, therefore, it will ultimately become necessary for the Education Authority to provide a school clinique in which the physical defects revealed by inspection can be treated at the public cost. Where, however, the parents are able to make their own arrangements, treatment may be left, as at present, to the private practitioners. The family doctor, so the experts say, is in a better position to advise his patients than any public official can hope to be. On that ground a school clinique, even in its own limited sphere, is only to be recommended so long as there is no alternative. For certain kinds of treatment, perhaps, there can be no alternative, and this applies particularly to dentistry. In Norwich 83 per cent of the children examined were found to have defective teeth, and it is quite safe to say that, except for extractions, no working-class family considers it necessary to give any attention whatever to this subject. Cambridge is the only Educational Authority as yet which has a dental clinique for the benefit of its scholars, but short of this much can be done by the health visitors, and in school, at least to emphasise the value of toothbrushes.

This sketch of the way in which medical service is organised in Norwich may be completed by a review of the various systems of mutual insurance on a provident basis. Of these by far the most important are, of course, the Friendly Societies. Altogether there arc ninety-four societies or branches of societies with a total membership (1906) of only just under 21,000. On the lowest estimate at least half of the adult wage-earning male population provide against sickness in this way. The special feature of a Friendly Society is that it provides an income in time of sickness in the shape of sick pay as well as an economical way of paying for medical attendance. In Norwich the average quarterly contribution is 6s 6d, and sick pay is given for six months at the rate of 10s per week and half pay for another three months. In the event of permanent disablement, including old age, continuous quarter pay is given by all societies, whilst one

Lodge of the Manchester Unity of Oddfellows gives its members a superannuation allowance of 3s 6d a week at the age of sixty-five. All societies give a funeral benefit of from £8 to £12.

The numerical strength of the Friendly Society movement in Norwich is certainly remarkable. Probably no other large industrial centre could show such a proportion of members in relation to population. It is partly a matter of race. In 1902 the Ancient Order of Foresters published a return giving for each county the number of adult members per thousand of population. Norfolk headed the list with 61.37 per thousand, and Suffolk came next with 50 per thousand. The East Anglian, it seems, is thrifty by nature. At the same time his wages are too low to admit of his providing for the future by any alternative way of saving. It is, for instance, difficult for him to join a trade union. There are only thirty-two trade union branches all told in Norwich, with an aggregate membership of under 4,000, less than a fourth of the Friendly Society membership. In Lancashire, where the trade unions are exceptionally strong and wages are high, the Foresters in 1902 could only show a membership of under 4 per thousand of population. In Norwich the trade union movement is becoming stronger, and this is sure to affect the position of the Friendly Societies. The trade unions, it must be remembered, to a large extent give the same benefits – excepting medical attendance – and something in addition. The Friendly Societies have, moreover, to meet the very serious competition of the large collecting insurance companies. It is true that these only give a benefit on death, but in nine cases out of ten it is the funeral benefit which really attracts the average healthy member of a Friendly Society. If this has already been provided for by a penny-a-week insurance policy which is collected at the door, the other benefits lose half their attraction. Great orders like the Foresters and the Oddfellows would do well to consider the possibility of adopting the same methods. An opportunity might perhaps be found in some plan of co-operation with the scheme of invalidity insurance which is promised by the Government.

The Friendly Societies provide medical attendance and medicines for their members by entering into a contract with a

medical man at so much per head per year. The usual payment in Norwich is 9*d* a quarter for each member, or 3*s* 6*d* a year. As an alternative a court, or individual members of a court, may join the Norwich Friendly Societies' Medical Institute. The Institute has attached to it at present thirty-three courts and three shop clubs, with a total membership of rather over 7,000. The scale of payment has recently been increased from 3*s* 6*d* to 4*s* per year for each member. An additional payment of 8*s* provides professional attendance for a member's wife and for his children under sixteen years irrespective of number. Unmarried daughters over this age pay at the rate of 4*s* a year. There are 1,048 families on the books and 1,314 wives and daughters.

At the Institute, therefore, a payment of 12*s* a year will cover medical attendance for a whole family. This does not include midwifery, for which a charge of 12*s* 6*d* is made in each case. The ordinary professional fee for attending confinements in Norwich is not less than a guinea.

The Institute employs three whole-time medical officers at salaries which amount on the average to rather less than £300 per annum. Until last summer no alteration in the fees of the Institute had been made since 1872, and it is probable that the scale of payment for contract attendance generally in Norwich is too low.

The formation of the Norwich Public Medical Service some years ago was, in fact, promoted by local medical men on this ground. This is an interesting attempt to provide an alternative to the ordinary form of contract attendance. It is entirely a private enterprise of the doctors who form the medical staff, who number seventeen. For individual members the contribution is the same as at the Institute, namely, 4*s* a year, and members have the right of selecting any doctor on the staff. Wives and children pay at the same rate, but not more than four children under fourteen years are charged for in the same family. The Service has its own collector, who collects members' payments at regular intervals. Roughly speaking, membership involves the payment of 1*d* a week for each member of a family with not more than four young

children. The fee for attending a confinement is extra, and is not less than 21s. Compared with the Institute, the cost of the Public Medical Service for a family is 26s annually, as against 12s. But this is not the most important difference. The Service enforces a wage limit, and will not admit as members individuals earning more than 25s a week, or families with combined earnings of more than 30s. This is a principle which the Friendly Societies will find great difficulty in accepting. So long as medical attendance is one of the normal benefits which attach to membership, it is not possible for any court to say that a member is ineligible for it on the ground that he is earning 26s a week, and not 25s, or has sons and daughters going to work who bring the combined weekly income of his family to more than 30s.

The relations between the Public Medical Service and the Friendly Societies in Norwich illustrates in a very apt way the inextricable confusion which has overtaken the whole question of medical treatment for the average wage-earner. There is no department of life in which the standard of consumption has risen so much during the last fifty years. The progress of medical knowledge has increased thecost of a doctor's professional training at least in proportion, but there has been no corresponding advance in the terms on which he is expected to undertake contract practice. This means, and there is no use in disguising the fact, that the best men are unwilling to undertake this class of practice, which is bad for the public and bad for the Friendly Societies. It may well end in discrediting the whole system of mutual provision against sickness.

If the Friendly Societies raise their quarterly contributions they may diminish their membership, and the situation is rendered still more difficult by the fact that they have not the whole field to themselves. In Norwich as in many other towns they have to face the competition of a dispensary, which is organised partlyon a provident and partlyon a charitable basis. At the Norwich Dispensary, establishment charges and incidental expenses are paid for out of charitable funds, at a cost of a little under £200 a year. In addition, subscribers have

the right of nominating a certain number of free patients. In 1908 these numbered 255. The provident side of the Dispensary is, however, its most important side. The number of paying members is not given in the published report, but the medical staff received from them in fees over £500 as compared with £66 received in respect of subscribers' nominations. Members' payments do not cover the whole cost, and the contribution is, on the whole, rather less than that required for membership of the Public Medical Service. On the other hand, it is rather more expensive than the Institute.

The most difficult problem in the organisation of provident medicine has still to be touched upon. The birth-rate in Norwich is declining somewhat rapidly, and it is therefore particularly important that working class women should be able to secure proper care in their confinements without undue difficulty or expense. The attendance of a doctor may be secured at varying rates through any of the three important provident institutions described above, but an increasing use appears to be made of the Norwich Maternity Charity. This may be partly due to the fact that only certificated mid-wives are now allowed to practise. Three out of the nine registered midwives in the city are employed by this charity. Last year (1908) the Charity attended 724 cases, which amounts to about twenty births out of every hundred in the city. The total expenditure came to £453, of which £65 was derived from a Provident Maternity Club carried on as a branch of the Charity. This was responsible for 224 cases, or rather less than a third of the total number dealt with. The payment is 5s, and this entitles a mother to the attendance of a mid-wife and of a doctor if necessary, an order for a small quantity of coals and milk, and the use of a bag of linen. As the ordinary fee for a midwife is 7s 6d, without any of these advantages, the Provident Club is considerably cheaper, and the number of women who make use of it is rapidly increasing. No woman is entitled to join who has not one living child, and there is an income limit of 23s a week. The same limitations apply to free cases who are admitted on the recommendation of

² Provident Medical Treatment. Members' Contributions.					
Dispensary.	Per annum.	Friendly Socie- ties' Institute.	Per Ann.	Public Medical Service.	Per Ann.
Man, wife, and children un- der 14 .	12/-	Man, wife, and children un- der 16 . .	12/-	Man, wife, and 4 or more children un- der 14 . .	26/-
Man and wife	8/-	Man and wife	8/-	Man and wife	8/8
Single mem- bers . .	5'-	Single mem- bers . .	4/-	Single mem- bers . .	4/4
Maternity cases . .	15/-	(Attendance by court doc- tor 3 6)		Maternity cases (doctor)	21/-
(Doctor, first case, 20/- ; second case, 15/-)		Maternity cases (doctor)	12'6		
Midwife .	5/-				

subscribers, except that in this case the income limit is 20*s* a week, unless there are more than four children, when it is 23*s*. The Committee, however, appear to experience considerable difficulty in enforcing these conditions.

Skilled nursing is provided in other cases of sickness by the Norwich District Nursing Society. The Society has a staff of six nurses, one of whom is occupied part of her time in the outpatient department of the Jenny Lind Infirmary. In the year 1908, 9,733 cases were attended in their own homes, including a few who were in a position to make a small weekly payment. There is perhaps no charity in Norwich which does more useful work. Wherever they go the nurses are missionaries of wholesome and cleanly living, and the rising standard which is observable in these matters is as much due to them as to any other agency.

The Invalid Children's Aid Association may also be mentioned here. This Society devotes itself specially to the care and regular visitation of physically defective and invalid children, and has a staff of twenty visitors to supervise the 180 children on its books. In co-operation with other societies it

gave other help in seventy cases, including thirty-two children who were sent to the country or to convalescent homes. The nature and value of the work accomplished will be best illustrated by quoting one of the cases dealt with:

I.C.A.A. CASE.
A.H., aged 3, suffering from infantile paralysis, was referred to us by the C.O.S. The doctor ordered daily massage as the only treatment likely to do the child any good, and this the mother could do herself if instructed. The latter was at first very despondent and unwilling to follow the advice, but entirely owing to the constant and helpful visits of the I.C. A. Visitor, she has been encouraged to persevere. The child is beginning to show signs of improvement, and the parents are very grateful for the interest and sympathy shown to the little boy.

It will be seen that the action of the Society is carefully directed towards strengthening and not weakening the responsibility of the parents.

The last two chapters have been mainly concerned with charities in Norwich, and some space has been taken up in pointing out the difficulties which arise from their number and lack of co-ordination. But there is another side to the picture. If those who receive donot always benefit, the spirit of those who give is still a possession of incalculable value to the city. It is not merely that the charities are rich in money. No one can devote much attention to the subject without becoming aware of the enormous amount of hard personal work which lies behind the mere gift of money. Such things make for strong and healthy citizenship, and without them no community can flourish. In the slow evolution of society the inspiration of this service of the strong for the weak has still a part to play, but stronger and more effectual than before as it learns to become more organised and persistent.

Social Influences

Previous chapters have passed in review the broad factors of industrial organisation, government, and social service which together make up the environment of life in Norwich. This sketch has now to be filled in with an account, necessarily incomplete, of the various ways in which its citizens endeavour to provide for the wider possibilities of life. By this means it will be possible to arrive at a general impression of some value as to the essential character of the city as a living organised thing.

Amongst associations of this secondary type – secondary in the sense that they do not contribute immediately to the material basis of life – the most significant in Norwich are the churches. Norwich is still as much as ever the capital of Puritan England. All the strongest forces in the city seem to find their readiest expression through theological and religious channels. No cause is likely to flourish here unless it is reinforced with the enthusiasm of a creed.

This remains true even in politics. Whilst trade unionism is relatively weak, Socialism is head and front of a labour movement which is powerful enough to return one of the two members in the parliamentary representation of the city. It is hard to assign any cause for this except that Socialism more than any other body of political doctrine makes an appeal akin to that of religion. It has visions and inspires prophets; it holds up an ideal which covers the whole range of human conduct. You cannot say

of the political faith of a Conservative or a Liberal that it contains aspiration touched with emotion, but you can say it of Socialism.

As every other faith desires occasions for edification, so does Socialism. It is a perfectly natural, and withal very English outcome of these facts, that there should be labour churches and Sunday-schools, and even a labour hymn book. It goes without saying that there is a labour church in Norwich. In East Anglia revolution has always taken a religious cast.

As this institution is new, and to many people frankly shocking, it may be worth while to digress so far as to describe the proceedings. The meeting is held in a small and decidedly dingy hall used on week-nights for a cinematograph entertainment. The afternoon on which the writer attended the weather was exceptionally bad, so that the attendance was probably smaller than usual, but there were between thirty and forty people present. They were all respectable working class people, rather well to do than otherwise. The chair was taken by a woman. After a hymn, which spoke nobly of toil and sacrifice and brotherhood, and was sung, oddly enough, to a tune from the public schools' song book, the speaker was called upon to address the comrades. He took as his subject the 'Hell of Poverty', and dwelt at length and with much fervour on the way in which life is crippled and impoverished by the lack of a sufficient material basis. It was crude, narrow, material; but behind it was an intenseconvictionthat a fuller and more glorious life was possible for stricken humanity. It was not, to say the truth, in itself very interesting. Perhaps all gospels sound rather threadbare to one beyond the pale. But each well-worn formula was received by the audience with a perceptible hum of edification – very much as the fifthly and sixthly of a Highland minister in a remote congregation of the wee free Kirk. For them these phrases were in all sincerity symbols of hope and promise. That is the significance of it. It was a confession of faith, a testifying, a gathering of the brethren to warm one another with the fire of conviction.

Whatever its faults are, Norwich has not fallen into the vice of indifference. If it cares at all, it cares intensely. Probably that is why it has inherited more churches, on a rough estimate, than any other city

of its size in the three kingdoms. Counting them all, there are not less than ninety-eight, representing fifteen denominations. The Church of England controls more than half this number, or fifty-two, organised in forty-seven parishes. The Wesleyans and the Baptists come next with twelve and eight respectively, whilst the Congregationalists rank fourth with seven churches. The Roman Catholics possess two, one of which is a particularly striking and beautiful addition to the public buildings of the city. In general, Nonconformity has not been fortunate in its architecture, but the old Meeting House, which is still owned by the Society of Friends, and the interior of the Octagon Chapel, are both exceptions in this respect.

There are ten other denominations with seventeen churches, including, however, six undenominational missions.

The forty-seven parishes of the Established Church are organised as a rural deanery with a representative council, which includes laymen as well as clergymen from each parish. The Nonconformist churches are provided with somewhat similar representative machinery in the Free Church Council. Between the Church on one hand and Nonconformity on the other, there is thus a certain parallelism which expresses itself in all sorts of ways. To some extent this has led to unnecessary duplication and confusion in fields of work in which political, social, and theological differences have certainly no place. Something has already been said on this point in Chapter X. In a cathedral city it is no doubt somewhat more difficult for either side to discover on how many things they can agree, but it is a discovery which only needs ordinary frankness and goodwill, and it would lead to a concentration of forces which would benefit everyone concerned.

It is not possible, even if it were worth doing in itself, to make the sort of statistical comparison between the various churches which has been made in other places. The spiritual influence of a church as a factor in the social life of a great city is not to be measured by the mere counting of heads. Between the Church of England and other denominations there are, moreover, certain differences of method and organisation which make such a comparison entirely illusory. On the whole, the Free Churches are concerned very much more with their own members and with the government of

their own church. They are democratic bodies, and the activities connected with them are largely initiated and sustained by the members themselves. An active church member of an average Nonconformist congregation is a much occupied man. His whole life outside business hours may very well centre in his church. This is true of women as well as men, and of the rank and file as well as of the leaders. The church provides for social and political as well asspiritual needs. It is a man's club, a centre of intercourse, a place of meeting for his young people; in all the relations of life it provides him ready-made with a standard of manners and morals. The last is certainly not the least importantfunctionof any church. The average sensual man endowed with noparticular tastes orability is exceedingly apt to become a social nuisance when he is taken away from the atmosphere of conventional respectability which gathers round an association of this kind. The association of a church is by far the most important and effective of all the devices by which society protects itself against barbarism.

By way of illustration, we give below a description of the duties of an office-holder in a small Nonconformist church, written by a Norwich working man. It is not every member, of course, whose time is taken up to thesame extent, but everyone has, at least, the opportunity of taking an active share in this busy corporate life:

The life of a 'real' Church official, in any average Nonconformist place, is filled to overflowing.

Besides holding some responsible position in the Church, such as secretary, etc., he is usually a steward, whose duty it is to hold out the hand of fellowship to strangers and members, showing them to their seats, providing hymn-books, etc. You will invariably find him holding an office in the Sunday School as superintendent or teacher, and President, it may be, of a Men's Bible Class, or a P.S.A. He will be expected to give a monthly address to the P.S.A., and often to provide a weekly lesson to his class. He will be found either 'opening,' or 'closing' the Sunday School once or twice a quarter.

He is often a local preacher, sent out several times in a quarter to fill the pulpits in country villages. In 99 cases out of an 100 he will be a Progressive in politics, and when you remember

that hundreds of such men are poured every Sunday into the villages, enthusing the congregation with that spirit of righteous discontent, you will be able to understand why many of the counties return to Parliament men of advanced ideas. He will belong to the 'Band of Hope' as president or vice-president, and there will be expected to proclaim against the Drink Traffic.

He will be seen working with the young on another night in the Christian Endeavour movement.

At the week-night meeting he is a regular attendant, often being found taking the service.

Usually there is a Debating Class in connection with the Church and School, and even there he is to be found prominent in discussion.

Friday night is usually a clear night from Church matters, and then he is found at some political gathering. He often enlivens the humdrum by being a Passive Resister.

Saturday night is often booked for Popular Concerts, at which he is expected to attend and perhaps arrange for.

The Church of England enters into the fabric of social life in Norwich in a rather different way. It is the special advantage of a parochial system that it enables a rich church – rich in comparison, however poorly endowed in relation to the work before it – to devote itself to the service of the very poor. Partly by organised and systematic visitation, partly through the provision of clubs and in other ways, it is able to bring social opportunities within reach of those who lack the strength and the initiative to provide such things for themselves. Its congregational life is not perhaps quite so vigorous, though this may be only an impression due to its less democratic organisation; but, on the other hand, its social work is very much more extensive. There are many dark places in Norwich into which the light of educated public opinion is only brought by the agency of the parson and the district visitor.

We have illustrated the way in which a Nonconformist church provides scope and social opportunity for its members, by an extract contributed by a church member. The social work of the Established Church may be similarly illustrated from the following

description of a well organised parish. The parish is a relatively small one, with a mixed population of a little over 1,200. Social organisation, apart from house-to-house visitation which is carried on by a staff of eleven visitors, of whom one is a salaried lay reader, centres in the parish institute. This is an eighteenth century mansion which has been adapted for the purpose. A special and rather exceptional feature is the care which has been taken to decorate the walls with reproductions of really good pictures. Here rooms are provided for a girls' club, with a membership of thirty-five, which meets once a week, in connection with which there are classes for cooking and sewing. On the same evening, in another part of the building, there is a gymnasium for boys. On three other evenings the rooms are used for separate clubs for older men and lads, and in connection with the latter there is a football team. Besides these organisations there is a weekly mothers' meeting, and a Band of Hope for younger children. Altogether the church is instrumental in providing a good deal in the shape of recreative and social opportunities for its 600 working class parishioners.

This impression of the social value of church life in Norwich may be supplemented by a few facts, mainly of a statistical nature, derived from returns received by the writer in answer to a circular enquiry. The one type of organisation which appears to be common to all churches is a Sunday School for children. There are certainly not less than 16,000 children attending these schools. Twelve out of the forty churches who answered the enquiry provided clubs for girls, but none had a larger membership than seventy. Except in two cases they were all connected with parishes. There is a girls' night school with 170 members, in connection with a Nonconformist church, and another has a similar organisation for men. It is curious that after forty years of elementary education there should still apparently be quite a number of elderly workmen who are glad to avail themselves of the advantages of a voluntary eveningschool to learn reading and writing. Only eight of the churches making returns appeared to have boys' clubs, with a membership varyingfrom ten to forty, and these again were parish organisations. These figures may perhaps be doubled for the whole city. In addition, seven parishes

have companies of the Church Lads' Brigade, and there are five companies of the Boys' Brigade, which is an undenominational organisation. So far as the churches areconcerned, the club movement is scarcely as strong as might be expected in an essentially industrial city. A very experienced social worker accounted for this by saying that the girls, at least, preferred to stay at home. It is one of the supreme advantages of relatively good housing that a poor man can enjoy real family life. Whether this applies to boys as well as girls is perhaps doubtful. In any case, only a very small percentage belong to clubs.

Contrary to the general rule, less seems to be done, on the whole, in the way of providing recreation and discipline for boys between fourteen and fifteen – the most critical years of life – than for older boys and men. Connected with the Church of England there are fifteen men's clubs, with an aggregate membership of between 700 and 800. An attempt is now being made to bring these together in a Federation. Two Congregational churches have also small organisations of this kind.

The Y.M.C.A., which has a membership of 640, and the C.E.Y.M.S., with 720 members, are not included in these totals. Neither of them can be said to appeal to working men. They are both, however, institutions of some importance. Their members are mainly recruited from clerks and shop assistants, and the C.E.Y.M.S. has always taken a leading part in the organisation of athletics. It was, in fact, a secession from this society which founded the City Amateur Football Club, which ultimately established the game on a professional basis. Neither of these societies are self-supporting. The annual subscription of 8*s* which entitles a member to the use of the club premises, only covers about a third of the whole cost. Athletics are separately organised, and in each case there isasmall extra subscription. The upkeep of the Earlham Road Recreation Ground, belonging to the C.E.Y.M.S., is partly met by receipts from 'gates'.

Both Societies have junior sections, in which the main attraction is a gymnasium. The Junior Institute of the C. E. Y. M.S., which has separate premises in Prince's Street, has also classes in shorthand, but these are not well attended. As a boys' club, with a membership

of 150, this part of C.E.Y. M.S. activity in Norwich ought to be a valuable factor in city life. Possibly the attempt to build up a spirit of fellowship and esprit-de-corps out of such diverse elements as the cathedral choristers, the post office messengers, and the Church Lads' Brigade of a neighbouring church is beyond the genius of any club manager. From this point of view – and it is quite the most important aspect of the matter – the club for boys over eighteen at the C.E.Y.M.S. Settlement House is the most successful undertaking of its kind in Norwich. The Settlement House in Calvert Streetis in the centre of the poorest district in Norwich, in a neighbourhood which has seen better days. The fine old merchants' houses in the main streets have been turned into shoe factories, and the worst paid and least regularly employed operatives live in the courts and alleys leading off them. For the sons of these men, who are just growing up into manhood, the Settlement House Club offers an invaluable chance of disciplined corporate life. The managers have succeeded in creating the spirit which gives a club something of the same influence over its members that a public school has over its scholars.

The history of this club illustrates in a singularly apt way one of the cardinal principles of club management. When it was first opened it attracted a membership of older men drawn mainly from the ranks of skilled labour. The elected committee of the club refused to admit as members candidates who were younger in age and belonging to an entirely different industrial and social status. They were overruled, and the upshot of the matter was that the personnel of the club completely changed. It is a safe rule that a club, if it is to have any vigorous corporate life of its own, must be fairly homogeneous in age and social status. To ignore this is always to court disaster. Under ordinary circumstances it is about as practicable to expect respectable middle-aged carpenters and their like to enjoy the society of rough and rather high spirited boys, who have just been promoted to minor places in lasting or finishing teams, as it would be to put the deacons of Westbourne Park Chapel on the Committee of the Athenaeum.

Everyone buys their experience, and the Settlement House has not only survived its early difficulties, but it is rapidly becoming

an important influence in the social life of the city. It was founded with the idea that the parent society in Orford Place would provide a recruiting ground for definite social service. In the second place, it was hoped to make the House a centre which would attract people of good will in the city who might afterwards be sent on to other work. These ends have only been partially achieved. Every parish which sent in a Return, except one in a well-to-do suburb, reported a need of more help, and as yet the Settlement House has been able to do little towards meeting this demand. As one clergyman puts it, the only kind of volunteers who are of any value to him are those who are willing to accept responsibility. Casual help, which is only to be relied upon when there is nothing better to do, is of no use at all; of this there is already enough. That is to say, a Settlement which does not ask first and foremost for residents is failing to take the one step which is really essential to success. A resident is one who has given up other ties in order to be useful; an associate must always be less free to devote himself to some definite piece of work. The mere fact that a man is living with other people with different interests and a different plan of life will often effectually prevent him from keeping regular engagements. But residence has other advantages. It creates a school of knowledge and experience which stimulates social enterprise in ways that a mere institution can never hope to do. The fact that Norwich is a relatively small place where rich and poor are not separated by physical space does not therefore make residence unnecessary or useless. Residence gets rid of the conventional difficulties which prevent different types of experience from coming in to close and human con tact. It explains and justifies itself, it makes for neighbourliness and frankness. Without it there must always be a suspicion of patronage. The Settlement House already has one resident, and this is a beginning which promises greater things in the future.

With one remarkable exception, the Nonconformist churches have established no organisation which appears to have a direct social influence outside the circle of their own members. The P.S.A. movement, which is represented in fourteen churches, and has a membership of about 2,000, cannot be taken as affording a basis for serious constructive work. The Adult School movement,

which has been pioneered by the Society of Friends, on the other hand, is a factor in city life of the greatest possible significance. There are now twenty-one schools with a membership of nearly 3,000. Four of these are women's schools which meet in the afternoon, but the men's schools assemble on Sunday morning at 9 a.m. No other organisation in Norwich offers such an example of intense corporate life. It is a fellowship which is primarily based on the frank discussion of religious questions from a Christian point of view. The movement has no creed and is not in any sense denominational, though it is more nearly denominational in Norwich than in most places. The schools usually meet, for instance, on denominational premises, but church as well as chapel rooms are now used for this purpose, and there are certainly many Adult School members in Norwich who do not feel able to accept any system of dogmatic theology. Such men can, however, take part in the simple worship with which most schools open and close. An Adult School is nominally organised in classes, each with its own leader, and the first half hour is devoted to a brief lecture, followed by questions and discussions on some topic of general interest, often on some social problem. In Norwich, however, there are still schools which adhere to the old plan of teaching writing which must, in many cases, be rather wasted labour. Grown men do not in these days so much want to improve their writing as to open and expand their minds. In addition, there are always in every school a number of subsidiary organisations designed to enable members to help one another. There is a charitable fund administered by the school, and arrangements for visiting and assisting sick or distressed members. Another common institution in the Norwich schools is a self-help society, which is a form of a mutual insurance against unemployment. In return for a small weekly payment members are entitled to an allowance for so many weeks when out of work. Altogether, an Adult School is the centre of many kinds of activity, quite apart from its unique spiritual work. The movement is still growing rapidly in Norwich, and no attempt at a survey of the forces which are moulding character and citizenship could afford to ignore it.

In any estimate of these forces the Friendly Societies must certainly be given a high place. On this subject something has been said in a previous chapter in a different connection. But a Friendly Society is very much more than a system of insurance. Fora great many of the 16,000 or 17,000 members of these societies in Norwich their court meeting is the one opportunity they have for a training in public business. Any member who attends at all regularly will at some time or other during his membership be expected to take office. The duties of auditor, treasurer, trustee, sick visitor, or chairman entail a great deal of serious and responsible work. A Friendly Society man has always plenty of scope for showing his capacity. Besides the ordinary business of the court, the disposal of its property, the assistance of members in distress, the interpretation and amendment of the rules, discussion often arises on matters of general importance, which are referred from time to time from the headquarters of the Order. National Insurance, Pensions, the Reform of the Poor Laws, for instance, are all questions in which Friendly Societies take an interest. Nothing has played a more important part in the political education of Democracy than the great benefit Orders.

The ninety-one courts and lodges in Norwich control funds amounting to well over £210,000, and every penny of this has been saved out of wages. But this is far from being the whole measure of what Norwich working men have accomplished in this direction. Working men own and control what must be very nearly, if not quite, the largest retail business in the city. The Norwich Co-operative Society has a membership of 8,536, with a capital o £84,500. The total sales in 1908–9 were over £223,000, and the members drew over £18,000 in dividends on their purchases. If Building Societies and the Norfolk and Norwich Savings Bank are added in, the working classes in Norwich have built up a thrift organisation which has an aggregate membership of nearly 50,000, and an accumulated capital of well over one million.

Numerically the trade union movement, as we have seen, is not very strong in Norwich. In two of its most important trades, in the manufacture of food and drink and in clothing, there is no organisation at all amongst employees. The Trade Unions

have none the less of recent years exercised an enormous influence on public life. Every branch is now represented on the Norwich Trades' Council, which includes representatives from twenty-eight trade union branches. The Council is affiliated to the Labour Party, and in addition to focusing public opinion on questions relating to conditions of employment, it has played a leading part in the organisation of a very strong labour movement in politics. Labour in Norwich is well represented both on the Town Council and the Board of Guardians. If it had not been for the Trade Unions and the Friendly Societies, a small but very active body of Socialists would never have succeeded in creating an effective political machine. Even now it is only a small minority of those who vote in the Labour interest who accept in their entirety the doctrines of Socialism. The Socialists are merely the fighting head of the movement.

The Socialist propaganda centres round the Labour Institute, which is the largest workmen's club in Norwich, with a membership of 800. The subscription of 4*d* a week carries with it membership of the Independent Labour Party, which represents the Socialist section of the Labour Party. The club has a recreative as well as a political side; there is a bar at which alcoholic drinks are sold, two billiard tables, and a 'women's parlour'. Very great care is taken to safeguard these privileges from abuse, and at present the Institute is the only place in Norwich to which a man can take his wife and child and enjoy a sober glass of beer under respectable conditions. The experiment is still rather new, and it remains to be seen whether the best elements in the club will succeed in keeping the upper hand. There is always an element of danger.

Politics otherwise in Norwich do not present any features of special interest which need be mentioned here. All parties have a ward organisation, of which a public house is usually the headquarters. At the ward meetings municipal as well as imperial politics are discussed, and to that extent all parties help to maintain the very vigorous interest which Norwich takes in its own affairs. It is the custom to hold monthly meetings at which the town councillors of the ward representing the party

are present to give an account of the business which has been transacted at the Guildhall during the month.

By way of concluding this chapter something may be said as to there creative side of life in Norwich. The postmen and the employees of the Corporation Electricity Works both have social clubs of their own. But the most important organisation of this kind is the social scheme at Carrow Works. Messrs. Colman provide their employees with a club house and playing fields, and two paid officials of the firm devote their whole time to the work of creating heal thy amusement. There are clubs for boys, girls, and men, a large hall for entertainments or lectures, a band, a gymnasium, a boathouse, everything, in fact, that heart of man or boy can desire. Very little, however, seems to be expected of the employees themselves in the responsible management of these advantages. In this matter the firm plays the part of a benevolent despot. It is very hard to say, therefore, how far the various clubs – they include an Adult School – have a real life of their own. There can be no doubt, however, as to the athletics. In football and cricket Carrow Works are serious rivals to the C. E. Y. M. S., and every Saturday they have at least three teams in the field. For the girls there is basketball, and the older men are ardent votaries of the ancient game of bowls. Besides its recreative side, Carrow social scheme provides an old-age pension at sixty-five of 8s a week. A sum of 2d a week deducted from wages pays for an extra pension of 2s a week, or corresponding capital amount, which may be drawn out when a man leaves the firm. The men prefer in practice to take a lump sum. Every employee who is not insured for a sickness benefit in some other society must join the Sick Benefit Society attached to the works, and they may if they choose pay for a medical benefit for their families. A sick visitor is employed by the firm, and there is a Trust Fund left by a former director which provides assistance for those who stand in need of it. There is a clothing club for employees which pays interest at the rate of 5 per cent on deposits up to the amount of £1. The club has nearly 2,000 members, and the average amount deposited is 16s 6d. Girls employed at the works can obtain lodgings at a hostel provided by the company at the rate of 1s a week. All these

things betoken an honourable anxiety on the part of the directors for the social welfare of their workpeople.

In another sphere the city itself does a great deal to provide higher recreation for the citizens. The Public Library goes back to 1878, and is housed in a building of no architechtural pretensions, but except that some of the rooms on the ground floor are rather dark, the accommodation is good. On the 31st March last there were 2,511 persons who were borrowing books from the library, and duringthe year 4,400 tickets had been issued. Rather more than a quarter of the borrowers are children. In the lending department there are 24,200 volumes, nearly 8000 of which are fiction. The total issues amounted to 86,800, and over 80 per cent related to fiction. In poetry and drama there were only 817 issues during the whole year. The reference department possesses 18,600 volumes, besides a valuable collection of books and pamphlets on local history, of which considerable use has been made in these pages. The reading room attached to this department is used by over 400 people every day, mainly for the purpose of reading magazines, though there are a certain number of readers who ask for works on science and natural history. Nearly 1,000 people every day on an average make use of the news rooms. For a total expenditure of under £2,000 this is a very fair record of work. It is a pity that nothing has been done so far to make the library in any way a centre of organised study. There are many men who do not care to join a class who would be glad of an opportunity of reading and discussing subjects in a less formal way. It is not sufficient to give people books; they have to be induced to read them. There is certainly room in Norwich for pioneer work on a voluntary basis in the formation of reading circles. The library might co-operate by providing a room and a list of books on the subject selected.

A bookseller, whose customers were mainly working class people, told the writer that he could always sell books – if the price were low enough – which dealt with social topics or with popular science. The two books which he was asked for most frequently were *Civilisation: its Cause and Cure*, by Edward Carpenter; and the *Story of Creation*, by Edward Clodd. Dickens, as everywhere,

is the most popular novelist. There is, therefore, not likely to be any insurmountable difficulty in getting together twenty or thirty men to read and discuss some critique of modern institutions, or an application of the theory of evolution. A course of study on either of these subjects would be an education in itself. At present working men in Norwich who desire to study these things have nowhere to turn for guidance and help.

In contrast to the Public Library, the city museum is the centre of a great deal of intellectual activity. The collections, magnificently housed in the castle which still dominates the city, are in some respects unique. The collection of raptorial birds, and of pictures by artists of the Norwich School, are in each case of national importance. There is also a considerable collection of local and miscellaneous antiquities and curiosities of rather unequal value. The number of visitors has dropped continuously from 159,000 in 1896, to 105,000 in 1908. This result is almost inevitable with permanent collections in what is after all a relatively small provincial city. The average citizen does not take the trouble to go to see things which he can look at any day of his life. To counteract this tendency it would perhaps be an advantage if the Committee could from time to time arrange loan exhibitions, particularly of pictures. Norfolk is rich in county houses, in many of which there are fine collections: in many cases the owners would no doubt be willing to allow those treasures to be shown in the capital of their county.

The number of visitors is not, however, an indication of the use which is made of the museum for purposes of study. The Norwich Teachers' Field Club use the museum for meetings and demonstrations, and some of the knowledge gained in this way is afterwards passed on to the children, who are brought to the museum as part of their school curriculum. But the work of the museum lies principally amongst older students, and this side of its activities is now being developed by a voluntary society – the Norwich Museum Association.

The object of this body is to focus at the museum the scientific activities of the district, to promote the systematic use of the collections for serious study, and to arrange for lectures and discussions of scientific subjects of immediate practical value.

The Association was promoted by the President of the East Anglian Horticultural Association, and many of the subjects dealt with in the lectures are of interest to gardeners and agriculturists. The lectures, which attract an audience of from 200 to 300, including many working gardeners, are interspersed with discussions, usually on the subject of the preceding lecture. A lecture on 'Soils', for instance, was followed a fortnight later by a discussion in which the audience were able to make sure of their knowledge and clear up practical difficulties. Another lecture and discussion dealt with the 'Food of Birds'. By these means the museum is really becoming what it always ought to be, an essential part of the educational equipment of the city.

The Corporation serves the recreative needs of the citizens in two other ways. It provides open spaces for games in Eaton Park and on Mousehold Heath, although the supply is not yet equal to the demand, and it provides popular music. In summer there is a band twice a week in Chapel Eield Gardens, and in the winter the city organist arranges Saturday evening concerts in St Andrew's Hall. These attract an audience of from 500 to 600, who pay 2*d* for admission. The programmes err if anything in being too popular, and the audiences on the whole do not seem to find them very interesting. They applaud, but they do not listen as if they found the music really satisfying. It is just as easy to teach people to like the best things, and an English city which has the enterprise to undertake municipal concerts at all might well make the experiment. Norwich is not an unmusical city. It supports a Triennial Festival and two musical societies, and there is no reason to suppose that the Norwich working man possesses no taste in this direction. The experiment is anyhow worth trying. There are certainly amateurs in the city whose co-operation could be enlisted.

On the other hand, it seems lamentably obvious that Norwich has not much taste for drama. A new theatre which was opened some years ago has now become a music hall, and the only other theatre in the city restricts itself to third-rate companies in such plays as 'East Lynne' and 'The Bad Girl of the Family'. Even these can only draw indifferent audiences. The form of entertainment

which seems best to meet popular taste is the music hall and the cinematograph. The music hall is perhaps dull, but its morality is always unquestionable. On the whole, it appeals to rather well-to-do working men and especially to boys. Rather curiously this is partly a question of clothes. Best clothes are a sine qua non for the music hall, whereas the cinematograph may be visited without this formality. It is also rather cheaper. Admission is only 2*d*, whereas the Hipprodrome is at least 3*d*, and if you have reached the stage of 'walking out', it is de rigueur to go to the pit, which costs 6*d*.

The popularity of the cinematograph is one of the remarkable phenomena of modern times. But it is after all the most primitive and the simplest of all forms of expression – pictures which tell a story. Here again the morality is always good. The stories which are thrown on the screen, invariably with a musical accompaniment, are either unspeakably sentimental, or crammed with the most thrilling horrors – but it is virtue which triumphs, and the villain never fails to get his proper reward, and innocence always comes by its own. To understand the fascination of such things it is only necessary to realise the endless monotony of industrial life. The average under-educated factory operative who has been cramped for six days in the week at one mechanical operation, demands the wildest and most thrilling adventures by way of compensation. It is a natural reaction, and is better satisfied in this way than in the public-house.

The same explanation no doubt underlies the popularity of professional football. It is an exciting gladiatorial show. Much has been written against professional football, and professional play can never be sport any more than a penny novelette can be literature. Both satisfy the same natural reaction, which demands and must have excitement. Amateur football, in Norwich at least, is not, as a matter of fact, as exciting as professional football, and it does not therefore meet the same demand. This craving for excitement is not a new thing – it is as old as human nature; what is new is that the modern way of satisfying it is less harmful than the old – as the falling revenue from excise abundantly testifies. The crowds who devote Saturday afternoon in Norwich to professional football are not, after all, putting their time to an

altogether bad use. They spend 3*d*, stand for two and a half hours in the open, and cheer their city after a week of monotonous confinement in the factory. They might have done better things, but they would probably have done worse. It would be very hard to show that the increasing sobriety of Norwich, and on this there is a general concensus of opinion, does not owe something, at any rate, to this new habit of watching football matches. Whether there is much betting it is difficult to say. A clergyman who has had great experience in such matters felt positive there was not, but others were not so sure.

But when all has been said, it still remains true that the public-house is the centre of social intercourse amongst workingmen in Norwich. Compared with larger cities the Norwich public-house is smaller and more home-like. There is a bar with room to sit down comfortably, and 'smoke room', or 'porter-room' adjoining. This is used for small meetings, and there is often a larger room or hall behind. Another difference is that the landlord has usually some other occupation. The house is not his only means of livelihood.

In these hostelries the typical recreation of the Norwich working man go hand in hand with the serious business of his trade union and his friendly society. The popular amusement in Norwich is beyond doubt the royal art of angling. The writer had curious confirmation of this fact in some essays which were written for him by elementary schoolboys. The subject set was 'How I Amuse Myself'. Football was obviously first in the estimation of those scribes, with cricket a long way behind, but almost every boy who mentioned going out into the country – and it is surprising how often this is mentioned – added that he went fishing, the only exception being a few plutocrats who went bicycling. Of fishing clubs connected with public houses there are at least a hundred, with an average membership of between thirty and forty. The members mostly come from the better paid ranks of labour, but there are said to be a dozen clubs amongst labourers earning less than 20*s* a week. The average subscription is 12*s* 6*d*, which is supplemented by a prize fund collected from other sources. The accumulated funds are spent on an

annual outing to Horning and Ranworth, or very occasionally to Wroxham. The members start in brakes in the early morning for the fishing ground, where they breakfast. The serious business of the day comes next, and is followed by a substantial dinner. Prizes are awarded according to the weight of fish caught, but the satisfactory feature about these competitions is that everyone gets a prize of some sort, not less in value than the difference between the expenses of the outing per head and the total subscription paid. The average amount is about 5s.

Besides fishing, some publicans organise bowling clubs. There is even a league known as the Anchor Bowling League with seven affiliated clubs which is carried on by a firm of brewers in the city. There are five clubs besides in the Norwich Bowling Association, and there are also a number of unaffiliated clubs. The Norwich Bowls Annual gives the names of twenty-six clubs in the city. Except at Carrow and a club which uses the municipal bowling green at the Gildercroft, an open space in the poorest district of the city, working men do not seem to take much interest in this game. It probably costs too much in incidental expenses. The game appeals more to the class just above them – the clerk who wears a collar and tie.

For working men a more popular amusement is either gardening or the fancy, which in Norwich means the breeding of canaries. Gardening has no convivial organisation attached to it, but it is possible to meet more enthusiastic gardeners in Norwich than in most places. It is one of the enthusiasms which seem natural to the soil. Besides the garden ground attached to most working-class houses in the city there cannot be less than 2,000 men who have allotments. For these the rent is usually 6d a rod.

Canary breeding is quite an important industry. The Norwich bird is famous for its song and is in great demand. Not less than 30,000 are exported annually from the city. There are between two and three thousand breeders in the city, and if a man is lucky he makes enough by his birds to pay the rent. On the other hand, if fortune is unkind he may find at the end of the season that he has nothing to show for his trouble. This is part of the attraction. Canary breeding' demands a good deal of skill and infinite trouble, and on

the whole it appeals to the steady man who is in regular work. This is partly due to the fact that a considerable outlay is involved for seed. In the shoe trade men are said to save up against the slack season in this way. Whilst in work they buy enough seed to carry them through the bad time, when they sell their birds as they want the money. A good deal of money, however, is spent in the canary clubs, of which there are about thirteen in the city. Meetings are held at regular intervals, when the members exchange information and discuss their difficulties. These meetings invariably take place on licensed premises, and the landlord is usually a prominent official. Occasionally there is a demonstration in handling birds or a lecture by an expert. The writer once had the privilege of attending a canary washing held on one of these occasions. Nothing could have exceeded the solemnity and decorum of the proceedings. The washing, it may be explained, was done with hot water and a patent soap preparation, and the skill lies in handling the birds without suffocating them. Afterwards they are wrapped in flannel and put in front of the fire to dry. Their subsequent appearance, it must be confessed, does not suggest that the victims thought the operation very good for their health.

In connection with the clubs there are shows two or three times a year at which prizes are given. These are solemn festivals which are celebrated by a club breakfast and half a day's holiday. But on the whole, the keeping of canaries is, as it ought to be, a gentle and humanising hobby, and its disappearance – there is no likelihood of this happening – would leave the city distinctly poorer. The canaries are bound up with the history of the city. They are said to have been brought over by the Flemish weavers, so that canary breeding has an historical claim to being the oldest industry in Norwich.

It is appropriate that this book should come to a close on this note. Perhaps its canaries and its history have done as much as anything else to awake that affectionate loyalty which is the special characteristic of the citizens of Norwich. It is a fair city and worthy of the noblest things. If anything in these pages can help forward the strong tide of its civic life they will not have been written in vain.